The Case of the Ugly Suitor

ENGENDERING LATIN AMERICA

EDITORS

Donna J. Guy
Ohio State University

Mary Karasch
Oakland University

Asunción Lavrin
Arizona State University

The Case of the Ugly Suitor

& Other Histories of

Love, Gender, & Nation

in Buenos Aires, 1776–1870

Jeffrey M. Shumway

University of Nebraska Press

Lincoln and London

An earlier version of chapter 5 was previ-
ously published by the Academy of Amer-
ican Franciscan History as "'The Purity
of My Blood Cannot Put Food on My Ta-
ble': Changing Attitudes towards Inter-
racial Marriage in Nineteenth-Century
Buenos Aires" in *The Americas* 58, 2 (Oc-
tober 2001): 201–20.
Set in Minion by Bob Reitz.
Printed by Edwards Brothers, Inc.
Library of Congress Cataloging-in-
Publication Data
Shumway, Jeffrey M., 1968–
The case of the ugly suitor and other his-
tories of love, gender, and nation in Buenos
Aires, 1776–1870 / Jeffrey M. Shumway.
p. cm.—(Engendering Latin America)
Includes bibliographical references and
index.
ISBN 0-8032-9326-7 (pbk.: alk. paper)
1. Domestic relations—Argentina—Buenos
Aires—History—Anecdotes. 2. Courts—
Argentina—Buenos Aires—History—
Anecdotes. 3. Law—Argentina—Buenos
Aires—History—Anecdotes. 4. Family—
Argentina—Buenos Aires—History—
Anecdotes. I. Title. II. Series.
KHA6212.S548 2005
306.8'0982'11—dc22
2004029237

For Kathy and the children

Contents

List of Illustrations viii
Acknowledgments ix

Introduction
The Ugly Suitor 1

1. *Buenos Aires*
Settings in Time and Place 8

2. *Lineage, Morality, and Industry*
Contours of Family and Society 20

3. *"Accept Us as Free Men"*
Ruptures in Society and Family 45

4. *"If You Love Me"*
Paternal Reason versus Youthful Romance 68

5. *"The Purity of My Blood"*
Attitudes toward Interracial Marriage 97

6. *Crude and Outdated Ideas*
Attitudes toward Women 115

Epilogue
An Old and a New Beginning 139

Notes 147
Bibliography 183
Index 197

Illustrations

following page 16
 1. Vendors on the streets of Buenos Aires, ca. 1800
 2. *San Francisco*, 1841
 3. *Pulpería*, 1864
 4. *Un nido en la pampa*, 1864
 5. *Interior del rancho*, 1841
 6. *La familia del gaucho*, 1841
 7. María Constancia Martíez's 1826 letter
 8. A *carreta* in the Río de la Plata
 9. *Soldados de Rosas jugando naipes*, 1852
 10. *Fiestas mayas*, 1841
 11 and 12. Porteño families at home and in the countryside

Acknowledgments

Many have aided me along the journey that has produced this book. I had the good fortune to spend much of that journey studying with Donna Guy. Now, with my own responsibilities in academia, the example of her commitment to her students and to history, which impressed me then, has taken on greater meaning. She always had time for her students and their children, whether during office visits, at *tertulias* in her home with her husband Gary, or during dinners of *mole poblano* from her elegant kitchen. For the many feasts, culinary and intellectual, I thank her. At the University of Arizona, I also received helpful guidance for this book from Michael Meyer, Kevin Gosner, B. J. Barickman, William H. Beezley, and the late Father Charles Polzer, S.J.

My gratitude also extends to my childhood years, when dedicated teachers in La'ie and Kahuku, Hawai'i, patiently turned my attention toward learning. I thank Kendall Brown for generously taking me under his wing in the early stages of my graduate studies. He, along with Thomas Pearcy, helped set the initial course for this project. My thanks also go out to Susan Socolow who gave helpful guidance as I made my first foray into Argentine archives, to Lyman Johnson for his advice and support, and to John Chasteen for help in solving a little mystery about the name of the ugly suitor.

In Argentina I was warmly received by the wonderful staff at the Archivo Histórico de la Provincia de Buenos Aires, "Ricardo Levene" in La Plata, the Archivo General de la Nación, the Instituto de Historia Argentina y Americana, the Academia Nacional de Historia, and the Biblioteca Nacional. José Luis Moreno, Silvia Mallo, Marta Golberg, Carlos Mayo, Ricardo Cicerchia, José Carlos Chiaramonte, Eduardo Saguier, Dara Barrancus, Noemí Gibal, and many others provided friendship and assistance during research trips. Across the Andes in Chile I have benefited from my association with Igor Giocovic and René Salinas Meza,

and the Sepúlveda and Mena families. I thank the families Darias, Gatica, Madariaga, Spencer, Goldberg, Zopetti, and Terán, all of whom opened their homes and hearts to me. Osvaldo and María Celeste Barreneche served as mentors and friends in Arizona and Argentina and I will forever cherish our relationships. Whether it was drinking *mate amargo* or learning the virtues of a certain soccer team, these friends taught me matters of culture in Argentina and Latin America I never could have learned within the walls of an archive.

Many thanks also to Asunción Lavrin, Donald Castro, and the staff and anonymous readers at the University of Nebraska Press. At Brigham Young University, Kendall Brown, Shawn Miller, Ignacio Garcia, Richard Kimball, and Craig Harline shared useful suggestions at various stages of the manuscript. Excellent students also helped with aspects of this project: Patrick Cragun, Ric Casper, Rhett Larson, Mark Skaggs, Nancy Morgan, Matthew Van Gieson, Jeff Richey, Mac Wilson, Micah Robbins, Elizabeth Burroughs, and the students in my History of Argentina courses.

Finally I give thanks to my family: to my father Eric Shumway for his example and encouragement in all aspects of my life and for his tolerance of a historian's style; to my mother Carolyn for her everlasting support; to my uncle, Nicolas Shumway, for welcome advice and hospitality; and to my in-laws Louine and the late Gus Shields for their years of kindness. To my wife Kathy and our children, thank you for the times you took me away from my books and reminded me what my life is really about. I thank Kathy in particular for fourteen wonderful years (and counting) of our own histories of love.

Introduction

The Ugly Suitor

No one will ever know how ugly Gumesindo Arroyo really was. We do know he was too ugly for José León Canicoba's taste, and it was Canicoba's daughter Francisca who fell in love with Gumesindo.

Gumesindo Arroyo lived in the port city of Buenos Aires and, as of March 1842, he had been visiting the Canicoba home for two and one-half years. But Mr. Canicoba, perhaps naively, did not expect this visitor to one day become his new son-in-law. When Gumesindo and Francisca asked permission to marry, Canicoba flatly refused for several reasons. Arroyo was too old for Francisca, and he did not have the means to support a family. But Mr. Canicoba saved his most passionate argument for another reason: Gumesindo Arroyo was simply too ugly.

The worried father had powerful cultural and legal traditions to strengthen his case. First, he was the patriarch of the family, and Hispanic culture gave patriarchs extensive control over their wives and children, at least in theory. Furthermore, Francisca was a minor and thus needed her father's permission to marry. Canicoba bolstered his opposition by citing a colonial marriage law issued in 1776 by the king of Spain, a law later extended to Buenos Aires and other New World holdings. The Pragmática sanción para evitar el abuso de contraer matrimonies desiguales (hereafter known as the Pragmatic on Marriage) gave parents the right to block their children's marriages to "unequal" partners. Although Buenos Aires broke from Spain in 1810, a host of colonial laws, including the Pragmatic on Marriage, remained in place until the late nineteenth century. Fortunately for Francisca and Gumesindo, the pragmatic also allowed children the right to challenge parental opposition in court. If children took parents to court, the resulting suit was known as a *disenso*, from the Spanish root word "to dissent." In such a case, a civil judge would hear the stories of both sides and their witnesses and rule in a manner that, in his eyes, would benefit the family and the state.

If the judge found the parents' opposition justified ("rational" in legal terms), then the parents won. If the parents' arguments were deemed "irrational," the court gave the children permission to wed against their parents' wishes. When Canicoba withheld his permission, his daughter Francisca felt she was faced with two choices: obey her father and sacrifice her personal happiness or take her father to court in hopes that a judge would grant her permission to marry the man she loved.[1]

Gumesindo and Francisca's case, which will be revisited periodically in later chapters, provides a useful introduction to the subjects of this book. On one level this is a collection of real stories about the everyday family life of men and women, parents and children, and lovers and friends in Buenos Aires and its surrounding towns during the late colonial and early national period (1776–1870). This time period brackets the year Buenos Aires became the capital of a newly organized royal territory, the viceroyalty of the Río de la Plata (1776), and the adoption of a new civil code (1870), which finally gave the new nation of Argentina its own set of civil laws. Many of the great women and men of nineteenth-century Argentina appear in the following pages: General José de San Martín, Bernardino Rivadavia, Juan Manuel de Rosas, Camila O'Gorman, Domingo F. Sarmiento, Dalmacio Vélez Sarsfield, and others. Mariquita Sánchez, for example, one of the most famous women of nineteenth-century Argentina, struggled mightily with her parents over her choice of a fiancé, a conflict that finally went to court in an 1804 disenso case.

Yet history is much more than the stories of the rich and powerful. The main stars of this book are the common inhabitants of Buenos Aires and its surrounding towns. These people, like Gumesindo and Francisca, usually did not leave behind detailed journals and letters for historians to examine. Fortunately, many did leave footprints in other ways, such as in court records dealing with family conflicts, where they told part of their life stories to each other, to lawyers, and to civil judges. These stories speak to us today.

A Brief Note on Sources

The sources used in this book include disensos, child custody cases, law school dissertations, newspapers, divorce proceedings, paintings, and other diverse literature. This combination of sources provides a view of significant aspects of the *porteño* (meaning from the port city of Buenos Aires) family as parents struggled to raise their children amid

the stresses of daily life. A few of these sources merit a brief introduction and discussion.[2]

Disensos, as mentioned earlier, were disputes between parents and children over the choice of a marriage partner where a judge would decide if parental opposition was "rational" or "irrational." The Roman Catholic Church and ecclesiastical judges presided over these types of conflicts during most of the colonial period; marriage was a sacrament, and Church doctrine taught that individuals should be free to choose their mates.[3] As elsewhere in Europe, the ideals of the Enlightenment and Royal Absolutism employed by eighteenth-century Spanish monarchs attacked ecclesiastical authority on many fronts, one of which removed Church jurisdiction over disenso cases and turned them over to civil judges. In 1778 the Spanish Crown extended the royal Pragmatic on Marriage to its American colonies, which gave parents the power to block their children's marriages to "social unequals."[4] The definition of "inequality" was ambiguous in the pragmatic, although it did show how the Spanish Crown tried to protect the social order of its realm. But words, especially words like "inequality" and "honor," can be variously defined. As seen throughout this book, parents, judges, and children frequently held conflicting definitions of honor and inequality, words with complex racial, social, economic, and behavioral variations.[5]

Child custody cases are another important source. In the majority of these cases, a mother or a father is trying to reclaim custody of a child they had previously given up to another family. When parents could not care for their children properly, they frequently allowed their child to live and work in another household. The host family benefited from the labor of the child in return for providing a proper education and acceptable living conditions. These arrangements could be in writing, but many seemed to be verbal agreements. A child custody case resulted when one of the parties would go to the judge demanding a child's return, usually for breach of contract. For years, histories of children and childhood came from documents that reflected the life of elite children. Child custody cases provide a glimpse into the lives of poor children, an important endeavor considering that the majority of the worlds' children past and present live in poverty.[6]

The court cases themselves offer a rich source of better-than-fiction stories. However, they do not always reveal the legal context behind the cases—that is, the background and ideological position of the lawyers and judges who played pivotal, but not always clear, roles in arguing

and mediating these proceedings. To address that context, though the subject still deserves more attention, I have looked into the legal world of nineteenth-century Buenos Aires.[7] Dissertations and course material from the law school of the University of Buenos Aires, founded in 1821, provide introductions to the way jurists approached the issues of the family from a legal perspective. These sources, along with general legal histories, bridge the theoretical world of the legal intelligentsia and the actual court cases, where the law played out in real life. This approach helps to reveal the connection between the state, elite culture, and everyday people in Buenos Aires as they mingled in the courtrooms of the great port city.

Court cases in general are an excellent source for scholars because they provide insight into a variety of social attitudes from multiple perspectives. Different social groups frequently have conflicting conceptions of values and mores in matters such as patriarchy, honor, race, class, and romantic love, among many others.[8] Although it is difficult to know how wealthy or how poor some of the litigants were or where they were from, it is clear that the court records contain a cross section of society. Litigants came from both the city and the countryside. Some were people of means while most were from the lower sectors of society. Children, parents, spouses, and judges all fought for their version of the ideal family according to what best suited them. While most might agree that Gumesindo Arroyo's ugliness was a matter of personal taste, and thus easily disputed, the more legally grounded conception of patriarchy was also vigorously contested. Francisca's conception of appropriate patriarchal authority differed from her father's. Later chapters will disclose how the judge defined it.

One of the more attractive and compelling characteristics of court cases is the intimate material they often contain, such as personal letters and testimony. These personal testimonies from the past display porteños' hopes and fears, their struggles and triumphs, their love and spurned romance, and their suffering and solace.

Questions and Issues

These narratives of everyday life identify the ideals of family living as outlined by law and custom, but they reveal even more distinctly the realities of life as families struggled to live up to those expectations in the real world of the home and street. In this real world, the family was the symbol and guardian of social status, which meant that court cases

burst with contention over conceptions of patriarchy, honor, race, and class. Family conflicts also highlight intergenerational gender relations (parents to children), which are sometimes overshadowed by attention to adult female-male relationships. The state also took on the role of family patriarch, using the courts and other institutions to nurture, order, and shape the national "family."

While these stories are useful and fascinating in their own right, on another level they help illuminate the larger history of the developing Argentine nation as it emerged from the shadow of Spanish colonialism to take its place among the independent republics of the Americas. The city of Buenos Aires, the focus of this book, played a central role in that development. In telling the history of a city or a nation, historians may focus on one or a combination of forces: economics, politics, gender, culture, art, geography, demography, and biography are some among many approaches. Many of these converge in family life, and the history of a nation can be told in part through the history of its families.[9] The national state, the Roman Catholic Church, and individual citizens all recognized the importance of the family in national development.

Juan Bautista Alberdi, one of Argentina's great nineteenth-century thinkers, believed that "the government of the home has an immense connection with a country's political government."[10] For the state, the family was a perfect place to inculcate patriotism and good citizenship. Laws and customs encouraged men and women to be good parents. Fathers particularly were under intense social pressure to govern their families as ideal patriarchs who, along with their wives, raised their children properly. Failure to do so, especially with children who were minors, could bring serious social and legal repercussions. For the Roman Catholic Church, the family was the sacred guardian of spiritual values.[11] For individuals, the family offered a network of material and moral support during the good and bad times of life. The family was also the bearer of social status and honor in Hispanic society, which made marriage a defining moment. Marriage helped determine future material welfare; marriage strengthened or weakened the family's social, racial, and economic position; and marriage perpetuated or undermined the honor and good name of the family. Understandably, parents had an intense interest in whom their children married and in the subsequent integrity of that marriage. The family, then, was a focal point of interest for the state, the church, and the individual, and courtrooms provided a crossroads where these groups met to define and defend their vision of family life.[12]

The political and intellectual currents swirling throughout the western world in the late eighteenth century had a direct impact on family life. The American and French Revolutions, and Enlightenment thought in general, inspired Latin American revolutionaries to sever their bonds with Spain. The revolution of 25 May 1810 ("the May Revolution") in Buenos Aires was part of that broader process of liberal revolutions throughout the western world. The impact of those revolutions has long attracted the attention of history lovers. In his celebrated observations of the youthful United States of America written in the early 1830s, Frenchman Alexis de Tocqueville found that the American experience made a distinct impact on family life. He concluded that the decline of aristocracy and the rise of democracy in the United States had weakened the traditional power of the father. "So at the same time as aristocracy loses its power, all that was austere, conventional, and legal in parental power also disappears and a sort of equality reigns around the domestic hearth."[13]

Gumesindo and Francisca's quest to marry freely brings up similar questions regarding the family and the nation in Argentina and Latin America. De Tocqueville might have wondered about the impact of independence in Argentina on family life and the traditional power of the father. At the heart of the case of the ugly suitor lay the question of the patriarchal power of José León Canicoba to control the destiny of his daughter. Did fathers have the right to do what Canicoba was doing? The colonial laws that supported him were still valid after independence, but were they interpreted and enforced in the same way after 1810? Did family life and gender relations change during the transition from colony to nation?[14]

To answer these questions, this narrative begins before independence and continues through the nineteenth century. The year 1810 has long been used as a traditional break in the scholarship on Argentina since the May Revolution of 1810 is recognized as being, roughly, the end of the colonial period and the beginning of the national period. This study spans the independence era on either side by covering the years 1776 to 1870. Examination of this time frame provides better understanding of both sides of Argentine independence: the late-colonial Bourbon government, the era of independence, the liberal decades of 1810–30, the rule of Juan Manuel de Rosas (1830–52), and the post-Rosas regimes and national unification until 1870. Many scholars favor straddling the independence era because they have found overarching continuities be-

tween the mid-eighteenth and mid-nineteenth centuries, a century that has been called the "Age of Revolution." [15] From this useful perspective, the political changes of independence can hide deep continuities in economic and social life. Those continuities have led some scholars to downplay the importance of the independence era as a major turning point in Latin American history, or even to question whether a definable "nation" emerged with independence in Argentina after 1810. [16] But the Age of Revolution is also useful in measuring change. As one scholar has argued, "there is a great deal to be learned from studying both sides of that [political] divide. How else, after all, can one really gauge change or continuity?" [17] Still, others worry that too much focus on continuity will detract from the important changes of the independence period. [18]

This book, then, looks at both sides of the political divide. Chapter 1 is a journey into the streets, culture, and history of Buenos Aires, where Francisca and Gumesindo and thousands of others sought assistance in court. Chapter 2 addresses the persistence of medieval and colonial law codes and how they perpetuated social attitudes and practices in familial and socioracial relations from colonial times well into the nineteenth century. Enlightenment thought regarding education and children also inspired ideas and policies that persisted into the national period. Chapters 3 through 6 examine how, alongside colonial continuities, independence from Spain and the nation-building efforts that followed energized a process of change that *loosened* the grip of patriarchal authority and increased freedoms for women and children in Buenos Aires. [19] While patriarchal power in the family remained strong, even dominant, it nevertheless suffered a decline after the colonial period because of pressure from disgruntled women and children, idealistic reformers, and a growing state government eager to create a modern nation. [20]

Where possible, I let the participants tell their own stories, which helps put a human face on the larger abstractions and generalizations of political, economic, and social history. Yet the personal also has a political side. Matters of the heart and hearth influenced matters of the state. Likewise, decisions made in the political sphere had an impact on family life and civil society at large. [21] These stories also infuse history with human passion—passion that shaped the history of conflicts over love, marriage, and family life; passion that surely shaped the case of the ugly suitor and his beloved Francisca.

1. *Buenos Aires*

Settings in Time and Place

As Francisca and Gumesindo made their way to court on 4 March 1842, the sights, sounds, and smells of a bustling city enveloped them.[1] Let us enter the city with them.

The whistles and calls of street vendors surely caught Gumesindo and Francisca's attention: caramels, pastries, and *alfajores* for the sweet tooth, or seasoned olives or Spanish *torta* for something more nourishing. The streets, mostly unpaved, were dusty when dry and turned into mud holes with rain. Closer to the river, the singing and laughter of women doing laundry could be heard. These were the *lavanderas* (laundresses), many of them Afro-Argentine, who spread out along the miles of riverbank next to the city. They would wash their clothes in a basin dug in the river bottom, then spread them out to dry. These women worked for hours in all kinds of weather, sustained by periodic breaks to drink the bitter tea known as *mate*, prepared with little fires kindled alongside their wash-basins. Laundresses were known for their laughter and general festive nature. "Like the laughter of a laundry girl" became a refrain referring to a loud raucous.[2] The presence and importance of the laundresses in the scenery of Buenos Aires was such that they captured the eye of many a painter of the port city.[3]

The noise of children was also in the air. Although children were not supposed to be out alone, the reality of porteño streets was different, especially for poor children. Many worked for their parents or guardians running errands, buying groceries, and even doing heavy manual labor (although this was officially frowned on). In their free time children played a variety of games. Young boys learned to ride horses by "bor-rowing" mounts tethered outside of buildings. The horses of doctors making house calls seemed to provide a ready opportunity for riding. The famous writer, Lucio Mansilla, recalled that everyone he knew had "taken their first equestrian lessons on a doctor's horse." Young girls

played with dolls made of leather and cloth, danced and sang together, played jump rope and dress-up. By the age of ten, however, girls and boys began training for their future positions in society according to their social class.[4]

Well-dressed women, perhaps on their way to church or to some literary gathering, caught the eye of many a passerby. Young porteño men were known to loiter outside churches to admire the ladies as they went by. One Englishman admitted that while the women of Great Britain deserved praise, porteño women (porteñas) were as beautiful as could be imagined.[5] Another foreigner was sure that anyone who beheld a porteña could not help but admire her. He commented further on their "exquisite" and elegant faces and was careful not to omit the mesmerizing dark eyes and voluptuous curls.[6] Porteñas frequently wore flowers and combs to adorn those curls. In the 1830s, combs known as *peinetones* had become so large and ornate that, in the words of one critic, they were "an exaggeration so exaggerated that they exceeded the limits of exaggeration."[7] A male artist's satirical depiction of women in the street showed men scurrying to stay out of the way of the *peinetones*. One man cries that he has lost an eye while others witness the destruction of a brick wall by a strolling woman.[8]

People on the street were mostly of Spanish descent, but Afro-Argentines were also a major presence. Afro-Argentines were involved in all types of economic activities as skilled artisans, carpenters, musicians, blacksmiths, laundresses, and wet nurses, among other occupations. The municipality of Buenos Aires employed many Afro-Argentines to clean the streets by day, which included disposing of dead animals, and to light street lamps by night.[9] Afro-Argentines were especially known as street vendors.[10]

Only the occasional Indian, as they were generically called, in the city served as a reminder that the Spaniards and blacks were newcomers to the area.[11] Indians of the region were for the most part nomadic or seminomadic and resisted integration into Hispanic society. While Indian labor was widespread in many other areas of Latin America, such as Mexico and Peru, the seminomadic Indians of the pampa largely avoided the clutches of labor-hungry whites. As with the analogous experience in North America, colonial and early national governments in Argentina faced stiff resistance from Indians until the late nineteenth century. Equipped with horses, lances, and some guns, Indians carried on a trade-and-raid relationship with frontier towns.[12] Even if only in

small numbers, Indians were still present in the city. The artist Emeric Essex Vidal painted two of them posing in front of a store in 1818. [13] Indians were also known to trade at *pulperías*, a kind of general store. [14]

People frequented *pulperías* to purchase liquor, tobacco, other daily necessities, and perhaps to play a hand of cards. The combination of gambling and drinking meant that violence was also associated with *pulperías*. One English visitor remembered that even the most trivial matter would "bring out the knives." Moreover "what in England would end with black eyes and bloody nose, ends here with homicide." [15] Judging by the clothing of the figures in Bacle's lithograph *Pulpería* (1818), patrons of urban *pulperías* came from the city and countryside. In the painting, one man is dressed in a European coat and top hat while others are clad in the traditional garb of the rural *peón de campo* (rural ranch hand) or *gaucho*—the Argentine cowboy and one of the more colorful members of the rural workforce who nevertheless made appearances in the city.

The definition of a gaucho varies even today depending on who does the defining. To some gauchos were nomadic horseman who lived off the abundant pampa. To others the gaucho was an outlaw and a symbol of the barbarism inherent in Argentina's colonial heritage. Still others defined the gauchos more broadly: as a seasonal ranch hand (*peónes de campo*), soldiers, or simply as *paysanos* (rural folks). [16] At different times and in different places, the gaucho was one and all of these things. Given that the courts in Buenos Aires served a large hinterland, many men who made their way to court would have been considered gauchos, *peónes de campo*, or *paysanos*. To a certain extent, the abundance of the pampa did allow significant mobility and freedom. Cattle, horses, and other game were plentiful on the pampa, providing a ready source of food, products to sell, and even building materials (bones were used for furniture in many dwellings). It is understandable, then, why a large number of English sailors jumped ship in the early 1800s to live among the gauchos. Some have exaggerated the nomadic lifestyle of the gaucho to such an extent that it seems that gauchos regenerated alone on the vast pampa. When one examines the iconography of the gaucho through the eyes of the artists who painted them, one sees the gaucho as an expert horseman and cowboy, but also as a companion and father. Carlos Morel's 1841 drawing, *La familia del gaucho* ("The gaucho family"), though perhaps idealized, is a warm portrayal of a gaucho surrounded by loved ones: his female companion, his children, and, of course, his horse. Other pieces of

art from the time period, as well as recent studies on the subject, reveal a much more complex and realistic view of life on the pampa, where women and children accompanied the gaucho as important segments of the rural population.[17]

Whether it was someone visiting from the countryside or city folk, all would have recognized the heart of the city as the Plaza 25 de Mayo. Political gatherings, celebrations, monuments, markets, and even public executions were all part of the plaza's functions. Since the founding of the city in the 1500s, it had been known as the Plaza Mayor. On the east side of the plaza, overlooking the river, stood the fort. The northern section of the plaza was dominated by the cathedral, which had been in some stage of construction since 1650. On the south side of the plaza was the Cabildo, or town council hall. In 1803 a long slender building called the Recova was built across the plaza north to south, effectively dividing the plaza in two. The western half was renamed Plaza de la Victoria after the defeat of the English in 1806–7. The plaza was then, as it is now, the political heart of Buenos Aires.[18]

As a nexus of spiritual and secular power, urban and rural dwellers frequently visited the Plaza de Mayo. The plaza was also an economic center. Fruits, vegetables, meats, and manufactured goods from as far away as China, India, and Europe were available here. The preferred method of transporting cargo in and out of the city was by *carreta*— a large wheeled cart. *Carretas* had wheels as high as nine feet tall, and they were made entirely of wood, even the nails. Thick leather lined the wheels and softened, if only a little, the jolts of bumpy trails. The English visitor Alexander Gillespie recalled the difficulty of travel by *carreta*. A trip to the province of Mendoza, at the base of the Andes Mountains to the west, would take thirty days, if all went well. Dangerous rivers, packs of wild dogs, and Indians were among the many dangers faced by caravans of *carretas*.[19] Because the river was so shallow along the banks, *carretas* also ferried passengers and cargo from ships.

Since the founding of Buenos Aires in the late sixteenth century, *carretas* had been used as the preferred method of cargo and even human transportation. There was a failed settlement effort in 1536; in 1580, Juan de Garay led expeditions out of Asunción, Paraguay, and those settlers established Buenos Aires permanently. In its early years, Buenos Aires was but a distant satellite of the large mining centers in Peru, including Upper Peru (modern-day Bolivia).[20] The monopolistic philosophies that dominated economic thought during much of the colonial period

meant that any export or import trade in Buenos Aires was supposed to go north along the authorized trade routes to Lima and eventually to Spain. Returning goods traveled the same path. This trading system led to ridiculously high prices and cycles of plenty and scarcity. Spanish cloth worth 2.5 pesos in Spain might cost as much as 20 pesos in Buenos Aires.[21] Such inefficiencies attracted smugglers, who could not resist the temptation to take advantage of Buenos Aires' strategic location on the Atlantic coast. Foreign merchants were always willing and waiting, and for the right price, customs officials might look the other way. It was not uncommon for a "damaged" English merchant ship to dock in Buenos Aires for "repairs," only to have the cargo unloaded and sold after a nice "gift" was sent to the proper officials. With smuggling a major part of its economy, Buenos Aires grew slowly but steadily. In 1615, the population of the city stood at 1,000. In 1674, the number had risen to 4,607, and by 1770, Buenos Aires boasted a population of 22,551.[22]

In the early 1700s, Spain's change of ruling families brought political and economic change to Buenos Aires. The royal house of Hapsburg was succeeded by the House of Bourbon. Like their French cousins of the same name, the Spanish Bourbons restructured their empire to make it more efficient and profitable. In 1776, hoping to spur economic development and block Portuguese expansion in the region, the Spanish government created a new viceroyalty—the Río de la Plata—with Buenos Aires as its capital. It was a major coup for Buenos Aires when Upper Peru, with its fabulous silver-mining center of Potosí, was taken from Lima and put under the jurisdiction of Buenos Aires. Buenos Aires' new status allowed it to trade directly with Spain and other Spanish colonial cities and, as a result, customs revenues skyrocketed. Before 1777, customs revenues had never exceeded twenty thousand pesos. In the 1790s, revenues surpassed 400,000 pesos, and by 1804, revenues reached nearly one million.[23] Even more than before, commerce dominated the Río de la Plata economy during the late colonial period. Buenos Aires' strategic geographic location at the mouth of the River Plate gave the city a decided advantage over other areas in a region dominated by overland trade routes and river commerce, most of which ended up in Buenos Aires.[24] In many respects, all roads led to Buenos Aires, creating a problem of lopsided development that continues to plague Argentina today.

Despite Bourbon attempts to reorganize the empire, chronic wars between Spain and its European neighbors fostered political and economic instability and, ultimately, independence in the Río de la Plata. During

one of the many Anglo-Spanish conflicts of the era, a British fleet sailed to Buenos Aires and invaded the city in 1806. The surprised viceroy fled and the city surrendered. Mariquita Sánchez later recalled how the 71st Regiment of Scots marched into the main plaza. Her memoirs described the invaders as "beautiful youths" with "snow white" countenances and "poetic" kilts. The English provided a "stark contrast" to the local troops, described by Mariquita as disheveled and poorly outfitted. "It must be confessed that our country folk are not pretty. They are strong and robust, but black."[25] Mariquita's recollections reveal an enchantment with *white* things foreign that would characterize important segments of Argentine society in the future. The British hoped to solidify their foothold in the Río de la Plata region for trading purposes, but before they could enjoy the fruits of their victory, the British were expelled from the city by the local militia—that dark and unsightly bunch referred to by Mariquita Sánchez. A second British invasion was repelled in 1807.

Even though the British were eventually welcomed as merchants and investors in Buenos Aires, the impact of these victories over the British cannot be underestimated. As Cornelio Saavedra, the creole leader of the militia recalled, "Buenos Aires accomplished this memorable and glorious defence with its own sons and its own people alone."[26] These "sons" of Buenos Aires Saavedra spoke of included the creoles, blacks, and mulattoes who made up much of his militia. The Argentine historian Bartolomé Mitre, who served as the first president of a united Argentina in the early 1860s, wrote that the defeat of the British "had a resounding impact on the world, and above all in the hearts of Americans, who were now made conscious of a force which had been previously unknown. They were given a new sense of nationality."[27] For many, independence from Spain now seemed more plausible. If the Spaniards could not protect the city as aptly as the local militia, what purpose did the Spaniards serve? The prospect of independence also made sense from an economic standpoint, especially for those in favor of free trade.

Independence

The British aided the construction of creole patriotism, but it was Frenchman Napoleon Bonaparte who forced the issue of independence on Latin America by invading Portugal and Spain in 1807. The Portuguese royal family escaped to Brazil. In Spain, Napoleon removed Charles IV and his son Ferdinand VII from the throne in order to make his brother Joseph Bonaparte king of Spain. This situation threw the

Spanish American subjects into disarray. How could Ferdinand rule the Americas when he was not even ruling Spain? Many groups throughout Latin America saw this as a golden opportunity to move toward greater autonomy. In Buenos Aires, liberals under the leadership of Manuel Belgrano, among others, concocted schemes for independence.

Further French incursions into the Iberian Peninsula in 1810 pushed the leaders of Buenos Aires to act decisively. In May of 1810, consistent with Spanish tradition in times of political crisis, local leaders in Buenos Aires called for a *cabildo abierto*, a type of open town council made up of wealthy men. Although more than 450 persons were invited, only 251 actually attended because the creole militia, which supported the cause of independence, had intimidated many to stay away.[28]

Still, tempers flared at the meeting as royalist and patriot delivered impassioned speeches. The main issue regarded the status of the viceroy and whether the council should set up a new government. Many men who would later be recognized as heroes of Argentine independence raised their voices at these meetings. Cornelio Saavedra, Juan José Castelli, and others argued that the government in Spain was dead, and power should revert to the people of Buenos Aires. For conservative royalists, such sentiment smacked of treason. Ultimately the liberals won, voting to establish a governing body, known as the junta, that would displace the viceroy. However, when the Cabildo decided to appoint the deposed viceroy as head of the new junta, the militia stepped in. According to one report, on the night of May 24, members of the militia went around to the houses of the junta leaders. Their message: If the viceroy was not removed from the junta, "they would teach them the way to shed blood."[29] As a result, a new "patriotic" junta was established by 25 May 1810. The new junta conveniently declared allegiance to the deposed King Ferdinand of Spain, an act that garnered support from the Spaniards in the city, but meant little or nothing in practical political terms. The reality was that the junta had embarked on a path of independence. For Cornelio Saavedra, president of the new junta, the removal of the viceroy and establishment of a new government were "the blows that broke the dominion exercised by the kings of Spain for almost three hundred years in this part of the world."[30]

Although moves toward independence received strong support in Buenos Aires, many parts of the interior opposed the May Revolution. In Córdoba, a bastion of traditionalism, Santiago Liniers, hero of the fight against the British invasion and a former viceroy, planned a coun-

terrevolution. Other elites throughout the interior favored a break from Spain but feared that the port city of Buenos Aires would replace Spain as the oppressor in the region. To resist royalist forces and other opponents, the junta in Buenos Aires sent an army into the interior. The wars for independence had begun. By 1812, forces from Buenos Aires had secured most of present-day Argentina from the Spaniards, although it was clear that Buenos Aires would lose control of Upper Peru (Bolivia today) and Paraguay. The year 1812 also marked the final major conspiracy against the new government. The leader, the Spanish merchant Martín Alzaga, was executed, along with forty other conspirators.[31] Another major development was the arrival of José de San Martín from Europe. A creole from the northern province of Misiones, San Martín was a veteran of combat in Spain and a great military leader. He helped establish the Sociedad Patriótica (Patriotic Society) to push for a full and official independence from Spain, which was finally declared on 9 July 1816. The next year San Martín led a force from Argentina in an epic crossing of the Andes, where he surprised and defeated Spanish forces in Chile.

The political scene after 1810 is somewhat confusing, but the basic chronology went as follows. The Revolutionary juntas of May 1810 were followed in 1811 by two consecutive triumvirates that governed until January of 1814. During the second triumvirate, a congress met and passed important social reforms (discussed in chapter 3). The triumvirates were replaced by a series of "supreme directors" whose tenures lasted until 1820. Late in 1815, a second congress was held in the northwestern province of Tucumán, where delegates finally declared the independence of the United Provinces of the River Plate on 9 July 1816.[32]

Long-standing divisions between the city of Buenos Aires and the interior hampered these initial efforts to establish a stable national government. Those divisions broke down along two main lines. Federalists advocated provincial rights, were generally more conservative, and strongly supported the Roman Catholic Church. Unitarians tended to be from Buenos Aires, were more liberal, and wanted to reduce the power of the Church.[33] The divisive issues included religious and political authority and economic concerns. What would be the role of the Church? Who would choose local political officials? Who would control the trade along the River Plate? Who would get the rich customs revenues from the port at Buenos Aires? What kinds of protection would there be for local industries against foreign competition? With its advantageous position

at the end of overland routes and at the mouth of the River Plate, Buenos Aires held an advantage over the rest of the provinces.

This was particularly true because the independence wars disrupted economic activity, especially in the interior provinces. The independence of Bolivia (Upper Peru), Paraguay, and Chile had cut off centuries-old trade routes vital to the northern and western regions of the country.[34] More than ever before, Buenos Aires became the dominant power. With Spain out of the economic picture, Great Britain moved in to fill the void (something it had done illegally many times in the past). British goods flooded the markets of Buenos Aires and competed favorably with local products. Soon, the gauchos of the pampas were wearing boots and ponchos made in Britain.

While the interior provinces languished, Buenos Aires grew steadily. Cattle ranching continued to be important, but sheep production increased markedly after independence, especially in the areas surrounding Buenos Aires.[35] Overall, as the population of Buenos Aires grew, agriculture in the surrounding areas increased to meet the market demand in the city.[36] Buenos Aires also became increasingly tied to the growing world market, and its ranchers and farmers held firmly to the idea that Argentina was an agricultural nation that should stick with its comparative advantage and not compete on industrial terms with the growing powers of Europe and North America.[37]

Indeed, the merchant and ranching interests of Buenos Aires benefited from this comparative advantage. Meanwhile, the interior provinces cast an envious and resentful eye on their coastal neighbor. Bernardino Rivadavia, a prominent unitarian (liberal) politician, tried various ways of overcoming the divisions between Buenos Aires and the interior and between unitarians and federalists. Rivadavia dominated the decade of the 1820s, first as a secretary in the government and then briefly as president. He produced an impressive record of liberal reforms that included substantial efforts to reduce the power of the Roman Catholic Church (discussed in chapter 3).[38] Despite his many successes, Rivadavia could not reconcile Buenos Aires with the interior. His proposed Constitution of 1826, for example, allowed the president to appoint and remove provincial governors. From the federalists' standpoint, Rivadavia's political transgressions, combined with his sins against the Roman Catholic Church, inspired fierce opposition. Federalist *caudillos* (strongmen) raised the cry of *religión o muerte* (religion or death) and united to resist the implementation of the constitution. These caudillos

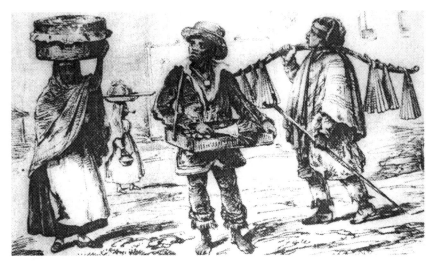

1. Vendors on the streets of Buenos Aires, ca. 1800. As Gumerscindo Arroyo (the ugly suitor) and Francisca Canicoba went to court to sue for permission to marry against her father's wishes, they would have encountered street vendors such as these hawking all kinds of wares (see chapter 1). Image courtesy of the Archivo General de la Nación.

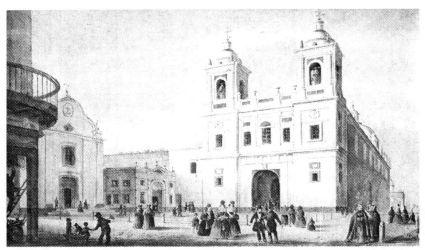

2. *San Francisco*, by Carlos Pellegrini, 1841. The Church of San Francisco, located in the center of Buenos Aires, besides being a place of worship presented the opportunity for many young men and women to at least get a look at each other in public. For some young bachelors of the middle and upper classes, churches and other main thoroughfares provided a chance to observe and perhaps make catcalls at the well-dressed women (see chapter 1 for more on the streets of Buenos Aires and chapter 6 for a discussion on men and women in public). Courtesy of the Museo Nacional de Bellas Artes, Buenos Aires.

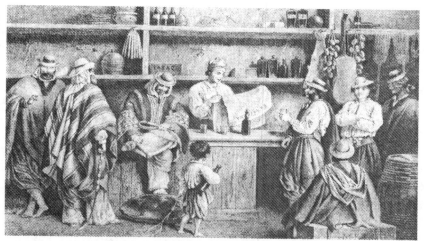

3. *Pulpería*, by Julio Pelvilain, 1864. *Pulperías* served as general stores and taverns where patrons could purchase alcohol, tobacco, food, and other household items. Even the young boy in the center of the drawing seems to be patronizing the store, perhaps on an errand for his parents or guardian. While children were not supposed to go out in public alone (the streets were seen as the origin of all vice), the reality was that the streets of Buenos Aires were full of children (see chapters 1 and 2). Courtesy of El Museo Histórico Nacional.

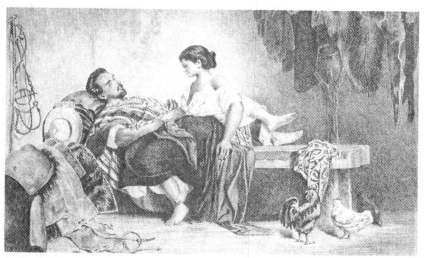

4. *Un nido en la pampa* (A Nest in the Pampa), by Julio Pelvilain, 1864. Country folk—perhaps a gaucho and his companion—in their modest dwelling, surrounded by the necessities and bounties of the pampa region: leather, feathers, clothing, chickens, and horse tack. (See chapter 1 for discussion of gaucho life.) Courtesy of El Museo Histórico Nacional.

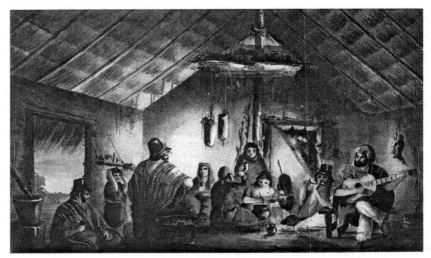

5. *Interior del rancho* (Inside a Rancho), by Carlos Pellegrini, 1841. An artist's look into a rural dwelling (rancho) of what might be considered a gaucho family. Pellegrini's painting reveals many aspects of daily life: food, including the famed *asado* (barbecue), drink, music, and family activities in general. Courtesy of the Museo Nacional de Bellas Artes, Buenos Aires.

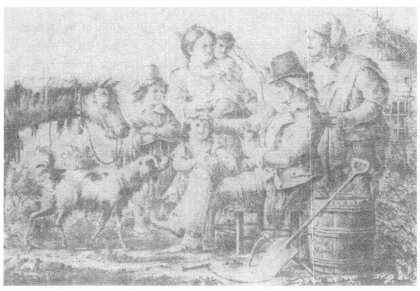

6. *La familia del gaucho* (The Gaucho's Family), by Carlos Morel, 1841. Morel's depiction of the famed gaucho shows him surrounded by the loves of his life: his female companion, his children, and, of course, his horse. Courtesy of the Museo Nacional de Bellas Artes, Buenos Aires.

7. María Constancia Martíez's 1826 letter to her fiance, Fortunato Rangel. After promising to marry him, and after confronting strong opposition from her parents, María Constancia informs Fortunato that she no longer wishes to marry and that he is "free" to pursue other women. Finally she asks him never to come by her house again. Fortunato could not believe this letter represented María's true feelings (see chapter 4). Letter courtesy of El Archivo Histórico de la Provincia de Buenos Aires, "Ricardo Levene."

8. A late nineteenth-century photograph of a *carreta* unloading cargo at Buenos Aires from the Río de la Plata (River Plate). Extensive shallows prevented large boats from coming close to shore, and thus the large-wheeled carretas helped get cargo and passengers on and off larger vessels. In earlier days the scene would have been much the same, although oxen were frequently used then to pull the carretas. Courtesy of the Archivo General de la Nación.

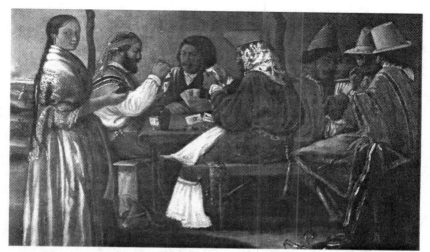

9. *Soldados de Rosas jugando naipes* (Soldiers of Rosas Playing Cards), by Juan Camana, 1852. This scene, perhaps at a rural pulpería, shows typical gaucho characters who were the foundation of support for Juan Manuel de Rosas during his governorship (1829–52). The woman on the left seems to be serving the men *mate*, the bitter tea commonly drunk in much of Argentina. Courtesy of El Museo Histórico Nacional.

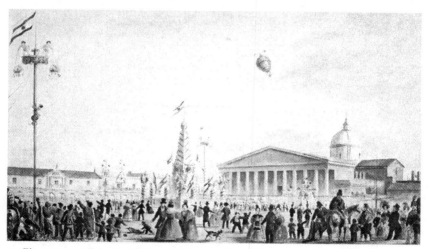

10. *Fiestas mayas* (May Festivities), by Carlos Pellegrini, 1841. To celebrate the May Revolution of 1810, considered the beginning of the transition from Spanish colony to independent nation in Argentina, a crowd gathers in the Plaza de Mayo around the obelisk known as the May Pyramid. In the background to the right is the cathedral with its remodeled neoclassical facade meant to project a more modern image of Buenos Aires. In the background to the left is the Cabildo, where the May Revolution officially began in May of 1810. (See chapter 3.) Courtesy of El Museo Histórico Nacional.

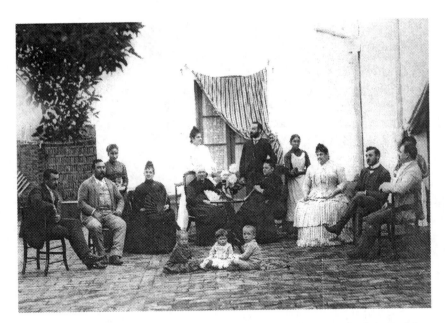

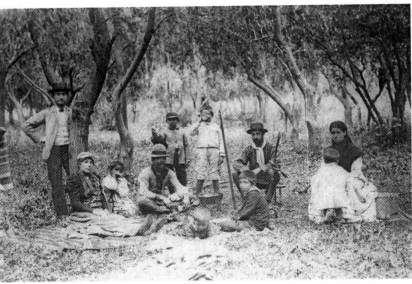

11 and 12. Porteño families posing at their home and in the countryside, ca. 1900. While many aspects of gender and family life persisted into the nineteenth and twentieth centuries, the struggles of the ugly suitor and those of other men, women, and children against colonial traditions, created some important new freedoms for women and children in nineteenth-century Buenos Aires. Images courtesy of the Archivo General de la Nación.

were usually large landowners with the charisma and power to mobilize their own private militia and, especially, cavalry. One of the best-known caudillos was Juan "Facundo" Quiroga from the northwestern province of La Rioja. Quiroga would later be immortalized in Domingo F. Sarmiento's *Civilization and Barbarism* as the quintessential barbaric element of Argentina. "Facundo is a type of primitive barbarism," wrote Sarmiento. "He recognized no form of subjection. His rage was that of a wild beast. The locks of his crisp, black hair, which fell in meshes over his brow and eyes, resembled the snakes of Medusa's head. Anger made his voice hoarse, and turned his glances into dragons. In a fit of passion he kicked out the brains of a man with whom he had quarreled at play."[39] While Sarmiento wrote in his customary exaggerated style, it was no exaggeration that pressure from Quiroga and other federalists forced Rivadavia to resign. His replacement, the federalist Manuel Dorrego, became governor of Buenos Aires province. Eager to regain power in the province, unitarians rose up in 1828 and, in a rash decision, executed Governor Dorrego, leaving the city in horror and increasing the intensity of the unitarian-federalist conflict.

Civil strife set the stage for the rise of the federalist caudillo Juan Manuel de Rosas, who would dominate Argentine politics for the next two decades. A wealthy *estanciero* (rancher) and military commander from San Miguel del Monte, a town to the south of Buenos Aires, Rosas was infuriated at the unitarians for their execution of Governor Dorrego.[40] His wealth and position as a militia commander and rancher gave Rosas a base of popular support that would help him sweep the unitarians from Buenos Aires and, for many, into exile in Uruguay and elsewhere.[41] With his motley crew of "federalists, gauchos, delinquents, and Indians," as one historian has described them, Rosas took the city. The provincial legislature then elected Rosas as governor, and granted him "*facultades extraordinarias*" (extraordinary faculties/powers), which legally gave Rosas a blank check of dictatorial power. The consensus behind Rosas allowed him to shatter unitarian opposition and establish a long period of reasonably stable rule. He remained in power, with a brief interim, from 1829 to 1852.

Rosas ruled with a heavy hand to ensure social order, which, in the eyes of his supporters, earned him the title of "restorer of the laws." Rosas did not tolerate opposition, and his tenure in office has been characterized as one of censorship and exile or assassination of his political opponents. "The Caligula of the River Plate" was just one of the many

names hurled at Rosas by his enemies. He also tied himself closely to the
Roman Catholic Church, which spread his influence and control into
all areas of Argentine life. Rosas' links with the Church, along with his
dictatorial-style rule, led many of his contemporaries, as well as later
historians, to label him as a throwback to the traditionalism and au-
thoritarianism of the colonial world. In reality, Rosas did not meddle
with most of the liberal and anticlerical reforms passed by Rivadavia and
the unitarians during the previous years. In many respects, then, Rosas
allowed processes started in the early years of independence to continue.
What did interest Rosas was maintaining order in society. This he did
on a number of levels, including fashion. Red uniforms, red clothing,
and red ribbons became signs of political persuasion. "If the ribbon was
carelessly tied: 'Stripes! The fellow must be a Unitario.' If the ribbon was
too short: 'Stripes for the Unitario!' And if a man did not wear it at all,
he was put to death for contempt of the laws."[42] So wrote the exiled
Domingo Sarmiento in one of his tirades against Rosas.

Although Rosas represented the federalist cause, he really was a prac-
tical rancher who wanted to further the interests of his province and the
ranching class. His goals were to nurture the cattle economy and protect
the interests of the Buenos Aires province. If one definition of federalism
is the economic self-defense of one's province, then Rosas can be called
a true federalist. He doggedly defended the "economic birthright" of
Buenos Aires province, which meant keeping the revenues from the port.
Nor did he and his followers want to "decapitate" the province by feder-
alizing Buenos Aires, a unitarist goal. The problem was that only Buenos
Aires could afford to follow this true federalism of provincial autonomy
because it had all of the economic cards in its hand—the city, the port,
the river, the trade routes, and the customs revenues. This reality was
understood even by Rosas' allies in the interior, who were not oblivious
to the continuing dominance of Buenos Aires under Rosas. They chose
to ally with him only as the lesser of other evils, namely, the unitarist evil.
Provincial federalists hoped Rosas would grant them some economic
concessions.[43] While Rosas made some attempts to alleviate problems in
other provinces, his efforts could not placate the interior over the long
term. In the end, the provinces turned against him. In 1852, Rosas lost the
battle of Caseros to General Justo José de Urquiza, a federalist caudillo
from the province of Entre Rios. Rosas fled the battlefield, boarded an
English ship, and sailed to exile in Great Britain. In the words of one
historian, "Rosas failed because he succeeded too well. He succeeded in

imposing upon the country the *porteño* brand of federalism, a political system to which the provinces could not be reconciled."[44] A few days after the battle of Caseros, the new provisional governor of Buenos Aires berated Rosas as a "savage unitarist."

With the fall of Rosas, exiled Argentines streamed back into the country. The challenge they faced was the same one that had confronted the May Revolutionaries: to unify the country and build a coherent nation. It took nine more years for Buenos Aires to finally join the other provinces and ratify a national constitution. In 1862, delegates from the provinces elected Bartolomé Mitre as the first president of the Argentine Republic. Mitre initiated an institutional revolution, setting about to establish a national tax system, legal system, and national army. In 1870, a new civil code was adopted and, finally, Argentina had its own set of laws. Until that time, with the exception of some notable reforms, colonial Spanish laws had continued to serve as the foundation of law in porteño society.

Even as these conflicts over national development raged, there were other conflicts—of a more mundane and everyday sort—which occupied the people's minds. Not everyone engaged the British in battle, crossed the Andes with San Martín, or struggled mightily with Rosas. Daily life carried on, for Francisca, Gumesindo, and others. Even when men and women were caught up in the political and military movements of the time, the demands of daily life continued. Part of that home life meant settling family disputes in the civil courts of Buenos Aires, whose judges were charged with keeping the order based on Spanish law. Let us now turn to those cases as windows into the lives of families in Buenos Aires and its surrounding environs, an area rapidly transformed from a colonial backwater into the capital of an independent republic.

2. *Lineage, Morality, and Industry*
Contours of Family and Society

Much to the horror of Damiana Vidal, the long arm of patriarchy extended even beyond the grave. By 1839, Damiana's marriage to Ignacio Lara was falling apart. When the couple separated, it must have been on bitter terms, because Ignacio decided to place their son, Ignacio Jr., in the custody of his aunt, Aurelia Frias. While this was his right under traditional Spanish law, that legality did nothing to ease Damiana's anguish at losing her child. When Ignacio Sr. died in 1842, Damiana thought that at last she would be reunited with her son. Her hopes were crushed, however, by her late husband's last will and testament, in which he declared that he wanted young Ignacio to remain permanently with Aurelia Frias. Word of the setback caused Damiana, in her own words, to "suffer inexplicable bitterness," especially when a judge ruled to honor the will. Legal precedent dating back to the Siete Partidas, the ancient Spanish law code that continued in force after independence, granted fathers that very right.[1] In her defense, Damiana and her lawyer tried to use the technical language of one of the laws to win their case. Apparently, her husband had not actually specified the "house" in which he wanted his son to live.[2] Such legal nitpicking failed to impress the judge, who upheld the dead husband's will over the will of the living mother. Although records show that Damiana appealed this decision, it is unknown whether the original verdict was overturned.

That both sides in this conflict used old Spanish laws, in a case occurring thirty-five years after Argentine independence, points to important relationships between colony and nation. Family relations, and the laws that governed them, reflect important continuities that bridge the late colonial and early national periods. On a general level, patriarchy as a governing concept of family and national life persisted. Many other basic contours of family life also persevered, such as ideals of appropriate parenting, obedience of children, the role of honorable and virtuous

behavior within and outside of the household. Of course, porteños, just as other human beings, frequently fell short of those ideals. Nonetheless, those struggles portray porteño families living their lives in the real world beyond the realms of ideas and ideals. The courts provide a vision of how citizens and the state drew the line between the ideal and the real.

Legal Concepts and Ideals of Family Life: Patriarchy

A society's laws shape its historical development and cultural identity. Just as many aspects of centuries-old English law survived the American Revolution to influence the United States, Hispanic societies have strong legal traditions hearkening back to medieval times. [3] Much of the civil law that governed Argentina and Latin America during the colonial and early national periods came from the Siete Partidas, seven books of law compiled during the reign of Alfonso the Wise of León and Castile (1252–84). The Siete Partidas, which attempted to regulate all aspects of society, were the "first extensive compilation of western secular law" since the Roman Emperor Justinian compiled his code in 529, parts of which are still found in many laws around the world. [4] The Siete Partidas were joined and modified by subsequent laws that were periodically recompiled, such as the Nueva Recopilación (new recompilation) of 1567. Thus when Carlos IV of Spain ordered a new compilation in 1805, he called it the Novísima Recopilación—the *really* new recompilation—and it contained all the laws that had been decreed since the Nueva Recopilación. By the end of the colonial period, then, the body of laws included the medieval Siete Partidas along with the additions from the subsequent centuries. After Argentina gained independence, most of these colonial laws, the Pragmatic on Marriage among them, continued to be applied.

Why did the laws remain the same? It is difficult to imagine what revolutionary leaders faced in 1810. The task of creating a new country was monumental. On one hand, they wanted to establish an independent nation, but did that entail expunging all that was colonial in nature? All laws were rooted in the colonial tradition. Would they start afresh with new laws for the new nation? Frequent civil wars also hampered reform. While some revolutionaries dreamed of a new system of laws, that would not come to pass right away. One of the greatest reformers of the independence era, Bernardino Rivadavia, reflected on this problem during his presidency in 1826: "Reforming the Spanish laws is so arduous and complicated, and the obstacles to that reform are so many and diverse, that it is necessary to realize the impossibility of achieving it ex-

cept through a slow and gradual process." [5] While revolutionary leaders passed many liberal laws, a high percentage of the old laws stayed intact until the new civil code (the Código Civil de la Republica Argentina) was adopted in 1870.[6]

This legal continuity perpetuated many social practices and attitudes surrounding traditional family life: patriarchal power, morality, honor, and ideas about marriage. Patriarchal right, or *patria potestad*, was a sacred concept that served as a foundation in Iberian and Hispanic society. Spaniards traditionally believed that the natural forces of biology endowed men with *patria potestad* over their families. The fourth *partida*, which focused on family law, asserts that the legal side of patriarchal power emerged in antiquity, when emperors directed wise men and philosophers to make useful laws.[7] The *partidas* defined the rights of patriarchs in detail to address different social and political situations. One extreme example cites a precedent from an earlier legal code when outlining the rights of a patriarch during times of war. If a castle was under siege and food ran out, a father had the right to eat his son rather than surrender the castle without order from his feudal lord. Fortunately for women, wives were protected from this culinary code. Although legal historians have not found the cited precedent, the idea reflects the extent of patriarchal power as envisioned in the thirteenth century.[8] Such attitudes also show that patriarchy is not just a man-to-woman or husband-to-wife relationship—it extends from fathers and mothers to children across generations. From a legal and theoretical perspective, women usually remained subject to patriarchal authority. When the man was deceased or absent from the home, however, wives could take over many of the responsibilities and powers of the husband. Under certain circumstances, then, matriarchy could take the place of patriarchy.

The complexity of patriarchy as it developed over time defies simple definition.[9] Patriarchal authority existed at both the state and family level. Saint Augustine taught that family patriarchy should support and be subordinate to state patriarchy. Over time, patriarchy became associated with the rule of kings over their subjects in an "organic union," albeit an unequal one. The king protected and governed his subjects, who gave him complete obedience in return. In cases of royal abuses of power, the people theoretically could oppose their ruler based on the ideal of reciprocity. This patriarchal king-subject model fit ideal family relations as well. Like the perfect king, the ideal husband ruled his family in benevolence and justice in return for obedience and respect.[10] Like-

wise, wives had recourse from abusive or neglectful husbands. Methods ranged from the process of divorce to more extreme measures, such as running away, and even witchcraft.[11] Although resistance from women and children was common, the ideal of patriarchal authority provided a means of ordering social relations in Buenos Aires and Hispanic America in general, especially during times of crisis.[12]

So it was with Antonio Acuña and his wife Andrea Paz. The couple had married in the early 1830s, but after two months of marriage, Antonio abandoned Andrea, who was then pregnant. After giving birth to a daughter she named Segunda, Andrea moved in with her sister Carmen. Andrea died and left her daughter in Carmen's care. Sixteen years came and went. Then, one day, Antonio decided to reclaim his daughter, which, he argued, was his paternal right. But Carmen had grown to love young Segunda and vowed not to give her up. In the court case that followed, Carmen told the judge of Andrea's dying wish that she take care of Segunda. "I have fulfilled that trust," Carmen told the judge. "Today, the girl is happy living with me and I have given her a proper education." Carmen believed that by his neglect, Antonio forfeited his patriarchal authority. "What right of *patria potestad* can a man have who abandoned his daughter before she was born, and who has not provided for her in 16 years?" Who had more right, she asked, "a father who has done nothing for his daughter, or me, who has performed all of the care of a loving mother?" In Carmen's view, Segunda would be better off with her, a woman of honor, than with a father who had neglected his sacred family duties and who lived a life of disorder.[13] Carmen did have some legal footing to stand on. The *partidas* do state that parents who abandon their children lose all authority over them. However, if the true parents of a child tried to reclaim custody, the *partidas* allowed room for it. In general, government officials were reluctant to remove patriarchal custody rights over young children.

Indeed, this is what Acuña hoped for. He responded to Carmen's attack with a patriarchal power play, using his status as the family head as leverage. It was Carmen, he argued, who was violating the sacred rights of *patria potestad* by not allowing his daughter to return to her father. The court proved sympathetic to Acuña's view. One civil official involved in the case argued that since no one disputed Acuña's paternity, there were no valid grounds to deny his request for custody of his daughter. "The rights of *patria potestad* are very sacred and the civil authorities need to respect them, save only in rare exceptions."[14] The judge was

happy to hear any evidence against Acuña's behavior, but barring any damning testimony in that regard, he saw no reason to resist the father's petition for custody. Ultimately, the judge ordered Carmen to turn Segunda over to the civil authorities, who would deliver the girl to her father.[15] For whatever reason, Acuña's abandonment was not enough of a blight on his character for the judge to rule against him; or perhaps the judge saw the supposed abandonment as more akin to the type of arrangement provided for foster children. Even in defeat, the laws provided that guardians like Carmen could be recompensed for their efforts. Carmen did end up asking for 300 pesos for every month she cared for the girl.[16] Although the outcome was harsh even by Carmen's contemporary standards, Acuña had acted within his legal rights. Patriarchal rights were seen as sacred, and in this case, upheld, but as Carmen's actions show, those rights could clearly be challenged in the courts of Buenos Aires.

Parental Responsibility

The sacred power of patriarchy also carried sacred responsibilities. Raising children was a natural obligation and constituted one of the most sacred duties of humankind. The fourth *partida* reasoned that if even the beasts raised their young, humans had an even greater obligation to do so.[17] Each parent or caretaker was required to give the children they cared for "food and drink, clothes and shoes, and a place to live," and, in general, to care for them "according to the wealth they possess."[18] As many cases will illustrate, determining the exact meaning of this last concept, and the benefits it entitled, was frequently a thorny issue.

It is not surprising that the time-honored basics of ideal parental qualities and responsibilities persisted after the colonial period. A judge summed up the ideal parent when a young suitor, Jaime Campos, came under fire in an 1851 disenso case. After hearing the evidence, the judge ruled that the young man had "good lineage, morality, and industry," which qualified him to be a responsible father and husband.[19] Women also exercised a certain degree of authority in the family and were under the same obligation to be hardworking, moral, and virtuous in their spousal and motherly duties. Many excelled at their roles, such as Hilaria Bejarano, of whom Pablo Páez testified that "there are very few of her sex who are such hard workers. Whatever work is needed to be done to make a living, she does it. Many men, despite being men, do not accomplish what she does."[20]

Both parents were charged to educate their children in secular as well as religious matters. The level of education expected from a family, however, was determined "according to the wealth they possess." Hence, education depended greatly on class as well as gender. As this next case shows, education for children of the lower classes usually meant trade-based instruction for young boys and training in domestic tasks for young girls. During an 1802 child custody dispute, Juana Coronel boasted of her daughter's ability in domestic tasks and religious training while at the same time offering a patriotic plug for her home province of Tucumán. By the time she was nine, Juana's daughter knew how to iron clothes, sew, weave socks, and do "all the other work that the women of Tucumán do, for as your honor knows well, as soon as babies open their eyes, they are put to work." She reminded the judge that, in Tucumán, "children are raised properly, especially the women, who learn the rosary, and all that is religious. They also teach them to work in sewing and weaving, and all else a woman should know in preparation for marriage."[21] Even though the *partidas* required that those who care for children teach them to read and write, only rare cases reveal children learning these skills.[22] In one of those exceptions, Antonio Maribais testified that he had been hired by Juana Ponce de León to teach young Nemecia Burgois in literature, writing, and arithmetic.[23]

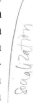

Socialization

Honor

When a family followed accepted social norms, society in general would consider them a family of honor. Hispanic ideals of honor were especially important in matters of marriage and family life. An honorable family was a legitimate family with properly married parents. Other important aspects of family honor included the sexual purity of females, socioeconomic status, character, and behavior. Across time and cultures, and even within cultures, honor has multiple meanings that can vary along racial, class, and gender lines; those meanings also changed according to different circumstances. As Lyman Johnson and Sonya Lipsett-Rivera have argued, "It is impossible to define honor with the precision of a chemical formula or botanical taxonomy; the meaning of honor is and always was situational, located in a specific place and time."[24] In some ways the concept of honor was a labyrinth of semantics. Members of the same family would use powerful definitions of honor in conflicting ways. The proposed marriage of a couple expecting a baby out of wedlock might be opposed, for reasons of honor, by one of the families if

the prospective in-law would tarnish the family's good name. That same marriage, others would argue, would bring honor to the family by preventing the couple's child from being born a bastard. These conflicting versions of honor abounded in family conflicts. Ann Twinam has shown how, especially for wealthy elites, honor was a negotiable commodity. But for the elites as well as the popular classes, honor was ultimately determined in the public sphere, where the concept was more malleable and open to interpretation.[25] While historically a notion claimed by the elite, during the late eighteenth and throughout the nineteenth centuries, popular classes also appropriated the ideal of honor. Virtuous behavior, rather than just bloodlines, was one way the popular classes laid claim to honor. Liberal ideals adopted by the government also emphasized the need for honorable and hardworking citizens of all classes.[26] Indeed, in colonial and nineteenth-century Latin America, the concept of honor had many faces.

In terms of social status, honor could be passed along from generation to generation through aristocratic inheritance and wealth as well as lineage, or *limpieza de sangre* (purity of blood). The idea of *limpieza de sangre* stretched back to the Spaniards' struggle to regain their land from the Moors and assert identity in the face of powerful Jewish and Moorish influences.[27] The overt religious nature of *limpieza de sangre* was quickly joined by racial prejudice. In the American colonies, Indian and African descent were added to the list of the tainted.[28] Another definition of honor hinged on moral behavior and integrity. By the late eighteenth century, honor could be defined in numerous contexts, from personal behavior to socioeconomic status to racial purity. Perhaps as a reaction to this growing confusion, the Spanish Crown issued the Pragmatic on Marriage, which spoke out against marriages between "unequal" partners. The pragmatic specifically referred to protecting familial honor against unequal marriages, but left the specific definitions of "unequal" and honor vague. Racial difference was perhaps the major inequity to be prevented, although parents also defined inequality in social, economic, and behavioral terms as well. Throughout the sixteenth and seventeenth centuries, while wealthier families may have had an easier claim to honor, it was not an exclusive possession of the elites.[29]

A disenso case from 1827 demonstrates the multidimensional nature of honor. By that year, Román Martínez and Francisca González had been living together for some time but had never bothered to get married despite their plans to do so. They had two living children (two

others had died), and Francisca was expecting again. By getting married, Román and Francisca could erase the stigma of illegitimacy that hung over their children and their family in general. Francisca's father, however, would hear none of it. He objected, in his words, "not because Román Martínez is poor . . . but because he is a gambler who does not know how to work." When asked about Francisca's existing illegitimate children, Pablo retorted that more disgrace awaited her if she married Román. To back up his case, the father presented witnesses who claimed that Román spent a lot of time drinking in the *pulperías*, where he liked to fight and play *truquos*, a card game often associated with fighting and roughhousing. For Pedro, such activity was unbecoming of a prospective son-in-law.[30]

But Román had a different definition of honor in mind. After all, had he not promised to marry Francisca years before, a promise his personal honor demanded that he fulfill? In addition, marriage would also allow their children to escape the dishonor of growing up as bastards (since neither of them had ever been married, their offspring were considered "natural" children, a status that, though illegitimate, could easily be remedied through marriage). Last, "the scandal caused in the community all of these years" would finally end. Román argued that all of these were worthy causes that would benefit him, his family, and the larger community as well. Witnesses also testified on his behalf, admitting that even if Román did occasionally take a drink or play a hand of cards, he exercised moderation and never bothered anyone. Román's arguments persuaded the judge that the marriage would benefit society more so than keeping them apart, and he granted the couple permission to marry.[31]

While someone like Román could fight for personal honor, the actions of parents and extended family members could complicate the honor equation. Jacinto Melo and Juana Correa learned this principle the hard way. On 9 November 1823 Jacinto initiated a suit against his father, Manuel Melo, for denying him permission to marry Juana because she came from a dishonorable family. Melo pointed out in court that only a few months before, Juana's father and uncle were whipped in public for crimes they had committed in the town of Luján. Such a marriage would be a stain on his family's honor, Melo contended. "As of this very day, no criminal act has ever tarnished my honor and good name. Of this I am proud, and it leads me to oppose the marriage my son desires with Juana." In this case the court agreed with Manuel Melo and

ruled that the difference in honor between Jacinto and Juana's respective families justified the opposition.[32] Although Juana's personal honor may have been impeccable, her family's actions tainted her enough to make her ineligible to marry Jacinto.

Ideals and Realities of Family Life

Honor and moral behavior were always vitally linked to marriage and family life. In the thirteenth century King Alfonso X himself had paid special attention to the compilation of the fourth *partida*, which dealt specifically with marriage and its myriad benefits. The prologue to the *partida* speaks of marriage being ordained by God when he commanded Adam and Eve to multiply and replenish the earth. Marriage would help populate the world, prevent fornication, provide peace and friendship, and create harmony within the immediate and extended family.[33] Later on in the same *partida*, the author states that "marriage is the joining of a man and a woman, made with the conviction of living together forever as one, . . . each one remaining faithful to one another. The man should not be with another woman, nor the woman with another man, but both should be together."[34] For those who remained faithful to their union, the *partida* promised an abundance of love among spouses and children.[35] In the eighteenth and nineteenth centuries, the ideal of traditional marriage continued as the symbol of social propriety. As one husband stated in 1862, "marriage is the union of the wills and of the hearts," while his wife affirmed that "marriage was an intimate association that is the basis of the family and the center of domestic happiness."[36]

As elsewhere in the world, the inhabitants of Buenos Aires honored the ideal of marriage in word, if not always in deed.[37] When parents, guardians, and others failed to live up to those ideals, however, the courtroom became the arena of debate as private individuals and state officials sought to preserve their own rights, protect vulnerable members of society, and alleviate social ills. Families went to court precisely because family life had broken down. In their description of those breakdowns, porteños revealed ideal expectations as well as the realities of heartache and suffering.

One ideal was that a legitimate marriage was the proper way to begin a family and raise children in harmony. When Tránsito Benítez tried to reclaim her son from Rafael Barrios, he resisted. According to Barrios, Tránsito's immoral behavior, which he would happily illustrate, made her unfit to care for her son. She was living with a man who was not her

husband, which would make it impossible for her to set a good example for Victorio and give him a proper education. By contrast, Barrios held up his as an ideal family who could better educate the boy "since we have a decent and moral marriage. For these reasons, no one can have more rights to this boy than I."[38] Other cases contain similar ideas. As one woman argued in trying to keep custody of a foster child, "Can a woman who does not fulfill the sacred duties of marriage provide a good education for her daughter? . . . Can she inspire honest thoughts in her? Can she teach her morality and religion when she herself is constantly offending those feelings and violating those principles?"[39] Men were not immune from similar attacks, even though, in practice, they had more freedoms than women did. When Luisa Ramírez tried to get her daughter back from her estranged husband, she informed the judge that her husband's misconduct was notorious, "whether it is his dishonest activities, or the fact that he is openly living with a woman who is not his wife, an environment he will undoubtedly expose his daughter to." Although the husband seemed to be within his legal rights, the judge in this case ruled that the daughter should stay with the mother.[40]

But even couples who had legitimate marriages faced their own realities of marital strife. When the ideal of marriage failed, ecclesiastical laws did allow for a divorce. For the Roman Catholic Church, the Spanish Crown, and most Latin American countries in the early nineteenth century, divorce meant a physical separation—either temporary or permanent—but not dissolution of the marriage. Divorce was usually a last resort as state and ecclesiastical officials did everything in their power to reconcile couples. If those efforts failed, the government sought to meet the needs of separated spouses and their children. Conflicts occurred within the bounds of traditional marriage. A legitimate marriage did not guarantee a happy family life, nor did illegitimate unions guarantee misery, for many unmarried couples enjoyed stable family lives together.

The 1862 divorce case of Toribio Aráoz and Juana Almada illustrates problems within the traditional bounds of marriage. While both parties understood the importance and ideal nature of marriage, they also recognized that a troublesome marriage could be hell on earth. According to Toribio, "when a couple does not love each other, and grows to detest one another, far from fulfilling its holy purpose, marriage becomes an eternal martyrdom." Juana understood the same truth: "Marriage turns into the darkest abyss when intimacy fails, or when spouses, whether

because of character or some other circumstance, forget their sacred obligations."[41]

Juana believed their relationship deteriorated for a variety of reasons. First, her husband was overbearing and physically abusive. "He has tried to control even the most minute details of my life," Juana told the judge. Without any reason, he "prevents me from fulfilling my duty to the church of going to mass on Sundays and holidays." Juana's accusation, on the surface, may have seemed absurd, for why would a man impede the religiosity of his wife, especially since the spiritual sphere was an appropriate one for the female sex. Perhaps the possessive Toribio felt threatened by the freedoms that going to church provided Juana. Indeed, the church could serve as a refuge from overbearing husbands. By establishing a close relationship—not necessarily sexual—with different men, including priests, women could counter, at least to a certain degree, the power of a domineering family patriarch.[42] Whether or not Toribio felt his control over Juana being challenged by her pious ways, he did obstruct her activity in the church.

Juana also complained of physical abuse. She remembered one particular day when her husband beat her just because "I got off the sofa to answer the door after he had ordered me to stay seated." When she sought help from her family, he threatened to poison her. Witnesses told of other instances of physical abuse. Through the couple's window, Paula O'Donnell once saw Toribio wrestling Juana, who struggled toward the window to cry for help. Paula rushed to the front door and knocked loudly. When Toribio finally came out, Paula asked to see Juana, in case she was ill or needed something. He answered roughly that his wife "needed nothing" and slammed the door in Paula's face. Toribio even became belligerent with his mother-in-law, who inquired of Juana's condition. He stated unequivocally that "in his own house he could do whatever he pleased." In addition to the witnesses, a doctor confirmed that Juana had "contusions on her arms, shoulders, and back." He also observed that Juana was pregnant.

Given his turn, Toribio tried to depict Juana as a delinquent wife under the influence of a meddlesome mother-in-law. Juana's mother, according to Toribio, "opposed our marriage from the very beginning, and after we married she has labored constantly to break it up." Juana countered with further proof of Toribio's misdeeds. Mercedes Castaño had known Toribio before he married Juana. Mercedes remembered Toribio telling her how Juana's mother indeed opposed the marriage.

Mercedes had asked him why he would continue in the relationship. Instead of professing love, Toribio had responded with spite: "He would marry just to show the mother and her daughter who wore the pants. And after they married, he would not let up on either of them. He would not permit his mother to set foot in his house, nor allow his wife to visit her mother."

As they did with others throughout the colonial and early-national periods, civil and ecclesiastical officials tried to reconcile couples like Toribio and Juana instead of granting a divorce. In one of the rulings in the case, the judge ordered Juana to stay with her mother for a period of six months. Toribio could visit her there "at appropriate hours, while maintaining appropriate moderation and decency." As for Juana, she should "receive him amiably" and not "dwell on past problems." In this manner the judge hoped to "reestablish the harmony that at present is so distorted, and to regain the trust and tenderness that should reign between good spouses." The court also recommended that "both spouses calmly meditate over their duties as Christians and as spouses, pleading for Divine aid toward a peaceful resolution." After the six months were over, the couple would again appear before the tribunal to see if their marriage could be saved.

The couple lived separated until 1867, when Toribio tried to get his wife to come back to him. Juana continued to resist. Back in court, Juana did not want to revisit all the details of why she wanted a divorce. "Those antecedents are found in the court records, and your excellency can consult them to refresh your memory." During their separation, Juana had given birth to their only daughter, who had since passed away. "She was the joy and happiness of my life." Now, she was so beaten down by life that she had trouble just getting around the house. In her despondent state, Juana continued to resist Toribio's attempts to reconcile, and that is where the case ends.[43]

Although legitimate unions were not immune from severe dysfunction, individuals involved in illicit unions, especially women and children, seemed more vulnerable to conflict and suffering because they lacked some of the protections guaranteed by law and custom to legitimately married couples and their children. Furthermore, partners in illicit unions, especially females, were open to accusations of immorality if they became involved in a court battle.

Hilaria Bejarano was accused of ascribing to attitudes that amounted to free love, a disgraceful notion for the court and society at large. In Oc-

tober of 1849, José Millan and a cavalry sergeant named Narciso had been getting into noisy confrontations and causing frequent disturbances in the town of San José de Flores. According to the local justice of the peace, the reason for these disturbances was the licentious behavior of Hilaria Bejarano, the mother of Millan's children. Witnesses observed that the sergeant Narciso would visit Hilaria after Millan left the house—scandalous behavior according to conventional wisdom, especially for the example it set for Hilaria's children. Of course, Millan took offense because Hilaria was insulting his manhood. All the while local officials feared that events would escalate into a violent confrontation between the two "rivals," as Millan and Narciso were referred to in the documentation. The justice of the peace confronted Hilaria about the situation, and the report he brought back from the visit was absolutely scandalous: Hilaria answered that she was not married to Millan, but only lived with him. Hence, she had no obligation to him and was "free to be with whatever man she pleased" (the words are actually underlined in the case, perhaps to alert a sleepy and overburdened judge to the shocking phrase).[44]

When given the opportunity, Hilaria told her own version of the story. Millan, she claimed, was not even living with her when the supposed "infidelity" took place. Furthermore, if Millan *had* fought with Narciso, it was not in competition for her affections. Rather, it was a result of their customary drinking binges that were "an ancient custom and well known in these parts." As for her alleged free love declaration of being with "whatever man she pleased," Hilaria flatly denied it. A mother would never say something like that in front of her children, she affirmed. Such an accusation was not only an "insult to me, but to mother nature herself." Moreover, Hilaria claimed never to have had inappropriate relations with Narciso.

Hilaria also vented her frustration over the intense scrutiny of her personal life while Millan's behavior was never really questioned. The judge "makes the most injurious allegations against me, yet at the same time he treats Millan with great consideration, brushing his well known public vices under the rug."[45] Thus Hilaria had butted up against the age-old double standard in gender relations. She, and all women, were expected to live up to strict moral standards while men seemed to violate those standards with impunity.

Besides facing the double standard of behavior, many women also faced the double shift of being a single mother having to support a fam-

ily. The struggles of these women and children highlight how difficult it was for women to find occupations that paid enough to keep them and their children afloat financially. [46] One woman lamented that her suffering was such that "the pen can in no way communicate the pain of the heart" when she was forced to abandon her motherly duties. The death of her husband and her lack of resources forced her to give up her children because her only other option was to hire her daughters out as prostitutes. [47]

gender necessities

The precarious predicament of Petrona Bengolea further illustrates the plight of many single mothers and female heads of household. The year was 1848 and Petrona had been looking for work, but having to cart her two-year-old daughter around with her made it impossible to find a job. Out of charity, Nicolasa Bengolea, most likely a family member, agreed to look after the little girl but, according to Nicolasa, the child was sick and cried incessantly, and she returned her to Petrona. However, Petrona soon reappeared in desperation. Her daughter was still hampering her attempts to find work. So dire were her straits, Petrona confided to Nicolasa, that "if she did not find someone to give her to, she would be forced to bash her child against the wall to free herself from the obstacle." Nicolasa again took pity on the child and agreed to take her on one condition: "that she give her up forever, which is why I made the great effort to raise her in the manner that she is found today." Months later, when Petrona returned again to take her child, Nicolasa agreed to return the girl if Petrona paid her for services rendered. When Petrona could not pay, the judge ordered that the little girl stay with Nicolasa until the debt could be met. [48]

Although the solution Petrona pondered—killing her child—is extreme, cases of infanticide were not unknown in the port city. [49] Her experience, along with others, shows that the "double shift" of a single and working mother was an arduous one in nineteenth-century Buenos Aires. The nineteenth-century economy in Buenos Aires was hard on women. In the mid-1800s, for example, women in the city and region were limited to the more "precarious professions" as laundresses, domestic servants, seamstresses, and ironers. If women were lucky enough to find employment, the jobs paid poorly and offered little job security. [50]

gendered divisions of labor

How did Petrona and others end up in these predicaments? Like an increasing number of their countrywomen, these women chose to engage in illicit unions. But under what circumstances did they do this? De facto

unions were increasingly common in Buenos Aires in the nineteenth century, which also increased the number of illegitimate births. A combination of expanding frontier, civil wars, and revolutionary sentiment meant more and more couples ignored the traditional rituals and ceremonies of marriage. Even for those who did follow tradition, it was not uncommon for engaged couples to have sexual relations before they were married.[51] In moral terms this was seen as "weakness of the flesh" and maybe even "seduction," if the man was to be blamed.[52] But premarital sexual activity would not necessarily compromise the woman's honor as long as the marriage went through.[53] In some cases, men vowed to marry their love interests, but never fulfilled, or could not fulfill, their promise.[54]

These relations created particular problems if the woman ended up pregnant. In the small towns of preindustrial England and elsewhere in Europe, sexual relations after betrothal but before marriage were also common, but community pressures helped couples follow through with their marriage plans. During industrialization the practice continued, but the burgeoning cities lacked the strong communal structure that had supported couples in the smaller towns. Hence the levels of abandonment rose in the confusion of city life.[55]

The dynamic growth of the city and hinterland of Buenos Aires seemed to provide a similar social context in which it was easier for a man to abandon his partner, even if he had promised marriage. One example is that of Elías Calderón, who in 1819 was locked in a court battle with Josefa Rojas over the custody of their illegitimate child. Josefa said Elías had deceived her by "abusing my honesty with the promise of marriage, a promise which he has never fulfilled." Nor had he cared much for the fruit of their illegitimate relation, a young girl named Adriana. While Elías had consistently neglected his daughter's spiritual and temporal welfare, Josefa claimed to have made great sacrifices on Adriana's behalf. Even worse, on top of his lengthy deception, Elías went off and married another woman. One of Josefa's greatest fears was that Elías would use Adriana as a servant for his new wife. "He probably wants the daughter of his sin to be a servant." For Josefa, seeing her daughter forced to work for a stepmother would be like "drinking the bitterest of cups."[56]

Juana Coronel, an Indian from Tucumán, also implied that she was a victim of another pretended suitor. Sometime around 1784, a man named Ignacio Torrado passed through Juana's home province of Tucumán on his way home from Peru. By her own account, Juana was

young, vulnerable, and unschooled in the ways of the world. Later, Juana testified that Torrado took advantage of her vulnerability, "fulfilled his depraved desires," and left her pregnant. After Juana had given birth to a daughter she named Angela, Torrado wanted to take the baby right away, but Juana did not permit it. Nine years later, Torrado passed through Tucumán again and this time succeeded in taking little Angela with him to Buenos Aires. Juana followed, but could not find her. After years of searching and grief, Juana finally located her Angela and went to court to get her back. She eventually achieved her wish.[57]

Besides a legitimate and harmonious marriage, another familial ideal was the separation and exclusion of women and children from public areas, an ideal constantly challenged by the reality of porteño streets. The street in particular was characterized as a zone full of vice and sexual danger. The social mores of the time forbade woman and children from taking to the streets alone, whether it was to work, shop, or stroll. Elite women were especially guarded in the streets, while the burdens of poverty forced many women to work in a variety of occupations that took them into the public arena.[58] Men had no such restrictions. A woman unaccompanied in the street or other public space risked unwanted advances from men and being labeled a prostitute. Men did all they could to prevent their female family members and children from frequenting the streets. In court, both men and women used the image of the streetwalker/prostitute to question the moral fitness of women and their rights to raise children.[59]

Take, for example, a child custody case from 1822. Manuel Caballero and Tránsito Córdoba were married probably sometime in 1818. On 25 March 1819 they baptized their new daughter, María Josefa Carolina. By the time little María arrived, however, storm clouds had already broken over Manuel and Tránsito's marriage. Manuel later recalled how, despite his best efforts to persuade her otherwise, Tránsito had "prostituted herself in such a scandalous manner that she guaranteed our perpetual separation."[60] Despite Manuel's protestations of love for her, Tránsito continued her despicable behavior, violated female decorum, and made a mockery of the sacrament of marriage. Manuel already had enough evidence to take his wife to court to seek a divorce if he so desired. But as often happened with many men in cases involving wives and infidelity, Manuel waited. Many men preferred to handle the situation outside the court system if possible, which they frequently did through violence. Going to court would only further publicize their humiliation.[61] Tránsito's

behavior, however, made the issue of privacy a moot point, for she had the audacity to visit her husband while she was accompanied by a male friend. Such public displays flaunted not only the norms of social behavior, but also Manuel's manhood, which he, as other men frequently did, might defend with violence. In all, the situation was ripe for disaster.

One night, Caballero ran into Tránsito and her male companion in the street. A scuffle ensued. Caballero, a military man, unsheathed his saber and wounded the man in the hand. Things could have been much worse for the interloper, especially because Caballero wielded a saber. Even so, Caballero was arrested and taken before a military tribunal. He admitted to wounding the "adulterer," and was later acquitted. Violent responses of husbands to adultery by their wives were justifiable and condoned by society, and a mere flesh wound paled in comparison to other acts of retribution taken by cuckolded husbands. The course of events did not alter Tránsito's outrageous and insulting behavior. She walked around town scantily clad and continued her public carousing with other men. Not only did she parade around the streets half naked, but she did so while she was very pregnant![62] Faced with the intransigent Tránsito, and having failed to resolve the issue first with persuasion, then violence, Manuel finally turned to the courts for help. He accused his wife of adultery and moral corruption and provided numerous witnesses who confirmed his story. Sometime before their child was born, the couple received an ecclesiastical separation (divorce).

After their separation the scandals continued. After the three-year period of custody granted to mothers by law, Manuel returned to court to claim custody of his daughter María Josefa. He again brought charges of scandalous living against Tránsito and now added child neglect to her list of crimes. He had paid substantial child support, he told the judge, but Tránsito used the money to throw dancing parties in her home and buy "adornments" for herself, even while their daughter walked around barefooted and wearing next to nothing. Caballero presented numerous witnesses who confirmed his story that his wife, in short, was a licentious woman who roamed the streets and lived a very "loose" life. A particularly damning testimony came from María Anastacia de la Rosa, a slave who lived nearby. As she peddled clothes along the streets, María Anastacia frequently saw Tránsito lying naked in bed in the presence of a certain man named "González."

These were not images of a model mother and wife, and Caballero hoped that they would disqualify his wife from having custody of their

children. He was right. Tránsito tried to counter his arguments, claiming that Caballero himself lived a life of debauchery. In addition, she argued, he had never supported his daughter, which forced Tránsito to beg in the streets. Her defense, however, never amounted to much. She could neither refute the testimony of Cabellero's witnesses nor produce witnesses to back up her story. The judge finally granted Caballero a type of custody of his daughter, but ruled that young María Josefa would have to stay in the home of a respectable family where women would be able to educate her.

While chaste behavior and proper decorum may have been more commonplace among elite families, this and other cases demonstrate that the social norms of honorable and appropriate behavior could be applied at all levels of society, even the lower classes to which Tránsito belonged. Masculinity and patriarchal rights could be defended informally through violence, but they were also championed in the court system.

The street also symbolized degeneracy and danger for children. Children, like women, were vulnerable to the evils of public spaces, especially to excessive labor but also to sexual abuse. Parents, guardians, and judges understood this concept clearly. In one 1842 custody ruling, a civil judge admonished Mariano Cabrera to care for the religious education of the girl placed in his care, making it clear that he "under no circumstances send her alone into the street."[63] One woman admitted to sending her foster child into the street, "but only on rare and urgent occasions, and they have always been during the day and in places very close to my home."[64]

The fate of the young adolescent Angela Coronel depended, in part, on her supposed exposure to the unwelcome influences of the street. Angela's mother, María, had placed her in the care of another family but now wanted her back because of alleged mistreatment and neglect. María's main argument rested on the allegation that one night an unknown man had come to the house where Angela lived and knocked on her window. It was obvious to her mother that Angela had made the acquaintance of this mystery man in the dangerous streets of Buenos Aires. One such occurrence was enough to call into question the girl's honor and her guardians' competence. In María's mind, if the guardians had taught her daughter to fear God, as they promised to do when they agreed to care for the child, then Angela would not have been involved in such unspeakable activities. For María, "the lack of moral behavior is the cause of the perdition of both sexes, and if [Angela] is walking

about the streets, there is no fear of God, for the street is the origin of all vice."[65]

Francisca Cariaga also used the negative image of the street in her argument to get her daughter back from Angela Gómez. In the depths of poverty, Francisca had given her daughter up with the understanding that the new guardian would employ the young girl in regular and acceptable domestic service. An important part of the agreement was that the young girl "not be sent into the street, because 12 and 13 year olds are not permitted there." Francisca claimed that the bargain had been broken because she had seen her daughter in the street many times, including one occasion in a butcher shop. She had gone to Gómez's house on two or three occasions to protest, to no avail. Angela Gómez countered with her own version of the story claiming that the girl's alleged roaming of the streets was "completely false." In fact, Angela claimed, life had improved for the young girl, who had originally arrived in her home almost naked, clothed only in a ragged shirt.[66]

Although opposing parties in child custody and divorce cases disputed details and allegations, the arguments of both sides demonstrate a consensus that the street was an inappropriate arena for women and children. Most porteños would have agreed with the Peruvian woman who in 1852 declared: "I want liberty, but not in the streets, because it is not honorable to expose myself to sinister interpretations."[67] The street, it seemed, was indeed "the origin of all vice."

Realities of Child Custody and Child Labor

The problem of children in the street highlighted a deeper problem in porteño society: the high levels of illegitimacy and abandonment. Illegitimacy rates increased dramatically in the early nineteenth century, with some areas in the city and countryside reaching illegitimacy rates of over 30 percent.[68] Female fertility rates were also high. During much of the first half of the nineteenth century, as much as 40–50 percent of the porteño population was under 14 years of age.[69] High fertility and illegitimacy rates along with the ills of poverty explain why large numbers of families gave up one or all of their children to be raised in other homes. Children from legitimate families had better legal and social safety nets than their counterparts in illegitimate unions. Judges could order illegitimate fathers to pay money to care for their illegitimate children, but paternity was hard to prove and many men evaded the law. Frequently women were left shouldering the burdens of single

motherhood in social and economic limbo. Even in legitimate families, the reality of poverty made for less-than-ideal circumstances for raising children. Poverty forced many single mothers, as well as couples, to give up the custody of their children. [70] Some, like Petrona Bengolea, even contemplated, or carried out, the killing of their own children.

Sensitive to these calamities, the state took a special interest in protecting children. After Buenos Aires became seat of the viceroyalty in 1776, the position of *El Defensor General de Menores* (Defender General of Minors) began taking on specific responsibilities of looking after child welfare. [71] The Defender of Minors was an individual who exercised substantial authority in deciding child custody cases. He investigated situations of at-risk children and helped organize child placement into a foster home, or putting-out arrangement. Defenders also made recommendations in child custody cases to civil judges and other local officials who dealt with child welfare issues in their jurisdictions.

The need for the Defender General of Minors highlighted the problems of poverty, abandonment, and neglect of children in the port city. Poor parents frequently placed their children in the custody of other families during the colonial and national period, usually because children were an economic burden for many poor families. [72] The practice of placing one's child with another family can be traced at least back to medieval times, when, according to the Siete Partidas, a man could "pawn" his son for food in times of extreme poverty, though such measures were only to be taken as a last resort. If a father wanted to reclaim his child at a later date, he would have to pay more money if the boy had learned something useful while away from his father. [73] Similar practices continued into the late colonial and national periods of Argentina, but instead of pawning their child, parents would exchange their child's labor for proper upbringing and education under someone else's roof. The following is a typical transaction from the nineteenth century.

> I, Mercedes Platona, widow, in utter poverty and without resources to feed my children and give them a Christian education, after consulting with persons of judgment regarding the fate of my children, have decided, for their own good, to give them to a person who will educate and provide for them. . . . I give and turn over my daughter Toribia Albin, eight years old, and my son Pablo, six. By virtue of this I leave and transfer all of the authority and dominion

I exercised over my children to Doña Luisa Ayres, and it is my will that my children be subject to her.[74]

Implicit in this "contract" was that the party receiving the child should provide what the mother could not do herself. Love and affection were not an explicit part of the equation.

Parents frequently attempted to reclaim the custody of their children. The most common reason was the breach, or alleged breach, of the original contract, which usually involved mistreatment of the children in one way or another. It was mothers who were most likely to reclaim their children in court, where their position as mothers gave them room to maneuver against men (and other women) as holders of legal rights.[75] In most cases, as the ancient *partida* outlined, parents who sought to reclaim their children were successful.

The following case was typical of custody battles: In 1846, Saturnina Buzaco gave her four-year-old son Emiliano to be cared for by Isabel Izquierdo. Four years later, Saturnina wanted her son back because, she accused, Isabel had violated the contract of guardianship. Isabel had treated her son cruelly, "forcing him to work more than his strength allows, making his life miserable and full of suffering that would be impossible even for an older boy." For that reason she desired to rescue him from Isabel's house.[76]

As Saturnina's case exemplifies, parents would couch their arguments in terms of their love and concern for the welfare of their children. Evidence abounds that parents did love their children—the mother from Tucumán who searched nine long years for her daughter comes to mind. However, less-virtuous motives were all too common. At the root of many custody battles was not necessarily the youngsters' well-being; rather, the concern was over the child labor they provided to their parents and guardians. Opposing sides in custody disputes frequently accused the other of wanting a child only because of his or her value as a worker. Parents accused guardians of using their children as slaves. When guardians did return children to their parents, almost all demanded to be repaid for the time and money they had invested in the child. Like many customs, the concept of compensation found its roots in the Siete Partidas. For those guardians who had true Christian charity and did not seek recompense, the *partidas* gave assurances of a higher reward.[77] Not many took this otherworldly option in nineteenth-century Buenos Aires.

Guardians, on the other hand, used similar arguments against parents, claiming that parents reclaimed their children only when they were old enough to be productive workers. Many accusations from both sides had merit. In one case, for instance, Toribio Luna, while away in military service, put his adopted niece in the power of his creditors to pay off his debt.[79] A similar motive is evident in the dispute between the widower José Cuello and Juan Landon and his wife, who had been caring for one of Cuello's children, ten-year-old José María. Years later, Cuello returned and wanted his son back, claiming he now had some patrimony he wanted to bequeath to his son. But Landon saw something more sinister in the father's desire: rather than having true love for his child, Cuello was more interested in his son's ability to work. "It appears that Cuello's pretense is not motivated by nature, but rather by speculation. Now is not the time when he should have remembered his children. He should have done it before, when their mother was sick and in the depths of misery." Nurturing a child was far superior to merely fathering a child, Landon added. Cuello has "done nothing more than giving them the initial spark of life. He is not the one who supported them or their mother when she was in good health, nor did he think of them when she was ill." Hence, "it is not nature, but naked self interest that brings him before the tribunals today to disturb those who took care of the mother and his children."[80]

Attempts to benefit from the labor of younger family members could also extend to the teenage years, as Concepción Alvarez discovered to her dismay. Every time she got serious with a suitor, her brother, acting on behalf of their absent father, prohibited her from continuing the relationship. Two men had already proposed to Concepción, and her brother denied his permission both times. For a time she suffered in silence. As she later recalled, "even when I thought his reasons were unfounded, I have suffered and resigned myself, obeying his resolutions." When Concepción received a third proposal, she finally decided to fight for her rights, and off to court she went. According to Concepción, her brother's opposition stemmed from his desire to have her continue to work for him in his home. The judge granted her permission to marry. After the ruling, her brother wrote a letter to the judge regretting the way his sister had embarrassed and denigrated the family.[81]

Although putting children out filled an important role in helping with child care and providing little bodies and nimble hands for the labor supply, the abuses of the system provoked heated criticism. In one

case the Defender General of Minors berated José Baliato, who sought recompense for his costs of raising a foster child. In his recommendation to the judge, the defender lashed out against Baliato, even though he agreed Baliato should be paid for his services. "What the Defender finds repugnant is that Baliato wanted to keep the boy in his power, like some kind of possession or hostage. Humanity must not accept such an idea without reproach, for it is an insult to its dignity."[82] What the Defender General of Minors saw was a system that, though useful, could lead to the exploitation of children in a number of ways.

Unfortunately, as the defender observed, children suffered greatly in family conflicts. Abusive work, sexual harassment, and neglect were the lot of many young children who worked in the houses and streets of Buenos Aires.

In one example of the dangers of child exploitation, for labor and otherwise, Manuel Castillo attempted to reclaim his stepchildren, whom he had sent to live with the carpenter Macario Falcón. According to Castillo, instead of caring for the children, Falcón was "using them as if they were his servants." Witnesses in the case testified that they had seen the girls doing heavy labor for Falcón on various occasions. One witness delivered the especially disturbing testimony that the girls may also have been suffering from sexual abuse. Falcón had been known to have "lifted up the girls' skirts in the presence of others" in his carpenter shop. The judge immediately ordered the children returned to their mother and stepfather.[78] How were children affected when they did not know their parents and were passed around from one household to the next? We can only imagine how five-year-old Adolfo felt the day he went to court as the center of a custody dispute. In 1835, when he was three years old, Adolfo's mother Josefa Alarcón had placed him in the care of Juan Barragán. Two years later, Josefa went to court to reclaim her son because she had found Adolfo in a miserable state: his hair was full of lice and Barragán's wife was mistreating the boy. When the judge asked Adolfo who his father was, the boy answered with perhaps the only male figure that it could possibly be: Juan Barragán was his dad. His mother then had to inform Adolfo that his real father's name was Justo Villanueva and that he was in Barragán's care only because of a contract she had made.[83] In another case, Epitasio del Campo was not even sure if he had fathered the two children he took care of. Although the mother signaled del Campo as their true father, he testified that he "could not speak with the same level of certainty as the mother."[84] And what of little Carlos, whose father, Juan

Lacalle, took him from his mother Dolores, against her will, and placed him in a house for abandoned children? The mother wanted the child back and went to court to get him. In court, Lacalle lied about being the father, claiming that he "could not recognize the child as his" because Dolores slept around with other men. Witnesses refuted that charge and helped establish Lacalle as the true father. According to the Defensor de Menores, Lacalle "preferred to abandon his child, neglecting a duty that is respected even among the savages.[85]

Glaringly absent in these painful proceedings are the voices of the children.[86] Most of the time parents and guardians told of what happened *to* the children, leaving us to wonder how children themselves might have felt. Dr. Juan Madera acknowledged the severe suffering of children when in 1817 he questioned why so much time was spent helping old people who were about to die when thousands of children were suffering, children who could be "useful to society." Instead, they suffered heavy workloads, hunger, and scant medical care, among other maladies.[87] Sometimes a child's voice squeaks through the cracks of bureaucracy, as when young Adolfo responded erroneously regarding the identity of his father.

One can only imagine what these children felt, and perhaps the vision of a novelist is closest to a child's perspective. Decades after young Adolfo misidentified his father, the Argentine novelist Ricardo Güiraldes wrote *Don Segundo Sombra*, in which the main character is sent to live with another family. "Six, seven, eight years old? How old was I when they took me from she whom I had always known as 'mother,' to bring me to this prison of a town under the pretext that I attend school. All I know is that I cried a lot the first week." Living with his so-called "aunts," the young protagonist remembered that they soon tired of their new "toy" and "nagged me all day." His guardians agreed with each other "only to tell me that I was dirty, that I was a delinquent, and that I was to blame for anything that went wrong in the house."[88]

It is not hard to imagine that, like Güiraldes's fictional character, many children experienced tremendous suffering as they, too, were separated from their parents and, in many cases, mistreated by their new guardians. While it is clear that strong affective relationships developed between parents and children, poverty combined with the need for child labor were powerful forces in shaping adult-child relations. The practice of foster care brought some promise of education and decent living, but

it also exposed children to suffering and abuse from those who were supposed to care for them.

Conclusion

Even as Buenos Aires experienced rapid population growth and capitalist development in the early nineteenth century, in many respects the families of Buenos Aires continued to function in traditional ways. [89] Colonial civil laws, derived from the ancient Siete Partidas and other Spanish laws, remained basically intact. This legal continuity helped perpetuate social attitudes and ideals of patriarchy, marriage, honor, and protection of women and children. The realities of familial conflicts also persisted. The precarious position of many a parent, especially single mothers, should warn against undue romanticization of the "freedoms" enjoyed by widows, single mothers, and female heads of households. More than likely, unless they were members of the elite, these women and their children suffered in poverty. But even as one appreciates the overarching continuities between colony and nation, beneath these surfaces one uncovers ruptures in porteño life that had important implications for Argentine families, society, and culture.

3. *"Accept Us as Free Men"*
Ruptures in Society and Family

Being from Spain had been a great advantage for men who had migrated to Spain's New World colonies, men like José Nazareno y López. During the colonial period, royal officials felt that *peninsulares* (Spaniards born in Spain) were superior to *criollos* (Spaniards born in the Americas), not to mention the others who represented varieties of interracial mixes found in the New World. Peninsular Spaniards were granted special commercial privileges and the highest political offices were reserved for them. Although *criollos* resented the discrimination, many wanted their daughters to marry Spaniards because it brought them into the privileged circle. These structures and sentiments changed in Buenos Aires after the May Revolution of 1810. Formerly prized as ideal suitors for the native daughters of Buenos Aires, Spaniards, now representative of monarchy and repression, were shunned, then banished from the land. Anti-Spanish sentiment appears to have been the case with José Nazareno y López, even fifteen years after the May Revolution. In 1825, José set his eye on Bonifacia Ruiz Moreno, but her father refused to grant his permission. José went to court, where he told that judge that Bonifacia's father opposed the marriage because José was a Spaniard. Apparently José understood the prejudice against Spaniards in Buenos Aires, because he tried to divert attention from his national origin: at least he had been *educated* in the Americas—across the river in Montevideo. [1] The anti-Spaniard attitude exhibited by Bonifacia's father had an official political side soon after the May Revolution. In a decree issued on 3 December 1810, the new governing junta referred to native Spaniards as "foreign persons" who were no longer "a precious part of ourselves." In March of the next year the junta banished all unmarried Spaniards from Buenos Aires, and other measures were taken to prevent marriages between creole women and peninsular men. [2]

The shift in attitudes against Spaniards hinted at larger processes of

change after 1810. To be sure, many social and economic continuities linked the colonial and national periods, but the break from Spain, and the nation-building efforts that followed, produced important social and cultural changes in porteño society. The idea of a new nation called for new identities and attitudes. These include the well-known political changes but also encompass ruptures (though by no means complete ones) that challenged social hierarchy, secularized society, and altered family relationships. Throughout the nineteenth century, by way of new educational programs and through the court system, the state increased its power to intervene in family life as national leaders tried to consolidate their nation-building project.

Society, Culture and the May Revolution

When the town council met at the Cabildo on 25 May 1810, many of its liberal members already had plans to separate from Spain. The influence of the Enlightenment, emanating from both Spain and the rest of Europe, had been present in Buenos Aires since the late eighteenth century. One future revolutionary leader, Manuel Belgrano, wrote of his reaction as he observed the French Revolution during an extended stay in Europe: "The ideas of liberty, equality, security, and property consumed me." He concluded that only tyrants were opposed to giving mankind "the rights that God and nature have given them."[3] Belgrano returned to Buenos Aires, where he helped foment the break from Spain in May of 1810. After the May Revolution, Enlightenment literature poured into Buenos Aires as never before. Printing presses multiplied, improving on the abysmal publishing environment of the colonial period. Newly begun porteño newspapers advertised new books, and new editions of old books, many of which dealt with politics and history.[4] The revolutionary governments responded in kind by passing legislation inspired by principles of natural rights and equality. One reformist thinker even proposed that Jean Jacques Rousseau's The Social Contract be required reading for all elementary school children.[5] The new printing presses, and the freedom to use them to discuss these and other issues, was a major achievement of the early years of the May Revolution.

The cultural arts of revolutionary Buenos Aires also reflected newly forming social attitudes and identities. During the independence wars, for example, dances that had been banned during the colonial period were allowed to celebrate revolutionary victories. Native dances played an important role in uniting the rebels against the Spanish. One minuet-

style dance from the colonial period was renamed the *Montonero Minuet* in honor of one of the rebel groups fighting the Spanish. This, along with other popular dances, provided at least part of an emerging national identity in the first half of the nineteenth century.[6]

Changes in the design of the Plaza de Mayo and in the architecture of the cathedral also reflected a change in mentality. Soon after independence, the city erected a monument known as the "Pyramid of May," a neoclassical and neo-Egyptian obelisk crafted in the style prominent in Europe—Italy and France, that is, for all things Spanish were now quite out of fashion.[7] The traditional façade of the cathedral was also replaced by a neoclassical structure that reflected modern French styles. Indeed, Bernardino Rivadavia brought in numerous French architects in the 1820s to help recast Buenos Aires' image. During the planning stages for new buildings, one of those architects, Jacobo Boudier, remarked that "when the institutions of a country have the tendency to erase the last traces of Spanish vassalage, the public buildings should manifest a style other than that of the Goths, because, as monuments they should reflect the public sentiment of the time in which they were built." Bourdier finished with a suggestion to get rid of the Cabildo and replace it with a building that was more "in harmony with the new times."[8]

New identities also began to emerge in literature. Bartolomé Hidalgo's *gauchesque* poetry, for example, praised independence and called for an egalitarian society to replace the Spanish colonial hierarchy. "We are no longer slaves," he declared in his *Cielito a la independencia*. A "new nation" had been born, one where "valiant Argentines" swore to fight an "eternal battle" against tyranny and despotism. Hidalgo also honored the valor of the Indians in battles against royalist forces. "Not even the devil could make them let up" in their destruction of the Spaniards.[9] Throughout his poetry Hidalgo showcased poignant American symbols, as in these passages addressed to the Spanish King, Ferdinand VII.

> I tell you, Fernando:
> Accept us as free men
> And stop raising so much hell . . .
> Keep your chocolate;
> we're pure-blooded Indians over here
> and drink only mate . . .
> In America, kings are not needed . . .
> The law is the same against all crime . . .

For the law, a poncho
is as good as a waistcoat and trousers . . . [10]

Hidalgo's images promoted ideas of freedom, equality, and national identity. Although chocolate is an indigenous American drink, it had come to symbolize privilege and wealth, while *mate* was the bitter tea favored by the gauchos and Indians of large parts of South America. The images of Indians and gauchos rejecting the king's chocolate in favor of their *mate*, and making fashionable European waistcoats equal with the rustic poncho, constituted at least a symbolic rejection of European domination and the exaltation of American political and cultural power. [11]

It would be a mistake, however, to ignore the incredible amount of literature that continued to denigrate Indian and gaucho culture. *La cautiva*, written by Esteban Echeverría in 1837, depicted the Indians as savage, rapacious, and bloodthirsty. Early on in the poem, his Indians "look with sick pleasure at the heads their knives have cut off" and celebrate the suffering of other Christians. In their camp the Indians are holding a young white mother as captive. She makes a daring escape along with a captive soldier and flees across the plains with Indians and savage animals on her heels. When she is finally found and taken to safety by an Argentine patrol, her first questions are of her baby son. "What happened to him?" she asks. The soldiers answer bluntly: "They slit his throat." Stricken with grief, she dies on the spot. [12]

Echeverría's cohort, the future president of Argentina, Domingo F. Sarmiento, also wrote disparagingly of Argentina's nonwhite inhabitants, including the Indian and the gaucho. Speaking of the gaucho in his famed *Facundo*, Sarmiento wrote that "it is necessary to see their visages bristling with beards, their countenances as grave and serious as those of the Arabs of Asia." For Sarmiento, the gaucho mindset was deeply imbedded in barbarism. Gauchos had "pitying scorn" for the "sedentary denizen of the city, who may have read many books, but who cannot overthrow and slay a fierce bull, who could not provide himself with a horse from the pampas, who has never met a tiger alone, and received him with a dagger in one hand and a poncho rolled up in the other, to be thrust into the animal's mouth, while he transfixes his heart with his dagger." Admittedly, Sarmiento held a certain admiration for gaucho traits in these and other observations. He looked favorably on the gaucho's fierce pride ("Alas, for the nation without faith in itself!") but

lamented the gaucho's rejection of European civilization, Sarmiento's key for Argentina's future progress.[13]

Reformist attitudes regarding social status, then, coexisted with traditional prejudices in the early nineteenth century. On one hand it would be out of place to expect a drastic change in traditional attitudes toward the lower classes and nonwhite ethnic groups just because of independence. Nevertheless, Indians were seen as an important element of post-independence identity, at least on a symbolic level. As the great Argentine liberator San Martín said of the Indians after his army moved into Peru in 1821, "In the future the aborigines shall not be called Indians or natives; they are children and citizens of Peru, and they shall be known as Peruvians."[14]

The political activity of the time provided a practical arena for the development of at least a part of the ideals expressed in the highly symbolic poetry of Hidalgo and in San Martín's statement. Some events in the political sphere did raise the social status of the Indian. After 1810, for example, the new governments integrated Indian and white militias. The internal political struggles that followed independence drove politicians to court lower-class support, resulting in a mobilization never before seen in River Plate society. The masses effectively answered the call, helping to save the new government from a Spaniard-led coup in April of 1811.[15] The military provided opportunity to ascend the social ladder and brought important income to the lower classes. The demand for labor was always high, and the wars only worsened the labor shortage. The simultaneous demand for workers and soldiers served as a mechanism to distribute wealth more evenly among porteño society. The gap between the rich and the poor did not disappear, but the revolutionary process reduced it.[16]

That the masses were indispensable as militiamen did not mean that the elites welcomed them as equals, even in the new republic. The elites of Buenos Aires were not unusual in needing the support of the masses, but at the same time they feared the potential power of the people. Both the slave revolt in Haiti in the 1790s and the bloody uprising of Father Miguel Hidalgo and his tens of thousands of peasants in Mexico in 1810 (only a few months after the May Revolution) represented the danger, monstrosity, and excesses of mass mobilization. Indeed, the government in Buenos Aires soon had its hands full with the caudillo José Gervasio Artigas, who led a popular movement that favored provincial rights and social reform. Fear of libertinage inspired political leaders to limit pop-

ular democratic reforms.[17] Hence, the May Revolution in Argentina, like so many revolutions, produced a tension between the ideal pursuit of liberty and the reality of dealing with a society that for generations had been based on racial and economic privilege.

As revolutionary leaders dealt with those tensions, they set about reforming the educational system in line with the needs of a new nation. Although improving education was not a novel idea in 1810, the May Revolution spurred leaders and educators to recognize the need to shape the youth into model citizens and soldiers of the new country. One educator of the time argued that primary schools should have first priority, "because infancy is more susceptible to impressions, good and bad doctrines, examples of virtue and scandal, and good and bad manners are all powerfully recorded in their spirits."[18] Education was also enlisted to bolster the fight against Spain. On 6 September 1811 the provisional junta ordered that the youth should become more familiar with military procedures by learning about military ordinances and weaponry. In addition, Thursdays were scheduled for students to learn about the future of the country and, later, for students to sing patriotic marches.[19]

Calls for more emphasis on education also came by way of newspaper editorials. Father Francisco de Paula Castañeda, a contemporary observer and social critic, made his point by inviting his readers to indulge him in a fictional scenario: Imagine that the armies of Buenos Aires had succeeded in conquering Upper Peru, Chile, and even Mexico. Such was the success of the Argentine armies that "even mother nature herself paused when she heard our name." After reaching such glorious heights, Father Castañeda asked one simple question: "How are we doing in education?" His response: terrible. If the modest success of the May Revolution was not bolstered by a strong education plan, then all of the triumphs were in vain, and, Castañeda lamented, an "abyss of ignorance" lay in waiting to "swallow the coming generation."[20] Others shared Father Castañeda's concerns. Reform continued during the 1820s when Bernardino Rivadavia gave educational policies new organization and vitality. The number of public schools increased, and the student population rose steadily throughout the decade and into the 1830s.[21]

The May revolution also ushered in a more secular society. To be sure, secularism had deep roots in the Enlightenment and was present in the policies of the Spanish Crown. During the late colonial period, the Spanish monarchy had successfully reduced the power of the Roman Catholic Church with such actions as the 1767 expulsion of the Jesuit order from

the entire kingdom and the confiscation of their property. The Church also lost ground in family-related issues when the monarchy removed its jurisdiction over disensos and placed those cases under civil authority. However, as witnessed in other parts of Latin America, independence brought new urgency and power to anticlerical movements. Anticlerical measures were strongest in Buenos Aires during the Rivadavian reforms of the 1820s. In November 1821 Rivadavia decreed that clergy could not enter Buenos Aires province without official permission from the government. Other innovations included suppressing certain religious orders in Buenos Aires and confiscating their property. In addition, tithes were abolished, along with the *fueros* (special legal rights) of the clergy.

Cemetery reform further eroded church authority. Rivadavia built public cemeteries and made it mandatory to bury the dead in them. These reforms were part of a process of modernization from a hygienic point of view. Old customs of leaving the body lying in wake for days and later burying it in a church vault were suspect in the eyes of new medical knowledge. [22] Besides their practical hygienic effect, cemetery reform was also laden with symbolism. The Church was losing control over the symbols and spaces of death and burial, one of the most important stages of the human experience, to a growing secular state that wanted both to improve public hygiene *and* consolidate national loyalties to itself.

Even when the pro-Church Juan Manuel de Rosas came to power after 1829, he did not roll back the anticlerical measures undertaken by his predecessors. Rosas did deal harshly with his enemies, but during his regime there was still freedom to criticize the Church. This is clear in the 1848 law school dissertation of Francisco Majesté, who argued that civil authority should trump ecclesiastical authority when the two powers conflicted. He and other reform-minded intellectuals turned to the example of Jesus Christ in the New Testament to shore up their anticlerical positions. What would happen, he posited, if the Pope and other church leaders arbitrarily called on their followers to disobey civil authority? The chaos would be intolerable. A good maxim, according to Majesté, was Jesus's answer to the Pharisee: "Render to Ceasar what is Ceasar's, and to God what is God's." [23] In a later dissertation, Leopoldo Basavilbaso made a similar argument, while adding some harsh criticism of Church activities. He argued that civil authority was usurped when Roman Catholic nations adopted the laws from the Council of Trent. According to Basavilbaso, Jesus taught that his was a spiritual, not a temporal kingdom. Early Christians submitted to the law of the ceasars,

but when the Christians themselves became the ceasars, they became the oppressors. "From then on, the spiritual kingdom of Christ became the most violent despotism in the world, a despotism that would have been universal were it not for Luther's revolution." Before Luther, popes had forced kings to kneel at their feet and imposed a theological intolerance in Roman Catholic nations, "all of which put the state inside the Church, and subordinated all material interests to the spiritual." Basavilbaso argued that "nothing was more contrary to the spirit of the gospel," than these attitudes and policies, and that there was "nothing more opposed to the will of Jesus."[24] Although these dissertations were written years after Rivadavia's reforms, tension between pro-Church conservatives and anticlerical liberals continued. One of the largest remaining issues was the marriage covenant itself, which still fell under Church authority while liberals longed for the day of a state-controlled civil marriage.

The symbolic decline of the Church can also be found in public records. Civil cases from the colonial period frequently contain religious statements and oaths. Swearing by the cross, for instance, was quite common, as seen in a child custody case from 1801 involving Ambrocio Cuchabuy, who swore "by the sign of this cross †," that his story was true (the crucifix was actually sketched right into the sentence in the record of the court proceeding as a visual testimony of the oath).[25] On 12 July 1804 a civil judge charged Mariquita Sánchez to swear an oath to tell the truth in her disenso case, which she did "in the name of the Lord God, and with the sign of the cross, promising to answer truthfully all questions put to her."[26] After independence, use of the cross declined.[27] In the process of secularization, Roman Catholic education also declined in favor of state-sponsored schools.[28]

Nor was the Church immune from being mocked by the press. A joke published in *El Centinela* made fun of the clergy, whom many saw as corrupt and hypocritical. A young boy went to confess to his priest. Apparently the boy had damaged some neighbor's property while trying to steal a nest full of birds from a tree.

PRIEST: Is the bird beautiful?

BOY: So, so.

PRIEST: Did you achieve your desire?

BOY: The chicks were too young and tender, so I left them for next Sunday.

The next Saturday, the priest went secretly to the tree, stole the nest, and gave it as a gift to one of his female parishioners. Time passed and the

young boy eventually returned to confess to the same priest. He told the priest that he had fallen in love with a young woman. She had made overtures to him, and he felt tempted to seize his opportunity with her.

PRIEST: Where did you find her?

BOY: In those nearby woods.

PRIEST: Is she beautiful?

BOY: Gorgeous!

PRIEST: What is her name?

BOY: Whoa! Wait just a minute, father. You will not be the first one to grab *this* nest![29]

Perhaps not by coincidence, the next section in the paper dealt with ecclesiastical reform designed to limit Church power.

Politics, War, and Ruptures in Family Life

The process of independence and nation-building served as both an interrupter and facilitator in marriage and family life. One of the most immediate results of the May Revolution, as seen in the case of the Montevideo-educated Spaniard José Nazareno mentioned at the beginning of this chapter, was the persecution and expulsion of peninsular Spaniards after 1810, a development that undoubtedly had an impact on many marriage plans. The military conflicts of the time also affected family life. The outbreak of the independence wars increased the demand for soldiers, which put a strain on families as fathers and sons were drafted into the military. While some served out of loyalty or obligation to local strongmen, others were drafted by force. The forced draft, known as the *leva*, targeted lower classes, and judges frequently sentenced criminals to serve in the army. "Criminals" might include anyone without proof of a job, and thus vagrancy became a tool used against the gaucho lifestyle. Workers, especially in the countryside, were required to carry a certificate of employment, known as the *papeleta del conchabo*, without which they were considered vagrants. Other recruiting methods were more creative. Finding his militia short on "volunteers," Colonel Agustín Acosta ordered his men to "proceed with the capture of twenty-five individuals."[30] Employers, especially in the countryside, feared these "recruiting" policies because they had enough trouble manning their ranching and agricultural enterprises. The emergence of civil wars between unitarians and federalists, as well as the continuing Indian problem, meant that military activity continually impinged on marriage and family life as husbands, fathers, and suitors were removed from their

homes. In a society where the patriarch wielded broad social and legal powers, his absence frequently created difficulties.

José María del Corazón de Jesus experienced such a problem in 1828, the year he hoped to marry Marina García. Like many men, Marina's father was away in the army, and José was forced to ask Marina's mother for permission. The mother rejected José's petition, leaving her daughter "in a state of complete desperation." When José took the case to court, the judge sent notice to find Marina's father and inform him that he would then have thirty days to appear before the court.[31] These types of delays, which could stretch on for months, surely had this and other couples in "complete desperation" as they awaited the fate of their pending union.

The courtship of María Alagón and Ubaldo Méndez offers further evidence of the familial difficulties stemming from the politico-military conflicts. In 1829, after going through the proper steps of courting, things seemed to be going well for the couple. Ubaldo had always gotten along with his future in-laws, and the sweethearts proceeded with their marriage plans. They were wrong. María's father, Juan Alagón, believed that the political waters of the country were too troubled for his daughter to be getting married and starting a family. Although he approved of Ubaldo as a companion for his daughter, he swore he would not consent to the union until the tumultuous republic settled down.

Alagón's concern puts a personal face on the anarchy that plagued porteño society during the late 1820s, when Buenos Aires and the rest of the provinces were in the throes of a bitter unitarist-federalist conflict over who would control the country. In 1828, unitarians had rashly executed the federalist governor of Buenos Aires province. In early 1829, right when Ubaldo and María were planning their wedding, the federalist Juan Manuel de Rosas laid siege to Buenos Aires and expelled the unitarians there. At one point during 1829, the tension in the city reached such a degree that musicians had to obtain special permission and escorts from the police "to prevent the exchange of words and insults that promote the arguments that upset the orderliness that the government wishes."[32]

While the fatherly Alagón fretted, Ubaldo apparently lost little sleep over these disturbances, at least with regard to his marriage. As time passed, it appears Ubaldo threatened to take the case to court in an attempt to override Alagón's opposition in a disenso case. The patriarch responded with conviction in a personal letter to Ubaldo dated 18 June 1829: "In answer to your response of yesterday, I reiterate what I told

you before: That as long as the present circumstances persist, and the country is not in perfect tranquility, I will not give in to your wish [to marry my daughter], despite your threats, because I know they were made in passion, without serious reflection on your part concerning the responsibilities you will take upon yourself." In the meantime, María sent Ubaldo a letter on 26 June expressing her frustration and urging Ubaldo to do whatever was necessary to obtain license for them to marry.

> My dearest Ubaldo,
> I have become completely disillusioned with my parents, who are using delay tactics in not acquiescing to my resolute desire to be united in matrimony with you. They do this, despite their understanding that I am firmly committed, and that nothing will make me change my course of action. I give you my permission to take the necessary steps to obtain license for us to wed. Know that you will always find me ready and willing to support you.
> Yours eternally, María Alagón.

Unwilling to accept Alagón's intransigent position, and encouraged by María, Ubaldo did go to court; the judge sided with the couple and granted them the necessary permission to marry.[33]

While the political and military instability impeded important aspects of family life, in other important ways, the realities and necessities of nation-building opened new opportunities for family formation. One new opportunity came in the form of new foreigners arriving in Buenos Aires after independence, namely the British. Post-independence leaders understood the need to attract foreign immigration, and their *ideal*, inspired by the Jeffersonian image of the hardworking yeoman farmer, was to bring in western and northern Europeans. If this model succeeded, however, most of the immigrants would be Protestant rather than Roman Catholic. This created problems because the sacrament of marriage still fell under Church authority, and the Church remained vigorously opposed to mixed unions and frequently refused to grant the necessary religious permissions (dispensations) to facilitate interfaith marriages. As outlined in the Siete Partidas, Roman Catholic men were not allowed to marry "Jewish or Moorish women, heretics, nor any woman who did not live Christian law."[34] Though Protestants did not exist in the 1200s when the Partidas were written, Roman Catholic officials easily fit them into the "heretic" category. Despite these obstacles, Protestant foreigners did not necessarily remain bachelors in Buenos Aires, and

their eyes frequently fell on the native daughters of the area. During the early years of independence, many hopeful suitors chose to avoid the issue by converting to Catholicism.

The English were by far the most numerous and powerful foreign group in and around Buenos Aires. Beginning with a colony of 124 in 1810, by 1825 their numbers had risen to 1,355 and then to 18,000 in 1854. Even with official Roman Catholic opposition to mixed marriages, some foreigners observed that by the 1820s porteño society had already achieved a high level of informal religious tolerance. One English visitor, Alexander Caldcleugh, wrote in 1821 that "I have found in all parts a great spirit of tolerance, and whatever the religious conviction of the inhabitants, they never make a foreigner feel any less for having heretical opinions."[35] This tolerance was codified in some respects by Article 12 of the Treaty of Friendship, Navigation, and Commerce, signed in 1825 by Argentina and Great Britain, which outlined some principles of freedom of religion and conscience. While Argentine leaders did not see the article as one of general religious freedom, the English interpreted the clause to permit interfaith unions.

The official tide began to turn in favor of interfaith marriages in 1833 when the government started pressuring Church leaders to grant the necessary dispensations. After 1833, throughout the Rosas years and later, permission was granted in most cases petitioning for approval of a mixed marriage. As one Argentine historian has argued, it would be a mistake to trivialize the implications of this policy. The sanction and practice of interfaith marriages in Buenos Aires is an important chapter in the history of the Argentine nation, for it marked the first step by the government to fuse the native and foreign populations of Buenos Aires.[36] These changes reflected the thinking of many people in Buenos Aires at that time. After all, one visitor observed, "liberal minded individuals do not allow religious differences to disturb the domestic peace. Besides, our differences are in form only."[37] Whether the policies were deliberately "liberal minded" or not, the facilitation of interfaith marriages broke down a significant religious barrier and must be seen, at one level, as an important transition from a traditional to a more open and "modern" society.

Shifting Attitudes toward Children

The May Revolution and nation-building also affected attitudes toward children in Buenos Aires. As with other areas of society, Enlightenment

thought of the eighteenth century had begun to view children in new ways. Better education and better upbringing would create better citizens.[38] Many early national leaders in Argentina were inheritors of these Enlightenment ideals, but the nation-building of the nineteenth century added a new dynamic to issues of children and childhood, for they were no longer subjects of a distant king but future citizens of a republic. As a result, the nineteenth century saw the Argentine family, and society in general, move *toward* what is regarded as "modern" social structures. Scholars use many approaches to their study of the family. Among these are demographic data, such as sizes of households, marriage age, fertility, and illegitimacy, all of which are important aspects of family life. Other approaches, and the ones considered in this section, are societal attitudes and perceptions of children and childhood.[39]

Scholars of the family will continue to debate what traits identify a "traditional" or "modern" family. When it comes to the history of childhood, one major point of contention surrounds the very definition of childhood itself. Some historians have argued that premodern views saw children as mere "imitators" and "apprentices" of the adult world.[40] As society in Europe modernized in the eighteenth and nineteenth centuries, families became wealthier and sought more private, secluded lives. At the same time, professionals began to separate children into schools, playgrounds, and other activities under the supervision of adults. As a result, childhood "emerged as a distinct phase of life."[41] An important part of this transition began when formal behavior, governed by strict hierarchies, was replaced with greater affection between parents and children.

Other scholars disagree with the notion that modern parents loved their children more than in times past and argue that parental love is biological and can be traced across cultures throughout time.[42] These discussions among scholars have revealed a complex view of childhood. Social relationships in general are subject to change from generation to generation, and the pace of change also varies. The rate of change can be affected by forces outside the family, such as political and economic factors. The concept of childhood and parent-child relations, then, is determined by a complex relationship between private family attitudes, political movements, and economic changes.[43] Hence there is room for those who argue for a continuity in parental love for children, while leaving space for certain levels of childhood "invention," or changes in attitudes toward children.

Hispanic laws and the records from Argentine civil courts help clar-
ify some of these issues in the case of Argentina and Latin America in
general. The Siete Partidas explain that "mercy and natural obligation
should motivate parents to care for their children," and men are "moved
to do it by the great love they have for the child they raise, whether it
be his own child or that of a stranger." The bond is especially strong
between father and child, and "as anyone loves a child they have engen-
dered, that love grows deeper as the child is raised."[44] In the second Par-
tida, when outlining how to raise children of royalty, the author stated
that the children should be treated well and not hurt in any way. If they
are mistreated, "then all of the love and care we have talked about in all
of these other laws will be for naught."[45] Expressions of this kind of love
can be found in civil cases from the colonial and national periods. In one
case from 1801, a young child Josef is mentioned repeatedly by name. His
father, Ambrocio Cuchabuy, loved his Josef so much that he "abandoned
all of his obligations and labors and went out in search of his son in all
directions."[46]

While these examples reveal a strong love-tie between parents and
children, the *conceptions* of childhood as a social state of being, as per-
ceived in Buenos Aires at the time, were in dynamic flux. Late-colonial
conceptions of childhood were caught between the traditional ideas that
saw children as little adults, and the Enlightened ideal of a separate
identity for children. For example, an important indicator of attitudes
toward children is the way they are referred to (or not referred to) in
official correspondence. During the late colonial period, children are
rarely identified by name or age. By the early 1800s, however, children's
names begin to appear more frequently, and increased expressions of
affection from parents and guardians toward the children are also more
evident.[47] In an 1819 child custody suit, Elías Calderón expressed love for
his daughter, Adriana. Alleged mistreatment of Adriana had awakened
his paternal senses: "I would be unworthy if I did not seek to provide
the best for a child whom I have loved and given life."[48] Another exam-
ple of attention and affection toward children is found in a letter from
Joaquina Castañeda in a child custody case. She pursued the case because
of the "love which I have for this child," who "returns my affection," and,
most of all, because the girl pleaded not to be abandoned.[49]

Popular literature of the time also reflects changes in attitudes toward
small children. *La Abeja Argentina* encouraged its female readers to
breast-feed their own children and not farm them out to wet nurses. The

use of wet nurses had come under heavy fire from Enlightened thinkers in Europe during the eighteenth century, which in turn echoed advice given as far back as the late medieval period. Mothers who nursed would raise stronger and more responsible children who would, in turn, fortify the nation. In Peru, for example, the organ of Enlightenment thought, *El Mercurio*, questioned the practice but focused on the dangers posed by an immoral wet nurse passing on undesirable traits rather than on the positive nature of women breast-feeding their babies.[50] In Buenos Aires by the early nineteenth century, *La Abeja* hit both issues hard. In a section entitled "Dangers Facing Mothers Who Do Not Raise Their Children," *La Abeja* expounded the virtues of breast-feeding while extending a warning: "Be forewarned that if you deprive your children of the nourishment that nature has provided you, you will give away, break, or at least weaken, the bonds of love and tenderness that tie you to your children." When children grow, *La Abeja* continued, they will come to know of their great deprivation. *La Abeja* offered mothers a glimpse of how their children would respond to them in the future if mothers did not change their non-nursing ways:

> You denied me the milk that nature had prepared for me in your breasts, the only nourishment good for me at the time. You put a mercenary in your place, someone I didn't belong to in any way. You abandoned me to the mercies of your capricious desires, your selfishness and greed. From her breast you made me suck the diseases of her body and the vices of her soul. In short, you have almost entirely renounced being my mother, or at least you have divided me with another. Indulge me, then, if I decide to withhold my affection from you, or at least allow me to share them with her that took up your slack and gave me the nourishment and care that you denied me.[51]

While many women were in favor of breast-feeding over wet nursing, many periodicals such as *La Abeja* were edited and controlled by men, and this harsh fictional scenario, especially its vengeful tone, might not represent the female perception of the problem. Nevertheless, it does reflect a move toward more loving parent-child relationships and shows the perception that children deserved more than they had been getting from their parents in the past.

Another hint at changing attitudes toward children was the push by some members of the intellectual community to raise the minimum

age of marriage. The ancient *partidas* had allowed girls to marry at age twelve, and boys at fourteen, a practice that continued well into the nineteenth century. In his 1867 dissertation at the University of Buenos Aires Law School, Fidel Cavia argued that the old laws were just that: too old and too outdated for a modern country like Argentina. Cavia quoted the French jurist and statesman, Jean Étienne Marie Portalis, who argued that marriage at such a young age denied children the experiences of youth. "Then there will be no youth for those who take the privilege the law gives them. They will leave infancy only to fall into decrepitude."[52] Besides the possible skepticism about the wisdom of marriage itself, Cavia's argument implied that infancy is not only a separate stage of development, but so is adolescence something that should be experienced before plunging into marriage.

The education of children also became more important as the state sought to maintain social order and inculcate republican values. As mentioned earlier, Rivadavia increased educational programs significantly during the 1820s. After the fall of Rosas in 1852, liberals sought to implement a new conception of the state of childhood. Whereas Rosas may have believed that education was not meant for everyone, liberals upheld the ideals of progress and the perfectibility of mankind through education.[53]

The changing perceptions and definitions of childhood identity and parent-child relationships were in dynamic formation in nineteenth-century Buenos Aires. Evidence from the ancient *partidas* as well as from court records shows that indeed parents have long loved and nurtured their children, an indication of an awareness that childhood had some kind of separate identity and that a strong love-tie existed between parents and children. Nonetheless, whether it was a matter of campaigns against wet nurses, or lawyers trying to raise the minimum age of marriage, or educational programs, new definitions and perceptions of childhood developed as parents, guardians, and the state negotiated between traditional societal norms and the new political, economic, and social realities emerging in the nineteenth century. Although the subject deserves much more attention, the post-independence era marks perhaps the beginning of a new *stage* of childhood identity in Argentina.

The Growing Power of the State

As awareness of the importance of childhood increased, it is not surprising that, as the nineteenth century progressed, government policies

also changed. Education reform as well as legal developments reflect the growing organization and power of the emerging Argentine state apparatus and its ability to intervene in family life. The colonial regime had always been concerned with strengthening the community and providing aid to those in need. A strong and healthy kingdom needed strong and healthy families. Children were seen as the seedbed of future generations and received special attention.

As mentioned previously, education became an important tool of post-independence nation-building. Yet many feared that education was a tool for increased state control of the family. By 1818 Argentines had imported the Lancaster method of teaching from England, which was a liberal and secular model of teaching that emphasized order and discipline. Some parents felt threatened by the new method: the government, through educational programs, was undermining the power and authority of parents while increasing the authority of the state.[54]

Besides educating children, the government sought to protect needy children from suffering and abuse. During the late-colonial period, the Casa de Niños Expósitos (house for abandoned children) and the Defensoría de Menores were established to aid poor children, whether orphaned, abandoned, abused, or neglected. However, the chronic lack of funds and organization inhibited these and other organizations from fulfilling their missions. After independence the state began to take a more active role in social assistance.[55]

The Defensoría de Menores, for example, took on a more specific form and responsibility during the reformist-era of Bernardino Rivadavia in the 1820s. According to one official statement,

> The office of the Defensor de Menores is one of those destined for honor that should satisfy the philanthropic sentiments of all good citizens; its principal objective is to look out for the interest of these members of the social class in question, save them from the greed of wicked guardians, or the complicated legal actions that have always ruined them. An owner of impeccable reputation will find great satisfaction in exercising with satisfaction these paternal functions and will win the blessings of important families and the respect of the entire society.[56]

Rivadavia also facilitated the formation of the Sociedad de Beneficencia, a charitable organization, out of the older women's group known as the

Sociedad de Damas (Society of Ladies), to care for poor and abandoned children.

However, the role of the state in mediating conflicts and protecting children was not always clear, state intervention was not always welcome, nor were its benefits always apparent. Many times, the presence of an abusive or neglectful parent or guardian made decisions regarding a child's welfare seem simple and obvious, such as one case in which a father beat his daughter so badly that he left her whole body covered with scars.[57] Other instances were more complex and harder to decide. The *partidas* charged parents and guardians to care for children to the best of their ability and according to their circumstances. Sometimes the state had to decide what situations or family "circumstances" were best for the children, a task that could prove very subjective. One particularly painful case, at least for Juana Bernal and her foster daughter Carlota, occurred in 1842. Juana had raised Carlota, now ten years old, since she was seven months old. Over the years, she had provided for and educated the child and developed a deep love for her. As Juana put it, "I love and care for Carlota dearly, and she feels the same towards me." The problem was that the priest in her town had taken Carlota away from her, and she now wanted the judge to get her back. The judge ordered the priest to explain his reasons for such behavior.

The priest answered that he had received a letter from the Sociedad de Beneficencia, which he handed over to the judge:

> Long Live the Federation!
> Señor Cura Don Martín Boneo,
> My dear sir: A philanthropist has proposed to pay for the schooling of an orphan girl. . . . Knowing of your characteristic charity, and since there might be among your parishioners some unfortunate orphan, please, by order of the Society, send such a girl if she can be found.
> Your affectionate servant. Pascuala Balaustegui de Arana. 21 January 1841.
> P.S. I forewarn you that no one will have the right to remove the girl, nor have any rights over her until she either gets married or reaches the age of majority.

The priest had searched high and low for someone who fit the requirements, and he found only Carlota to have enough aptitude to receive such a scholarship. She was an ideal candidate in part because she lived

with Juana, a poor widow who, the priest believed, could never offer Carlota any prosperous future. The priest summoned Juana and informed her of the scholarship. Surely, the priest thought, Juana understood the many benefits a distinguished education would bring to an orphan like Carlota. "I concluded by telling her that no one could deprive this young creature this scholarship that offered her opportunities that she could never give her." Juana apparently agreed in principle to allow them to take Carlota, but she later fled the area, despite an order from the local Justice of the Peace to hand over the girl. In a note to the judge, the Justice of the Peace could not find words to express his disgust at the way Juana was handling the whole situation.

What had been a local dispute then turned into a child custody dispute, in which the judge agreed with the priest and rejected Juana's plea that Carlota stay with her. He justified his ruling, stating that the girl was an orphan and was going to receive a "proper, Christian education that the woman who raised her cannot give her." Simply put, Juana did not have the right "to deprive her of such benefits." The last line recorded in the case was short but ominous: "Doña Juana was notified. She did not sign her name because she did not know how."[58] One can only imagine how Juana Bernal felt after she received the news; or how she felt when she had to say goodbye to Carlota, a girl she had raised almost from birth. Carlota's feelings were probably similar after being uprooted from the only home she had ever known. Who knew what was best for the girl? Was Juana's poverty reason enough to remove Carlota from her home, especially since she would have no rights whatsoever over the girl, who would probably be living somewhere in the city where it might be difficult for Juana to visit her? The charitable scholarship was obviously something that Juana could never offer, but was it worth breaking up a lifelong relationship? The civil and ecclesiastical officials thought they knew the answers to these questions.

Juana and Carlota's case shows the two-edged sword of increased state intervention, but it also raised important issues regarding the "fitness" of poor families to raise children. That question was central to this next case, in which state initiative took on a new and more active form. On 7 March 1862, the Defender of Minors of San Vicente sent the following letter to the Alcaldes del Partido:[59]

In your cuartel there are some orphans and children of impoverished parents who set bad examples for these unfortunate crea-

tures, whether it be from their immoral lives or from their indigent situation. It is your duty to take the necessary measures to place these children in the care of individuals who are educated enough to make them happy.

issues w/ contraception?

You should proceed personally, or through your subordinates, to take a scrupulous survey of what has been aforementioned, reporting back to this Ministry by way of a note that specifies the names of the parents and children who fall into these categories. I hope that humanity and patriotism carry you to the most exact fulfillment of these objectives. Signed: Manuel Fernández

It did not take long for this concerted effort to bring results, as the following letter dated May 15 to the Alcalde of Cuartel 4 illustrates: "In the house of Don Mariano Rosas there is a *morena* (mulatta or parda) with two daughters. The older of the two is under the care of Doña Antonia Gutiérrez, whom your Honor will order to have turned over to the house of Don Cornelio Doncelas, who has been charged with receiving her. The mother should also be ordered to appear before this court with her other daughter as soon as possible. Signed: Manuel Fernández." The Justice of the Peace ordered the girl to stay with the specified family.

The "morena" referred to was María de la Paz Canaveris, and she had a different version of the story, which she took to the court. She had raised and educated her daughter appropriately, but when her daughter "reached the age where she could do productive work," she was taken by local authorities and "placed in the house of friends of the municipal official where she was to work as a servant." If she could not have her at home, she at least wanted to place the child in the home of someone she knew and trusted. María's lawyer also tried to present a conflict of interest argument. "Even if her [the mother's] conduct was bad, which is not proven, why not put her [daughter] where her mother would like her? Or is it to be supposed, by chance, that the friend of the Municipal Defender is better than the mother's suggestion?"[60] This and other cases indicate that local politics heavily influenced the placement of minors, who in turn served as valuable laborers. Although no evidence suggests that the judge was funneling servants to his friends, heated disputes over child labor make it at least a possibility.

Other cases also demonstrate the higher levels of organization by the state. On 27 May 1870, a child custody case was settled with a ruling from the Defensoría General de Menores. The ruling held that the 13-year-old

girl in question would be placed with a certain family, who was charged with caring for her temporal needs, teaching her to read, write and count, and instilling moral principles and religious piety; and they were not to allow her to go into the street. In addition, the family would have to present the girl every six months before the defender for examination.[61]

The dissertation of Rómulo Avendaño, which he wrote in 1869 as he finished law school in Buenos Aires, further illustrates the idea of an expanding state authority and responsibility for child welfare. He told a story of a young child named Félix who was taken from the Casa de Niños Expósitos by Manuel Cárdenas, who agreed to raise and provide for the boy. When Cárdenas died, the Defender of Minors and others claimed that the boy should continue to receive support from whomever inherited Cárdenas's estate. The inheritor, however, refused to provide for the boy, and the courts supported the decision. Avendaño recognized that progress had been made in the treatment of underprivileged children in the late colonial and early national period. He mentioned the colonial attempts to help poor children and other efforts after independence, such as the 1811 decree which provided that *expósitos* be cared for with public funds. Despite the progress, however, Avendaño still found room for improvement in the experience of little Félix, meaning that the state needed to take a more active role in protecting children's rights.

While Avendaño had the children's welfare in mind, he was not oblivious to the benefits and dangers that would come to the nation because of its treatment of children. "He who has been nursed in a strange place, who has played with brothers of misfortune instead of brothers of blood relation; he who has been educated by social superiors instead of by parents; he who has seen all of his companions disappear suddenly, one by one, into the system of public charity; he who has never enjoyed the delightfulness of a home—does he not perhaps deserve our attention, and should our voices not rise up in defense of his unrecognized rights?" The hopeful graduate extended his line of reasoning by turning to Christian doctrine. The ancient law of Moses, which stated that "the sins of the parents will fall on the heads of the children up to the fourth and fifth generation," was supposedly "erased by the Savior's martyrdom." Mistreating children, he continued, not only ruined their lives, but it would also come back to haunt the state. "When the fortune of a young child is manipulated with such calm, sinking him in misery; when an immoral jurisprudence is established (permit me to classify it in this manner), it is natural that the soul of a twenty-year-old would be brimming with

indignation. But I do not despair that I will see a triumphal justice, a resplendent truth, when the seed of goodness and love which we have in our souls overcomes our passing interests."[62] Such was Avendaño's displeasure at the treatment of little Félix, and such was his hope for a brighter future.

All these examples illustrate the increased vigor of the state and its institutions. Young Carlota and her caretaker Juana Bernal lost a battle with the new Sociedad de Beneficencia, supported by government officials. María de la Paz's case from 1862 presented something new in the 100 cases examined for this chapter, in that this was the first time such a concerted and rigorous approach was taken to seek out children in danger. There appears to be a change from passively dealing with at-risk families as they came into court to a more vigorous approach. In the 1870 case, not only was the state intervening on behalf of these children, but the welfare of the child would be assured by periodic inspections. Avendaño's dissertation reflects how lawyers and other intellectuals were pushing the boundaries of childcare. Clearly, the welfare of children would have an impact on the welfare of the nation, for good or for ill.

These attitudes and activities show the growing sentiment of interventionism and positivism that would come to characterize the men and women later known as the *científicos* (scientists) and *higienistas* (public health doctors). In the 1850s, the government established a municipal public health board. The power of these groups increased in the 1870s when the first chair of public health was created.[63] *Científicos* and *higienistas* believed that state officials could improve society through the use of scientifically proven methods, whether in the economy, or in civil society, particularly in matters of public health. For *científicos* and *higienistas*, the poor were the cause of their own problems. Marginal groups of society needed first to be controlled, then reformed.[64] Taking children away from unfit parents, systematically sought out, was a rational policy that would improve society.

After independence, social assistance grew and became more organized as the century progressed, and children received increased state attention. These welfare activities reveal the continued movement, begun during the late colonial period, toward the secularization of social assistance and the evolution of what were once seen as privileges toward "rights to protection" for the less fortunate members of society.[65] However, in many cases, the less fortunate had little power to determine what was best for them. The boom of institutionalization in the mid-

to late-nineteenth century did not emerge from a vacuum but was the fruition of ideas about social progress and the importance of family life and childhood that had existed since late colonial times, which had now been infused with the dynamism of nation-building.

Conclusion

The politics, ideologies, and military actions of the May Revolution created ruptures that rippled through society. Many of the traditional mechanisms of social segregation and privilege, such as titles of nobility and special *fueros*, were abolished. New forms of education shaped a new generation of citizens in an emerging republic. Attitudes toward children and childhood were also in a state of dynamic change in the nineteenth century as seen in heightened awareness of children and their needs. Meanwhile, the state sought to mediate the complex disputes over issues of love, labor, and family life. Children were targeted with new educational curricula in an attempt to create patriotic citizens. This reflects the continuation of the Enlightenment emphasis on the importance of childhood experiences in shaping adult lives but with a new and dynamic twist of a type of republican childhood. The state sought to protect children when necessary and, over time, state intervention into family life increased as post-independent governments saw the youth of the country as an integral part of the nation-building project. One such youth was Mariquita Sánchez.

4. *"If You Love Me"*
Paternal Reason versus Youthful Romance

María de Todos los Santos Sánchez de Velazco y Trillo was only fourteen years old when she decided on whom she wanted to marry: Martín Jacobo de Thompson, her second cousin on her mother's side. It was not uncommon for cousins to marry, and at 23, Martín was handsome, well educated, and had already begun a promising career as an officer in the royal navy. Martín visited Mariquita (as she was known to family and friends) frequently in her home, where they fell in love. In the winter (midyear in the southern hemisphere) of 1801, they were engaged to be married. When Martín approached Mariquita's parents for permission, they banished him from their home. They already had someone more appropriate in mind for Mariquita to marry—Diego del Arco, a Spaniard much older than Mariquita.

Mariquita stubbornly resisted her parents' matchmaking while remaining true to her love for Martín. Perhaps she had been influenced by Father Manuel Azamor y Ramírez, a family friend who had spent considerable time in the Sánchez y Velazco home during Mariquita's youth.[1] The Roman Catholic priest was an outspoken proponent of the rights of couples to freely choose who they should marry without undo interference from their parents, a stand the Roman Catholic Church had taken at least since the Council of Trent in the mid 1500s. The Church had also presided over parent-child conflicts over marriage choice for most of the colonial period. In 1795 Azamor y Ramírez had published a treatise in which he used the story of Samson and Delilah to emphasize a couple's right to choose. Although they disapproved of their son's choice in a partner—she was, after all, a literal Philistine—Samson's parents, who were "just and good," respected his choice. Samson, also "just and good," did not feel obligated to follow his parents' council; he committed no sin by marrying an "unequal" partner; nor did he fail to honor his parents, as commanded in Exodus. What the case of Samson and his

parents illustrates, according to the Roman Catholic priest, is that "the parents understood, being just and good, that they could not, nor did they have the right, to impede the marriage and the choice of their son in such a delicate matter, a matter in which men and women possess all the natural freedom and spontaneous free will."[2] Perhaps Mariquita heard this version of Samson and Delilah's romance from Father Azamor y Ramírez himself.

By the time the priest had written his treatise, the Bourbon monarchy had drastically reduced the Church's authority by taking jurisdiction over marriage-choice conflicts away from the Church and putting it under civil authority. Any future Samson and Delilahs would most likely have to answer to a civil judge. Priests were also expressly banned from performing marriages, especially secret marriages, without parental consent. This is not to say that parents and judges had all power to control their children's marriages, but fathers like Mariquita's felt comfortable in making vigorous patriarchal power plays. Like many other parents, he and his wife thought they knew what was best for their fourteen-year-old daughter and that their love for her trumped her love for her cousin Martín Thompson.

Whether it was Romeo and Juliet, Samson and Delilah, or Mariquita and Martín, conflicts between children and parents over love have long histories that span culture, race, and class boundaries. However, the cultural and legal context of those timeless conflicts—how love was expressed and experienced and how conflicts over love were dealt with in a given society—varies across time and space. Like Mariquita and Martín, Argentine youth in the early nineteenth century fell in love and wanted to marry for love. Indeed, the ideal of romantic love was on the rise in Europe and the Americas. At the same time, parents were also motivated by love—paternal love—to oppose certain marriages to avoid the pain and suffering of a bad union, among other reasons. Parents saw young men and women as incapable of making rational choices about marriage, choices that would affect the rest of their lives and the honor of the immediate and extended family. These two loves—romantic and paternal—clashed frequently in the home and spilled over into the civil courts. When the cases did get to court, their results reveal societal attitudes toward individualism, patriarchy, and romantic and paternal love and how these concepts, and their respective advocates, struggled for supremacy in the civil courts of Buenos Aires and in the emerging nation of Argentina. The disensos will form a large part of the discussion in

the next two chapters. This chapter will examine the romantic element while chapter 5 will focus more on issues of race and class in marriage choice.

Individualism and romanticism (used in this chapter to denote romantic love) are important elements in the study of the modern family. How much freedom did children possess in choosing their mates in a given society? To what extent was marriage motivated by affection, family politics, race, or class? When, why, and how did these freedoms and motivations change? In the case of Europe and the Americas, conservatism, liberalism, industrialization, and urbanization are some key topics that scholars consider as they attempt to answer these complex questions. Although scholars disagree on details, many argue that patriarchal authority controlled marriage choice in traditional societies while modernizing societies weakened patriarchal authority and allowed more freedom for couples to choose their mates. A major question surrounds the when and why of the shift from traditional society, in which parents had more control over their children's marriages, to a more modern and individualistic one, in which children have more freedom.[3]

In its own unique way, and in its own time, Buenos Aires also experienced the forces of modernization. One must wonder how the processes of change—namely, the political and economic reforms of the late Bourbon period, economic and population growth in the city and countryside, the liberalism of the Enlightenment, and Buenos Aires' own revolution in 1810—affected romantic love in Buenos Aires. Spanish Bourbons attempted to bolster patriarchal power over marriage choice in the late colonial period by issuing the Pragmatic on Marriage in 1776.[4] In the Bourbon way of thinking, as economic concerns increased with the rise of capitalism, the position, power, and authority of the male head of household also increased. Family order insured societal order, and the family patriarch was the key to maintaining family order. An important element of this power entailed controlling marriages, and the pragmatic strengthened the patriarch in this regard. In Europe, then, individual freedoms increased with the rise of capitalism while in Latin America, at least in the case of marriage choice, the Bourbon version of capitalism increased patriarchal control and limited the freedom of couples to marry mates of their own choosing.

Then came independence in 1810. Evidence from the civil courts of Buenos Aires, especially the disensos, indicate that after independence, patriarchal power declined (though by no means did it disappear) rela-

tive to the colonial period, and children enjoyed more freedom to pursue their romantic desires.

The Road to Court

The road to court began with a familial conflict over marriage choice. The resulting court records are useful because they contain the stories, words, and ideas of parents, children, lawyers, and civil judges on the matter. Couples frequently told the story of how they came to be engaged and why they decided to take their case to court.

Mariquita and Martín's road to court was as long and arduous as a mule ride up the Andes Mountains. Mariquita's father was the first to make a major power play in the conflict. Through his political connections her father had the royal navy transfer Martín to Spain. Mariquita remained adamantly opposed to giving in to her parent's wishes that she marry someone else, and in response her father placed Mariquita for a short time in the Casa de Ejercicios (roughly translated as the "House of Spiritual Exercises"), a place of physical seclusion and spiritual meditation frequently used by parents to punish and persuade their wayward daughters.

Mariquita's father passed away in 1802, but any hopes that a parental reprieve was forthcoming evaporated in the face of her mother's heated persistence in opposing the union. Mariquita may have seen her mother as a weaker adversary, but whatever the case, when Martín returned from Spain, the couple took her mother to court on 7 July 1804. Martín recounted their now three-year odyssey of trial, suffering, and separation to the judge. A few days later, Mariquita lent her voice to the fray in a letter to the court. "For three years I have attempted through sweetness, love, and moderation, to at least gain my mother's permission, if not her approval, for me to carry out my honest and just desires. All has been in vain, and each day she grows more inflexible. Hence, it behooves me to defend my rights . . . my love, my salvation, and my reputation desire it."[5]

The judge ordered Mariquita's mother, María Magdalena, to justify her opposition. She answered that she did not oppose the general idea of her daughter getting married, but she could not support her proposed marriage with Thompson for a variety of reasons: her husband had felt so opposed to it when he was alive; Thompson was a close relative; he did not have the training to handle the family business; and she did not like his military profession. "I know that this marriage will not produce

the results that should be integral to a Christian matrimony," she added. Christian marriage, for María Magdalena, was one that promoted "harmony between parents and children" and not "the scandal and ruin of families that is so contrary to the holy ends of matrimony." If Mariquita had no other options to marry, if no other man was interested in her, she would not mind that she married Thompson. But as long as there were more desirable suitors lining up to court young Mariquita, "What reason would there be, what prudent magistrate would compel and constrain [a mother] to giver her consent?" The root of the problem was that Mariquita was "a young girl, gullible and inexperienced who allowed herself to become involved in the web of an astute and cunning pretender."

Martín responded passionately in defense of his honor and his intentions. "The sole consideration that this marriage has been in the planning for three long years, having survived the many attempts by her parents to derail it, should prove to your Excellency that it is not the work of cunning and seduction on my part or lack of experience on her part." Mariquita and Martín's pleas convinced the judge, who granted them permission to wed on 20 July 1804.[6]

Couples many times tried other tactics before deciding to go to court, as the following case of Antonio Garmendia illustrates. By December of 1825 Antonio had fallen desperately in love with Angela Tani, but her father, Luis Tani, refused to give the couple permission to marry. The conflict grew bitter and even burst into public view when Luis Tani insulted Antonio at the theater where the couple worked. The private family struggle was almost surely heightened by Angela's celebrity status: she was a well-known lyric soprano, originally from Italy, who had lead roles in opera performances in the city such as Rossini's *La Cenerentola*.[7] Perhaps it is fitting that Angela's love life would correspond with her vocation as a vocalist of romantic-era music. For, indeed, Antonio had formulated a daring plan that would rival any opera plot: in the dead of night he would sneak into the Tani's courtyard, scale the wall beneath Angela's window, rescue his beloved, and run away under the stars of the eternal pampa skies! On a dark summer night in 1825, Antonio put his plan in motion. He successfully scaled the wall, then reached for Angela's window. Freedom and happiness were only seconds away. Suddenly, his footing slipped and he slammed into the pane of glass. In horror and disbelief Antonio watched the glass careen toward the earth, breaking loudly in the courtyard. Their peaceful slumber interrupted, the inhabitants of the house rushed to see the cause of the raucous. They quickly

found a dejected Antonio perched on the wall, his plan shattered before his eyes.[8] Only after failing in this dramatic attempt to elope did Antonio and Angela seek redress in court, where, as will be discussed later, the plot thickened even more.

Romantic Love

Once in court, couples did their best to present a strong case by highlighting their desire to marry their partner of choice. While a reader might assume that a bond of romantic love existed between couples, the expression of love in disensos varied, and over time, seemed to become more explicit. Mariquita Sánchez referred to her love for Martín more implicitly in 1804. Her free will was to marry Martín "because my love, my salvation, and my reputation desire and demand it."[9] Later disensos contain more powerful declarations of affection. In 1824 Gabriel Casas explained that after he met young Eulalia de los Santos, "I found in her qualities that drove me irresistibly to love her. From that moment, I have tried make myself worthy of her love." As time passed, Gabriel remembered, "My aspirations were satisfied after I found out that she felt the same as I."[10]

Couples frequently wrote personal letters to each other, and later presented them in court as evidence of their free will. Many of those letters were attached to the records of the case and hence provide a direct window into the lives and loves of porteño families. In 1831 Carmen Figueroa wrote a letter to her boyfriend Toribio Fernández. Carmen's grandmother, in the role of matriarch, disapproved of the couple's proposed marriage and, as Carmen suggested in her letter, the couple's only hope was to seek help in Buenos Aires:

> Yesterday I was taken before the priest by my grandmother. I thought that this would bring an end to my pain, but it has only served to further torment me. . . . I am convinced that nothing can be done here. Since there is no authority here to protect us, if you love me, you must make the sacrifice and go to Buenos Aires to find some way to end our hardship. Do not worry about money, for I, your true love, have enough. Carmen Figueroa.

Though short, the letter is rich in detail and implication. As the letter indicates, Carmen and Toribio found no sympathy in the town of San Antonio de Areco where they lived. As is characteristic of rural areas, family connections with local political, and in this case, ecclesiastical

leaders, played an important role in family conflicts. While Mariquita Sánchez may have been inspired by her friend Father Azamor y Ramírez's espousal of free will in marriage, not all priests intervened on behalf of the free will of couples, and in this case the local priest actively supported the grandmother's opposition. It is also clear that Carmen did not take a backseat in her courtship. Not only did she urge Toribio to take action on their behalf, but she offered to provide material assistance if necessary. After hearing the case and taking some information about Toribio, the judge granted the couple permission to wed.[11]

Some letters were written by the person speaking in the letter, and those who could not read or write had to dictate their letters to someone who was literate. This situation left the door open to possible misunderstandings and outright manipulations, as seen in the following letters from Deidamia Cullar to her fiancé, Manuel Fernández:

> My Dearest Fernández,
> I have found in my mother a thousand obstacles to reaching the goal of our union by the bonds of matrimony. I authorize you to go to the pertinent authorities of this country and, counting on my good will, conclude this matter that has left me mortified, disgusted, and sad.
> Deidamia Cullar.[12]

Manuel went to court and presented his case powerfully. According to him, the union he proposed with Deidamia was a worthy one that would also benefit the development of the republic. Consequently, the mother's opposition was hurting the stability of the nation. Things took a quick turn for the worse, however, when Deidamia wrote another letter, in which she addressed Manuel as "Señor" (Mr.) instead of "My dearest."

> Señor Don Manuel Fernández,
> Having the misfortune to find out that you have committed a terrible deed of deception in making me sign a letter without me knowing what it contained, and as you have sought the ruin of my dear mother, I tell you that from this day forth, communication between us will cease. I have not given you authority to do what you have been doing. Try to forget me as I have done so with you. This is all I have to say to you. BSM
> Deidamia Cullar.[13]

The problems of illiteracy are evident in this case, but who was ma-

nipulating whom? Since Deidamia apparently could not read or write (the initials BSM are perhaps those of her transcriber), it is unclear how much she knew of either letter's contents. Did her fiancé Manuel not reveal the true contents of the first letter when he had her sign it? Did her parents make her sign the second letter without telling her exactly what it said? Another distinct possibility is that, regardless of the letters, Deidamia may have backed out of the relationship after witnessing the contention erupting in her family over the proposed marriage.

This seems to be a unique case, however, and no evidence exists to suggest that the feelings expressed in other letters and documents are anything but sincere. In a less controversial case, one suitor declared that his intended bride had "all of the attributes that bring happiness to a marriage." Through courtship, "I resolved to prepare her heart in a manner favorable to me, and obtain her will of promise concerning marriage." It soon became apparent that "we sympathized with each other, for we were both touched by the feelings of love and desired to join ourselves through the sacred rite of matrimony."[14]

Paternal Love

While couples championed romantic love, parents countered with their own love-based arguments for withholding their consent. As one opposing father remarked, "the tender love that all parents feel for their children cannot but protect them from all things that might be damaging and put them on a path of misfortune and disgrace."[15] Another father argued likewise. "Is it not right for a father to avoid by all means, if possible, a fatal disgrace that threatens [his daughter], which she cannot see because of her blind passion, her weak sex, and her lack of experience?"[16]

Parents based their arguments on time-honored patriarchal prerogatives that granted fathers extensive control over their children's lives. More specifically in the case of marriage choice, the royal pragmatics issued by the Bourbons during the late colonial period provided the legal basis for parental opposition. Since minors (until 23 years of age for women and 25 for men) were required to obtain permission from their parents to marry, age was at the heart of most disenso cases.[17] By law, a girl had to be at least 12 years old to marry but needed parental consent to do so. This legal detail frustrated Pedro Freyre, who hoped to wed María Isabel Caballero. Her father opposed on the grounds that she was only 10 or 11 years old. María testified that she wanted to marry Pedro and that her mother also favored it. Her father stood firm, however, and when

the judge ordered an examination of María's baptismal record, it showed that she really was only 11. The judge declared the dissent as rational and just, "in attention to the fact that the baptismal record shows that the girl does not have legal age."[18]

Although the minimum age of marriage for women and men was respectively 12 and 14 years, parents did not necessarily agree that marriage was appropriate at that age. Indeed, parents frequently thought that their older children were too young to wed if their proposed mate was unacceptable. In the following disenso case, Francisco de Ayala's father claimed that, at 17, his son was too young to take on the responsibilities of matrimony. Besides, his intended bride, Gregoria Miranda, was old enough to be his mother. Francisco's baptismal records revealed that he indeed was 17 years old. Despite the evidence against him (he did not even contest the large age discrepancy), Francisco hoped to sway both the judge and his father by telling them of the love and tenderness that had grown strong between him and Gregoria. This time, the plea of true love fell on deaf ears. The judge seemed to focus on Francisco's age and the fact that he was still in school. "In light of the decree of 10 April 1803" (one of the later modifications of the Pragmatic on Marriage), the judge declared the opposition "just and rational."[19]

As seen in previous cases, Roman Catholic baptismal records were vital in resolving many age-related disputes. Ideally, every baby was baptized soon after birth and the record of the baptism contained the date of the sacrament, the name of the child and its parents, whether the child was legitimate or not, and other related information. Frequently in disenso cases the different parties disagreed over the age of one or both members of the couple involved, and the judge would order a check of the baptismal records. Such was the case with Juan de Dios and his father. The father agreed to give his reasons for opposing Juan's marriage, even though the decree of 1803 did not require him to do so because his son was a minor. First of all, his son was only 16 years old, while his intended bride, Mercedes, was over 40. In addition, the woman was incurably sick. Juan responded that he was older than 16 and that Mercedes was not as old as his father claimed. He also told the court that he had some land on which he planned to plant some wheat to support himself. The court sent its doctor to check on the health of Mercedes and found that although she was sick, he "did not consider it dangerous," and she was healthy enough to marry. The status of the case rested on the ages of the couple. Church records revealed that Mercedes was baptized on 11 September

1790, making her 36, while Juan de Dios was baptized on 9 March 1811, making him 16 years old. The 20-year age discrepancy proved too great for the court, which sided with Juan's father in blocking the marriage.[20] In a similar case, Manuel Ituarte's brother was surprised that Manuel planned to marry, especially since he did not have the means to support a family. Furthermore, Manuel's girlfriend, Rosa Seguizamón, was far too old for him. Rosa was a "*señora quadragenaria*" who "had already finished the second third of her life while he had not even finished his first." In other words, Manuel was only 21 years old while Rosa was in her 40s.[21] The record of the case ended with the judge's order to consult baptismal records.

Parents frequently infused their age-based oppositions with arguments that emphasized the immaturity of their children. Parents juxtaposed the irrational romantic love of youth, along with its danger of short-term pleasure and fleeting passion, with their wiser paternal love that looked toward long-term happiness and the preservation of family honor. As one father argued, his daughter's tender age made her unable to apply "discernment and mature reflection regarding a matter of such importance, while her happiness or disgrace depends on the outcome."[22] As a mother, Petrona Rosende appealed to the judge's understanding of the ills of youth and passion. "Your honor understands that the first moments of indiscreet passion pass away and are followed by irremediable consequences." Petrona wondered how "honorable parents who have labored so hard to sow in [their] tender daughter's heart the most appropriate principles of education and morality" could allow her to marry into a bad situation. As far as Petrona was concerned, all those qualities would go to waste if her daughter married her prospective suitor.[23] In a similar case, José Sosa claimed that "the duty given me by nature" regarding "the future happiness of my son" inspired his opposition to his son Constantino's marriage to Juana Ferrer. If his son went through with his proposed marriage, Sosa felt that it would be "the origin of innumerable misfortunes and disgraces throughout the course of life." In addition, Sosa did not believe that Constantino felt "true love" for Juana. "True love," Sosa argued, was based on "appreciating the person," and not on passion.[24]

Other family members and guardians could also oppose marriages using rationalist rhetoric. When María Ignacia Cabrera opposed the marriage of her niece Lucía Varela, she spoke much like a parent. Having raised Lucía from her youth, María claimed that she, more than the

suitor, had Lucía's best interests and happiness in mind. She had given her niece a fine education and had loved her since birth. "But this same love, this desire for her good fortune, is what has driven me to oppose a marriage that diminishes her education, which is an affront to her lineage and compromises the honor of her whole family."[25] For Aunt María, true love was a rational decision that would preserve Lucía's social status as well as the family's honor.

We now return for a fuller account of the case of the ugly suitor to further illustrate the extent to which some parents went to exalt paternal love and patriarchal prerogative over romantic love. Since 1839 Gumesindo Arroyo had frequented the house of José Leon Canicoba, who had a daughter named Francisca. As time passed, Francisca later remembered, she began to have feelings for Arroyo. As she saw it, if Arroyo was worthy of coming into their home in the first place, then he was worthy of her affections. Francisca thought that she acted prudently as she pursued a relationship with Arroyo. "I did not endeavor to foment a passion without thinking of my family." In her eyes, Arroyo's good conduct did not represent a threat in that regard, and she was startled by her father's vehement opposition, something that was "very cruel" for her. Francisca felt as if she faced two choices: either take her case to court, or sacrifice her own happiness.[26] On 4 March 1842 she and Gumesindo initiated their suit against her father.

In court, Canicoba listed his complaints against Arroyo. First of all, he claimed that his daughter was only 14 years old and Arroyo was 40. Such age discrepancies were not healthy in a marriage, Canicoba argued, because "each generation has its inclinations or propensities," and the two are rarely reconciled. Besides the age difference, Canicoba had another major complaint: Arroyo was just plain ugly! His face was scarred over, and he had only one good eye. "It is not right for a father to give his young daughter, innocent and without any knowledge of the world, to an older man, ugly, with a cut up face, blind in one eye, and without any means to support her." Canicoba's alarm at Arroyo's scarred face may have a significance beyond just a statement on personal appearance.

Canicoba and others probably understood that Arroyo's scars may have been the result of the knife fighting that was so common in nineteenth-century Buenos Aires. Arguments and insults frequently escalated into armed conflicts between knife-wielding adversaries who used violence to negotiate and defend their position in the social order.[27] Perhaps Canicoba did not have the evidence to prove that Arroyo's scars

came from a knife fight. That Canicoba did not even argue a possible connection between the scars and criminal conduct may be further indication that knife fighting was not out of the ordinary in the rough-and-tumble world of Buenos Aires and its surrounding towns.

Whatever the origin of the scars, for Canicoba they still made Arroyo unfit to marry his daughter, even though for the moment she may have been enamored. "With time, passion turns cold, and the eyes become aware of what they cannot change. They compare things and realize the deception [of passion], and look on towards other more pleasing vistas . . . and seek out a new passion that damages the marriage." Canicoba believed that all of these reasons made his opposition just and rational. "Rarely does a father have such good causes as the ones I have."

Arroyo wasted no time in launching his own offensive. "It appears, your Honor, that Canicoba is proposing to turn this tribunal into a farce." First of all, Francisca's baptismal record revealed that she was really 22 years old, and Gumesindo was only 26, not 40 as Canicoba claimed. "And while I certainly don't have millions of pesos, I do have a little establishment of my own." Furthermore, Gumesindo continued, the "ugly" argument was simply absurd. "Your honor, I do not aspire to the title of handsome, but standing before your Excellency, Canicoba could not dispute the regularity of my features and figure." Gumesindo also took offense at the notion that, with time, Francisca's passion for him would die and ruin the marriage. "In effect he is insulting his daughter, denying her the potential of being a faithful wife." He reasoned that if the passion of romance diminished over time, so would the passion with what is ugly. Even if physical beauty declined with time, "the qualities of a faithful and good husband will engender loyalty" in a wife. Arroyo further argued that Canicoba had also insulted his own wife with his statements by questioning the ability of a woman to be committed to a man of less than princely appearance. As Arroyo put it, "[Canicoba] never was handsome. Nevertheless, his wife was always faithful to him." After Arroyo demonstrated that he had the means to support a family, the judge disregarded his apparently unsightly features and granted him and Francisca permission to marry.[28]

Evidence and Allies

While many children may have questioned the validity of parental opposition, evidence abounded in porteño society to feed parental paranoia. Divorce, scandalous behavior, and failed relationships were the kinds of

situations that many parents feared and hoped to prevent when they opposed a child's marriage. A civil suit from 1801 and 1802 provides a broad picture of what such a scenario would be like. In the winter of 1801, Pedro Camps y Amirola had fallen passionately in love with Dionicia Rey. But as Pedro moved toward marriage, he encountered stiff resistance from his guardian, Juan Rexach. Apparently, Rexach had observed signs of moral weakness in Dionicia's behavior and would not give his permission for the marriage. He warned Pedro that a marriage to her would bring "fatal results" to Pedro or anyone else who married her. Despite the opposition, Pedro took his case to court and won a disenso case, in which he obtained permission to wed against his guardian's wishes. In July 1802, Pedro and Dionicia were married.[29]

A few months later, Pedro was back in court. This time, instead of the determined and love-struck suitor, Pedro appeared as an abused husband. He charged that Dionicia had exhibited scandalous behavior that was tarnishing his honor and ruining his life. If things did not get better, he would have to seek a divorce. He recounted to the judge his sad experience. He admitted that despite being forewarned by his guardian Rexach, he had been "induced by a lack of wisdom and experience which is characteristic of youth." In only a short while, the prophesies of Rexach had come to fruition. Dionicia had proven herself uncontrollable. "In only three months Dionicia kicked me out of the house four times," Pedro complained to the judge. It seemed that Dionicia wanted to be married in name only while she "exercised her libertinage, shamelessly parading herself in public both night and day in the company of men of ill repute, debasing her marital status and her youth, and sending me to my grave with her antics." The results of Pedro's admitted folly of passion were devastating. He lost the support of his father, who was going to give him money to go into business with Rexach. He had also lost favor with Rexach himself by going against his will in the marriage. On top of it all, "my wife threw me out into the street, showing extreme ingratitude and tyranny." In all, Dionicia's behavior was inappropriate and scandalous. Pedro presented witnesses who testified that Dionicia walked the streets in bad company. Convinced by such testimony, the judge ordered that Dionicia be deposited in the Casa de Ejercicios, where she was not to be allowed to visit anyone until she went through the appropriate spiritual reform.[30] Regardless of the gender of the perpetrator of social improprieties, which in this case happened to be a woman, this type of scenario is exactly what caused many parents consternation.

Parents also had allies in the legal profession. As Fidel Cavia put it in his 1864 dissertation, "love imposes certain duties to fulfill, and rights to exercise, and the man has that love, and those responsibilities." [31] Cavia cited intellectual heavyweights from Europe to bolster his claims. Montesquieu wrote that since humans received reason in stages, children needed to be guided, not just fed, until they could guide themselves. Jeremy Bentham also argued that minors should not be allowed to marry under any circumstances, because they do not fully understand the meaning of the contract they are agreeing to follow. While Cavia sympathized with Bentham's view, he did not completely agree with the utilitarian. Minors can get married, Cavia insisted, but they needed parental guidance "to make up for the age deficiency, to save them from the ills of inexperience, and the mournful consequences of thoughtlessness." While Cavia provided this possibility for children, the whole point of his dissertation was that minor children who rebel against their parents' wishes in marriage can be legally denied their inheritance. The right to disinherit for this reason went back many years and was reinforced by the pragmatic of 1776. The pragmatic and its later refinements also granted children the right to dispute their parents' oppositions since the king understood that many parents would abuse their right, but the clauses that provided children recourse against unjust parental opposition did not state whether or not the disinheritance clause remained. One might argue that if an opposition was invalid, then parents would not be able to disinherit their children. On this matter, Cavia was a strict constructionist in that he interpreted the letter of the law: the law did not expressly say that disinheritance was prohibited in irrational cases; hence it was still legal.

Not only was it legal, but in Cavia's mind, it was the right thing to do. Disobedient children, he argued, push their parents to "the edge of death." If a parent were denied this right, what denigration would follow. "Behold, the repulsive spectacle that would convert a child into the accuser, dragging his parents, the authors of his life, before the courts of humanity." The judge has the right to grant the child permission to marry, but the law should leave the right to disinherit in place. "For these reasons I think the pragmatic has not lost its validity, as some have argued." Cavia continued by posing the question, "Does not the paternal consent spring from that tenderness with which they gaze upon their children? From that love that will never abandon them, from the vital caring for their preservation, education, and enduring happiness? This

is the purpose of parental consent. . . . Let us not make patria potesdad the lowliest of rights!"

For Cavia, marrying without consent was worse than many other crimes, and he even equated it with an attempt to murder one's own father. "It may appear illusory to argue that I see it as an attempted homicide: physical blows to a victim are not the only types of blows that can produce death. Rejected affection, offended fondness, and repudiated love burden the soul, extinguish the will, place man on the edge of his existence, and finishes by making him disappear." Cavia conceded that some fathers "use their power to oppress their children in order to preserve some money to line their pockets. But the actions of some unnatural fathers should not condemn the majority of innocent fathers who act out of more noble sentiments."[32]

Cavia's dissertation laid out some of the basic views of parents and their sympathizers in disenso cases. Cavia's work also provides insight into intellectual and juridical debates regarding the continuing validity of colonial laws such as the pragmatic, debates that are not as visible, or at least not clearly articulated, in the actual court cases themselves. Clearly, some lawyers and jurists considered the old laws obsolete and in need of reform while others like Cavia preferred to maintain them. There did appear to be a consensus on the ideal and proper role of parents. No child, judge, or parent would argue that parents did not have certain rights over their children or that parents should not influence their children to choose wisely in marriage. Disagreements emerged over the extent to which parents were justified in wielding their paternal authority to influence a child's choice of a partner. Parents, children, and their lawyers then struggled to determine whether parental actions fell reasonably within the bounds of proper parenting. In the end, the judge decided.

Persuasion and Coercion

Armed with evidence of societal ills, and supported by legal and cultural traditions, parents combined their rational arguments with the art of persuasion as well as coercion to control their children's marriages. Their goals were to preserve family honor and status and to save their children from pain and suffering.

After breaking a window in his failed attempt to elope with the opera singer Angela Tani, Antonio Garmendia tried his luck in court. He told the judge that Angela's father always tried to control his children and was an "enemy to the marriages in his family." Antonio also accused

Angela's parents of beating her "with sticks and fists" (*a palos y puñadas*). Angela's father based his case on paternal authority and proper behavior, both of which he believed Antonio had violated. In court, Angela's father, Luis Tani, presented a diagram to the judge showing where Antonio had scaled the wall in his desperate effort to steal Angela away. Not only had Antonio blatantly disregarded the authority of a father who had forbade him from courting his daughter, but he also broke costly window glass. Mr. Tani had opposed the marriage in the first place because Antonio had no useful job with which to support a family. According to Tani, although Antonio claimed to be a hard worker, he lacked the means to be a contributing member to society. "Such marriages, instead of being useful to the country, are the plague of the republic, and cannot bring forth anything beneficial."[33]

When the judge tried to investigate Angela's feelings on the matter, her mother informed the court's messenger that her daughter was sick. Besides, the mother continued, it did not really matter because Angela did not want to marry Antonio anymore. The judge was clearly skeptical of the mother's claim because he sent an official police doctor to check on Angela's condition. Besides medical duties, the additional instructions to the doctor reveal what fathers were capable of: the judge instructed the doctor to inform Mr. Tani in no uncertain terms that Angela was under the express protection of the court and that he should not try anything violent or coercive to influence her views.

The judge also wanted his messenger to ask Angela if she had indeed written a disturbing letter that had come to the judge's attention. If she had truly written it, then there was even more reason to worry about Mr. Tani's violent behavior. The letter, which did turn out to be written by Angela, provided a key piece of evidence and was included in the court record. "I am ready and resolved to marry Antonio, as we have both suffered a thousand torments and more," Angela confided to her friend (it is unclear who the letter was addressed to). "I fear the wrath of my family," she continued. Angela also feared for the safety of her colleagues at the theater. It seems that Mr. Tani was blaming Angela's misbehavior on Mariano Rosquellas, a famed violinist, singer, and composer, who was the impetus behind many of the operas in Buenos Aires during the 1820s.[34] "My father thinks he is responsible for this marriage," and "if I leave the house, the first thing he is going to do is to take his pistol and shoot Rosquellas. It would pain me so if an innocent person had to suffer."

In the meantime, the doctor did find Angela confined to her bed, but he concluded that she suffered more from mental trauma brought on by her parents' mistreatment rather than from any physical infirmity. The doctor was convinced that Angela was a victim of her father's violence, and she deserved "all the attention of the tribunal." Heeding the doctor's counsel, the court placed Angela in a type of safe house, shielded from her father's influence. At liberty to speak her mind, Angela said that she had no freedom in her house and that her true desire was to marry Antonio. The actions of the parents along with Angela's testimony convinced the judge that Tani's opposition was irrational, and he granted Antonio and Angela the license to wed.[35]

Although the court granted parents the right to guide and persuade their children, it did not look favorably on outright coercion. Nevertheless, persuasion and coercion could be a successful tactic in getting children to back out of an intended marriage. Sometimes parental action was behind the scenes and invisible to the court. In these cases it can be assumed that at least a considerable amount of persuasion was going on, if not outright coercion. Alejo Queral may have come up against this phenomenon of persuasion and coercion. Alejo had worked hard in court to prove that he was a worthy suitor. However, after the case had been going on for over two months, to Alejo's great surprise, his fiancée wrote a letter to the court declaring that she no longer wanted to marry him. The court verified that the letter did indeed express the girl's will on the matter, and the case was over.[36] Did the young woman decide on her own not to marry, or did she give in to parental persuasion?

María Constancia Martínez claimed that "careful reflection" caused her to go back on her promise of marriage to Fortunato Rangel. Included in the case is her personal letter (see fig. 7), both poetic and devastating, breaking the news to her fiancé:

> My dear Sir:
> Reflecting with maturity and good sense that I am not the woman that nature has destined for you, I thank you and give thanks for the love you have shown me. I no longer wish to marry and I give you complete liberty from me to seek another woman. And I plead with you to do all you can to avoid even passing by the door of my house.
> From your ever grateful
> María Constancia Martínez[37]

Fortunato was astonished when he heard news of the letter. Before the judge he declared that "I cannot convince myself, for now, that [the letter] is dictated, nor is it the voluntary product of her that is claimed to be its author." To assure that no foul play was involved, Fortunato asked the judge to separate María from her parents to see whether she really wanted to marry him or not. "If it turns out that she answers affirmatively, ask her if she wrote the letter, and who persuaded or forced her to write it. If her answer is negative, this case will be ended, as it will be without purpose." Granting Fortunato his wish, the judge summoned María to court. She testified that indeed she *did not* write the letter. The vindication that Fortunato must have felt the moment he heard those words was probably as sweet as it was fleeting, for María continued that although she herself did not write the letter, her sister had written it, with permission, and it expressed María's will on the matter. A dejected Fortunato, as promised, dropped his case.[38]

Although María only admitted to having a "careful reflection," other women openly acknowledged that they were backing out of their marriage commitment because they preferred not to continue against the will of their parents. When Francisca Méndez explained her reasons for opposing the marriage of her daughter Pilar to Francisco Ramallo, she claimed that the court needed no explanation because Pilar had changed her mind. Pilar admitted that she had given her word in marriage, but that she no longer wished to marry because she had "decided to please her parents, who did not approve of it." She added that she had already informed Francisco of her decision.[39]

Sometimes parents asserted that their child had a change of heart on their own and not as the result of paternal pressure. The parents of Nicodemas Gonzales told the court that even though they disapproved of their daughter's proposed union with Felipe Leyba, they would allow her to marry if it was her will to do so. Nicodemas later testified that she had changed her mind about marrying Leyba "because she would rather please her father." Perhaps upon reflection, she changed her mind by herself, although the possibility that her parents forced her to recant cannot be dismissed.[40]

While some cases do not reveal the extent of parental persuasion, when couples continued to question and resist opposition, parental pressure and coercion became even more evident. When Andrés Oporto and Felisa de Campos were planning their wedding in 1830, her father Gregorio was strongly opposed, for he felt that Andrés did not have the

resources to support a family. Undaunted, Andrés challenged de Campos in court, claiming that he did have the means to support a family. On 6 August 1830, Felisa's mother, Paula Buseta, appeared before the court and testified that her daughter no longer wished to marry Andrés. With Felisa conspicuously absent, her mother assured the court that her daughter had acted under her own free will and not in fear of her father's threats. For the moment, the court apparently set aside the mother's claim and proceeded to hear witnesses. After another witness confirmed the good character of Andrés, the judge declared the parents' opposition irrational. Prospects looked good for the hopeful pair.[41]

On October 2, however, Felisa's mother again showed up in court, this time bringing Felisa with her. She restated that her daughter no longer wished to marry Andrés. Wary of parental coercion, the court took Felisa to a separate room and urged her to freely express her will on the matter. Asked if she still wanted to marry, or if "by her own free will she had decided against it, and not out of fear or pressure from her parents," Felisa replied that she had "resolved not to marry against the will of her father." With the girl's personal will thus expressed in private, the court could do nothing but honor her statement.

Andrés, meanwhile, did not keep an idle watch on these affairs. He told the judge that Felisa was acting out of fear because her father had threatened to throw her in jail if she persisted in challenging his will. Sensing the urgency of the matter, the judge deposited Felisa in a safe house, then brought her to court alone and assured her that she was under his protection. This time, Felisa happily exclaimed that her true desire was to marry Andrés. Thus the case finally came to a close with an approval from the judge.[42]

Daring Strategies

Outside of court, children had additional strategies to achieve their romantic desires. Indeed, the persistence of a couple seemed to have a direct correlation to their success. As seen in many cases, one strategy was running away together either before or after going to court. By being a little daring, Celestina Suparo overcame the rational opposition of her mother, Bárbara Banavente, who objected to Celestina's proposed union with Felipe Butes. During her testimony, Doña Bárbara spoke of how hard she had worked to educate her daughter. She did not necessarily want a rich husband for Celestina, but she did want "an honorable mate, capable of supporting her," especially since she had another daugh-

ter who had "married very badly." Butes, she continued, did not make enough to support a family. The judge agreed in this case and ruled in favor of the mother. However, Felipe appealed to the judge, claiming that he did have the means to take on familial responsibilities. In response, the judge called Bárbara back to court. She returned and informed the judge that Celestina had fled the house where she was staying. Bárbara feared that her daughter and Felipe may have been together, and, as a result, she now felt that it would be better if the couple married.[43] By running away together, the couple in essence compromised their honor because it was assumed that they had consummated their relationship. The only way to repair the family honor, at least for Bárbara, was for Celestina and Felipe to marry.

In a similar case, although a judge had already upheld Manuel Melo's opposition to his son Jacinto's marriage, Melo had to seek further legal assistance against his rebellious son. Disregarding both legal and paternal authority, Jacinto moved in with his girlfriend Juana Correa and, according to his father, had given himself up to all kinds of "corruption and prostitution." In his own defense, Jacinto maintained that he was over 25 years old and beyond his father's jurisdiction. Efforts to find his baptismal records in the parish failed, however. Jacinto overcame this lack of evidence by producing witnesses, including his uncle, who testified that he was over 25 years old. The judge then reversed the opposition and allowed Jacinto to marry Juana.[44]

Occasionally parents would voluntarily retract their opposition, some because of resignation while others were simply not fully committed to sustaining their dissenting views in court. When the court summoned Francisco Génova to give his reasons for opposing the marriage of his daughter, he replied that he was too busy to come to court. He added that if his concerns about the boy's laziness, questionable birth, and lack of the means to support a family did not convince the judge, he would defer to the court's judgment.[45] Other times parents might back out after resolving their doubts about a child's marriage. Pedro Nolasco Pereyra had heard that his daughter's suitor, Juan Carlos Torres, came from a family of inferior blood and would not agree to the union unless Juan proved his Spanish ancestry. Later, after hearing witnesses on the matter, Pedro told the court that "having been well informed of the good conduct and manners of Juan Carlos Torres, he desists from his previous opposition to the marriage."[46] Had these and the other couples not dared

to question paternal authority, they would not have been able to pursue their matrimonial desires.

A Forbidden Love and the Legacy of a Dictator
No discussion of romance would be complete without considering perhaps the most famous clash between romantic and paternal love in nineteenth-century Argentina: the story of Camila O'Gorman, daughter of a wealthy porteño family, and Ladislao Gutiérrez, a Roman Catholic priest. Their story is even more interesting because it took place during the governorship of Juan Manuel de Rosas, and his involvement in the case presents an additional powerful party, essentially the head of state, in what otherwise may have been just another love affair played out between parents, children, and perhaps local civil or ecclesiastical tribunals. Rosas' fateful decision of how to handle the case has been used as stark evidence of the brutality of his dictatorship, an affirmation of the violent crimson motto emblazoned on official documents of the Rosas government: "Long Live the Federation! Death to the Savage Unitarians!" What can their story tell of life under the Rosista government? What can the case of Camila and Ladislao reveal about romantic love in the nineteenth century? To this tragic story one can draw comparisons with other cases of couples who defied their parents' wishes regarding marriage and see how they reflect on the Rosas regime and the development of the Argentine nation.

Camila's Irish grandfather had come to the River Plate region as a doctor during the late colonial period.[47] Camila had a privileged upbringing and most likely knew how to play the piano as well as take part in other appropriate female activities. Some of her biographers paint her as a passionate and romantic youth who stalked the bookstores of the capital looking for the latest novels to read and piano compositions to play. Her counterpart in the tragedy was Ladislao Gutiérrez, a young priest from the province of Tucumán. Ladislao was the nephew of the governor of Tucumán, a staunch supporter of Rosas. Thus the young priest arrived in the capital with the highest of recommendations, was well received, and soon had a parish in Socorro—an area of town with a good number of English and Irish residents, among them the O'Gormans. The O'Gormans frequently held *tertulias* (literary salons) in their home, and Father Ladislao Gutiérrez was always invited. Between meetings in the O'Gorman home and encounters at church, he and Camila had ample time to meet and fall in love. But there was no future for a priest and the

daughter of an elite family. Granted, many a priest had trampled his vows of celibacy with women, but such priests and their partners were not as well-connected as either Camila or Ladislao. The couple understood this and finally decided to elope and start a new life together.

On 12 December 1847 they ran away to the province of Corrientes, where they set up a school under the names of Máximo and Valentina Desan de Brandier. News of their flight hit the port city like a bombshell, and when Governor Rosas heard of their escapade, he expressed his rage to a confidant: "I am not so naive as to be surprised by the scandals of the clergy. But what I cannot permit or tolerate is their disrespect for authority—that they laugh at and ridicule it. . . . I will find them, even if they hide under the earth, and I will make them an example of warning: I will shoot them wherever I find them." It did not help matters that the exiled liberals in Uruguay and Chile used the scandal to criticize the lack of morals in the Rosas dictatorship.

Camila's father was also greatly offended by her decision and made his indignation known to Rosas himself in a letter dated 21 December 1847:

> Long Live the Argentine Confederation!
> Death to the Savage Unitarians!
> Buenos Aires on 21 December 1847
> Most Excellent Senor:
> I take the liberty of addressing Your Excellency by means of this letter, to raise to your Superior understanding the most atrocious act ever heard of in this country; and convinced of Your Excellency's rectitude, I find consolation in sharing with you the desolation in which all the family is submerged.
> Most Excellent Señor, Monday the sixteenth of the current month I was advised at La Matanza (where I reside) that my youngest daughter had disappeared; I instantly returned and have learned that a clergyman from Tucumán named Ladislao Gutiérrez had seduced her under the guise of religion, and stole her away abandoning the parish on the twelfth of this month, letting it be understood that in the evening he needed to go to Quilmes.
> Most Excellent Señor, the preparations he has made indicate that he is heading inland, and I have no doubt he will cross into Bolivia, if possible, since the wound that this act has caused is more for my unfortunate family, and the clergy in general; consequently,

he will not feel secure in the Argentine Republic. Thus, Señor, I beg Your Excellency to send orders in every direction to prevent that this poor wretch finds herself reduced to despair, and, understanding that she is lost, she may rush headlong into infamy.

Most Excellent Señor, that my presumptuous letter may find you at Luján, and the state of affliction in which I find myself, compel me to bring to the attention of Your Excellency these descriptions of the fugitives. The male individual is of average build, thin of body, *moreno* in color, large brown eyes that bulge somewhat, curly black hair, a full but short beard of twelve to fifteen days; he has two woven ponchos, one black and the other dark with red stripes, he has used them to cover pistols in his saddlebags. The girl is very tall, black eyes, white skin, chestnut hair, thin of body and has a front tooth that sticks out a bit.

Most Excellent Señor, deign to overlook the style of this letter. Your Excellency is a father and the only one capable of remediating a case of transcendental importance for all of my family, if this becomes public knowledge.

All of them add their pleas to mine, to implore the protection of Your Excellency whose humble servant is Adolfo O'Gorman[48]

Whether the governor had already heard about the couple's escape or not, it appears that Adolfo O'Gorman thought he might be breaking the news to Rosas. O'Gorman also lays the blame for the scandal at the feet of the priest Ladislao and not with his daughter. It was quite common to fault the man in these situations and to argue that the woman was somehow blinded and deceived. Camila may have disagreed with the idea that she, and other women, did not exercise agency in the affairs of love. Or perhaps it was too painful for families to admit that one of their daughters would follow such a course of action willingly. In any case, it is probably true that Adolfo O'Gorman did not anticipate the horrible sentence Rosas would later impose.

While the inner dynamics of Camila and Ladislao's decision to flee may never be known, what is evident is that the arm of Rosas was long, and eventually Ladislao was discovered at a party in Corrientes by Father Miguel Gannon, ironically an Irishman, who recognized his wayward coreligionist. In María Luisa Bemberg's popular film *Camila*, Father Gannon confronts Ladislao with the ominous statement that "the arm of God reaches everywhere. How long did you think you could

continue to escape? He does not forget those whom He has chosen. It is not by coincidence that I am here in this remote village."[49] The couple was taken into custody and soon was on the road back to Buenos Aires.

As word of their capture spread, many friends and acquaintances lined up in defense of Camila. Rosas' own daughter, Manuelita, wrote Camila that she had pleaded her case to her father. Rosas' sister-in-law, María Josefa Ezcurra, also wrote Rosas a letter in which she urged the governor to be merciful. Like Camila's father, Ezcurra placed responsibility squarely on Ladislao's frocked shoulders. "You should remember that she is a woman who had been lured into forbidden paths by someone wiser than she." Camila's family should shoulder much of the blame, she continued, since they exhibited "gross neglect in permitting this relationship to occur. Now they have nothing to do with her."

For a time it appeared that Camila was going to be placed in the Casa de Ejercicios. Police went to the institution and arranged for her arrival, and even ordered a piano to be put in her room and made sure that she would not be subjected to the religious rigors of the Casa. Nevertheless, Rosas ordered that the couple be taken straight to Santos Lugares and shot. Some accounts reported that Camila was pregnant, but Rosas supposedly ignored the news and let the orders of execution stand. When the Catholic Father Castellanos visited Ladislao, the captive priest wanted only to hear of his beloved Camila. "Why do you want my lips to tell you of the fate of that unfortunate soul?" Father Castellanos implored. "Forget about it and think of yourself. These passing moments should not be lost." But Ladislao insisted, and Castellanos relented: "Prepare yourself for the most terrible tidings: Camila will die as well." Ladislao then penned his final letter to Camila. "My dear Camila, I have just learned that you will die with me. As we have not been able to live together on earth, we will be united in heaven before God. I forgive and embrace you, your Gutiérrez."

On the morning of August 18th, the couple was led blindfolded to the place of execution. As they waited for the order to fire, Camila called out to her lover. "Are you there Gutiérrez?" "Here I am, Camila, and my last thought will be of you." "Merciful God, I will die with him." The English writer John Masefield later described the final scene in an epic poem:

So in the dawn, the drummers beat the call,
And those poor children, wakened to be killed,
Were taken out and placed against a wall

Facing the soldiers, then the bell was stilled
That had been tolling, and a minutes space
Was given for their farewells and last embrace . . .
Then hand in hand they faced the firing squad . . .
Who shot them dead into their waiting graves.[50]

The shots that felled Camila and her lover echoed throughout the country and abroad. The exiled opposition deftly used the execution to their advantage. Whereas Camila and Ladislao's original sin gave the exiled muckrakers opportunity to point out Rosista degeneracy, the couple's execution became a rallying cry against the renewed evidence of Rosas' brutality.

For his part, Rosas never doubted the decision. Even in his later years in exile in England, he recalled how he alone made the choice to execute the couple. "No one advised me to execute the priest Gutiérrez and Camila O'Gorman, nor did anyone speak to me on their behalf. On the contrary, all the leading members of the clergy spoke or wrote to me about this insolent crime and the urgent necessity to make an exemplary punishment to prevent similar scandals in the future. I thought the same. And as it was my responsibility, I ordered the execution."

Rosas did take an interest in many of the legal details of his administration, sometimes even passing judgments on issues himself, and this seemed to be one of those instances.[51] In this case, Rosas paid a high price as opposition leaders used the execution to foment anti-Rosas sentiment. One observer even argued, "It would have been better for Rosas to have lost a battle than to shoot Camila."[52] According to one biographer the act sealed Rosas' reputation as "one of the cruelest of rulers as well as one of the most powerful," this despite evidence that Rosas actually had been getting less violent in the years preceding the execution. His dreaded henchmen, the *mazorca*, had been disbanded two years earlier, and the number of executions had dwindled as well. But the execution made people fear that Buenos Aires would again suffer under a reign of terror.[53] Rosas could not have known the magnitude of the reaction to the killings, perhaps even at the time, but surely not of the long-term historical impact. As one historian has noted, "Rosas could not elude the inevitable and poetic consequence of his decision: her death would give birth to a legend. As opposed to love-struck girls, legends bring with them the delicious taste of eternal life."[54]

The legend of the brutal Rosas did live on, and continues today. He

has been depicted as a conservative reactionary to the revolutionary ideals of the May Revolution, a throwback to the paternal populism and authoritarianism of the colonial world.[55] Camila's story fits this picture well. While legends do have a certain longevity, it is clear that the Camila case was a sensational one. What of other cases of forbidden love during the Rosas regime? Did conservatism and reaction permeate the legal establishment during the Rosas regime? Did it penetrate every home? One might guess that the court records would reflect a certain amount of heavy-handed patriarchy and conservatism, at least when compared to those of the more liberal era of the 1810s and 1820s. The evidence suggests otherwise. There is no visible break between the liberal period of the 1820s and the Rosas regime of 1830–52. In fact, the trends that began with independence continued into the Rosas period. Women questioned patriarchal authority using Enlightenment rhetoric. Children continued to forcefully challenge their parents' will concerning marriage. This is not to say that Rosas did not rule with an iron hand or that he does not deserve much of the criticism that has been leveled against him, but it suggests that examining different aspects of life during the Rosas era might reveal a more complex picture.[56]

The Courts Decide

Governor Rosas did not make the decisions in most marriage conflict cases. That duty was left up to the judges in the civil courts. The position of the courts in the struggle between romance and reason can be interpreted by examining the discourse of the judges in the various cases as well as their final rulings. In some cases, it is clear that judges sympathized with parental views. María Cépeda's mother opposed her marriage to Plácido Velázquez because the latter was an unsavory character. When the couple went to court, María's mother stated that "seeing the stubbornness of my daughter in wanting to proceed with the marriage, . . . I promised to give her my permission." The judge commented on the mother's opposition, stating that it "had proceeded from that love that is so natural among fathers and mothers, which obliges them to seek out the best qualities of morality and industry in those persons who will bring happiness or disgrace to their daughters." The judge concluded that in this case the mother's opposition was more of an admonition to think before acting rashly.[57] Regardless of the outcome of the cases, the judges in these civil disputes placed a high premium on maintaining harmony in the family.

Other times, the judge demonstrated more overt support for parental views. One of the most prominent judges of the time, Manuel Antonio Castro, believed that many unions were caused by "youthful passion, often impetuous and indiscreet."[58] Juliana Gómes believed likewise regarding her daughter Candida's relationship with José Merchante. Juliana simply could not "look with indifference upon the fatal results" that would surely beset the young couple because of their age. She offered to reconsider her opposition if the couple would wait at least one year, "so that they can think about it more clearly" and have a better idea of the firm foundations on which to build "a perpetual union throughout their lives." To the judge, this seemed like a reasonable alternative to a hasty marriage. He asked Candida if she would consider giving her mother filial respect and honor her request of waiting to get married. Candida's firm response displeased her mother and perhaps even the judge. She could not wait and wanted to be married immediately. The judge obliged her, even though he clearly sympathized with the mother.[59]

While judges sympathized with parental worries on one level, an overall analysis of the judgments in the disenso cases shows that children were gaining more freedom to pursue their romantic interests. Judges after 1810 commonly disregarded the Bourbon innovations of the late eighteenth century regarding marriage choice and favored the free will of couples over patriarchal authority. During the late colonial period, children won in 64 percent of the cases. Post-independence courts, however, ruled in favor of the children in 86 percent of the cases.[60] It is significant to note that children won a majority of the cases in the late colonial period. The difference of more than 20 percent becomes more significant, however, if one accepts the notion that the Bourbon Pragmatic on Marriage strengthened parents against their children in the late colonial period.[61] The post-independence change, then, indicates not only an increased sympathy for children against their parents, but also a *directional shift* of power away from the parents in marriage conflict cases. Marrying for love was becoming more of a reality for porteño couples. As one English observer in the early nineteenth century noted, he and other "compatriots who have married for love understand that religious formalities have little meaning."[62] Although he spoke from the perspective of an Englishman, the disenso cases show that he had passionate Argentine cohorts in his romantic sentiments.

While disenso cases show that patriarchal power over marriage choice was declining (though not disappearing) in the early to mid nineteenth

century, further evidence of the weakening of patriarchy came from contemporaries who observed and lamented it. For some porteños, the weakening of patriarchal power seemed to be eroding the very foundations of porteño society by attacking the traditional family structure. Father Francisco Castañeda lamented that because of the revolution, "children are not punished, because the child is subject to his parents only in terms of being provided for; but when they are grown, parents are forced to make an alliance with their children so that the latter do not beat them down because of the terrible upbringing they received. Another result of that attitude is a general spirit of rebellion."[63] One woman suggested, "If we wish to be happier in the forthcoming decade, let us whip our children without pity whenever they fail to conduct themselves correctly and as good Christians."[64]

Conclusion

Romantic love, long esteemed by passionate youth, gained new ascendancy over patriarchal authority in the revolutionary era in Buenos Aires. The ideals of freedom and equality espoused by liberal porteños throughout the nineteenth century had direct bearing on freedom and romanticism in marriage.[65] The increased contact with Europe after independence may have also "softened" the more rigid aspects of Iberian-Argentine society, namely, the idea of an absolute patriarch.[66] Of course parents still had a powerful say in what went on in their children's lives, but a notable shift had occurred. One patriarch advised a young suitor to seek love but in a prudent fashion: "Marry for love. But do not marry a woman, however attractive she may be, if she does not belong to your own circle or possess your own culture."[67]

Toward the end of her life, Mariquita Sánchez also sensed this shift in porteño culture and life. At the request of a friend, Mariquita wrote her *Recuerdos del Buenos Aires Virreinal*, a memoir that touched on numerous aspects of porteño life in the late colonial period. Her epochal romantic struggle to marry Martín Thompson caused her to reflect on how things had changed since the early 1800s. Mariquita at once recognized that romantic love was much more acceptable by the 1860s while at the same time placing her struggle as a precursor to those changes. The change is evident in Mariquita's own writings. In the letters she wrote during her disenso case in 1804, she only mentioned the word "love" one time, and in the same sentence with other subjects (that she needed to marry because "my love, my salvation, and my reputation

desire it"). In her memoirs, she mentioned the topic much more pas-
sionately. During the viceroyalty, Mariquita recalled, fathers arranged
many marriages. "To speak of the heart was a devil's lie to those people."
Women resisted parental meddling, but that frequently meant joining
convents instead of marrying someone who inspired aversion instead
of love. "Love! A scandalous word in the mouth of any young woman.
Love was persecuted. Love was seen as a deprivation." Speaking from
the 1860s, however, Mariquita saw something new. "Oh youth of today!
If you only knew of the suffering of the youth of yesteryear, you would
know how to appreciate the happiness you enjoy! [68] Without denying
that Mariquita may have been waxing nostalgic in her *Recuerdos*, she
clearly saw a change in the times. The increased freedom to marry that
Mariquita fought so hard for also had a direct impact on another old
issue: interracial marriage.

5. *"The Purity of My Blood"*
Attitudes toward Interracial Marriage

Lorenzo Barbosa could not believe what his daughter Josefa was contemplating. In early 1821 she had fallen in love with Pascual Cruz, a mulatto. For Lorenzo such a relationship was out of the question, for he and his family were white. When the couple asked his permission to marry, he expressed his revulsion by exercising his paternal right to withhold his consent. In return, Josefa and Pascual exercised their right to take Lorenzo Barbosa to court. In court Lorenzo invoked the royal Pragmatic on Marriage to support his contention that Lorenzo was unequal to his daughter. Pascual, on the other hand, claimed that Lorenzo's argument of racial inequality was "irrational" and should be dismissed by the judge. Three witnesses appeared before the judge, and each one confirmed that Pascual's father was a mulatto, thus confirming the young suitor was indeed of African descent. The judge pressed further. How was Pascual's moral conduct and behavior? The three witnesses praised him on all counts. The judge then asked Josefa what she wanted to do. She was eager to marry Pascual. After considering all the information, the judge overruled Lorenzo's opposition and granted the couple permission to marry.[1]

In addition to revealing attitudes concerning romantic love, disensos are a useful tool to examine attitudes about race in Buenos Aires, especially since race was a major factor in many parents' opposition. Lorenzo's prejudice was not uncommon in Buenos Aires in the late eighteenth and early nineteenth centuries. The idea of *limpieza de sangre* (purity of blood) had a long history in Buenos Aires and Hispanic America in general and was especially prevalent in the middle and upper classes. In disenso cases from the late-colonial period, racial inequality was the most frequent reason used by parents to oppose their children's marriages, and the parental success rate in these cases reached as high as 50 percent.[2] However, colonial attitudes about interracial marriage

did not continue unabated after the May Revolution of 1810. A comparison of disenso cases like Pascual and Josefa's from the late-colonial and early-national periods reveals that after independence in 1810, interracial couples had a *greater measure* of freedom to marry than did their late-colonial counterparts. While parents won in 50 percent of the cases in the late eighteenth century, their success rate dropped to 20 percent after independence when they used the race argument.[3] In the early to mid nineteenth century, economic factors replaced race as the main concern for parents. The state also sought to facilitate marriages that would be economically stable. This is not to say by any means that racial discrimination disappeared in this or other areas of social relations. Parents, especially from the elite, could still win disenso cases based on racial inequality well into the nineteenth century, though such victories were less prevalent over time. On the national level, many Argentine leaders and intellectuals had the racist goal of "whitening" the country, which led them to marginalize and even erase the presence of Afro-Argentines in the country's history and identity.[4] Disensos, then, provide a welcome resource to further examine the role of Afro-Argentines in Buenos Aires and how nineteenth-century Argentine leaders struggled to build a nation from a socially and racially heterogeneous population.

The Racial Question in Late-Colonial and Independence-Era Buenos Aires

The issue of race, especially in terms of the Afro-Argentine population in and around Buenos Aires, is a controversial subject. In the past many Argentine historians have ignored or downplayed the contribution of blacks to Argentine culture and development.[5] In recent decades, however, historians in and outside of Argentina have begun to piece together the role of African influence in Argentina.[6] What is clear is that, in the nature of its population, Buenos Aires was unique when compared with the other great metropolises of the Spanish empire. According to the censuses, the population in Buenos Aires in 1810 consisted of 70 percent whites, 30 percent blacks and mulattos, and only about .5 percent Indians and mestizos.[7] As might be expected from their numbers, Afro-Argentines were integral to the city's economic well-being, and among their numbers were many highly skilled artisans. One foreign visitor to the city commented that perhaps part of the reason that blacks were so essential to the economy was that the Spaniards were so lazy.[8]

Apparently, the number of blacks in the population and their eco-

nomic success aroused fears among the white population of racial mixing and the subversion of the traditional social order. Those fears extended to the Spanish Crown as well, which issued the Pragmatic on Marriage to strengthen parental control against "unequal" marriages. While the pragmatic did not specifically define "inequality," racial difference was perhaps the major concern.[9] The new law, then, bolstered existing prejudices against blacks, mulattos, and the poorer classes.[10]

The May Revolution provided a political and social context for patriots and reformers to apply Enlightenment ideals of natural rights and equality. In 1812, for example, Bernardo de Monteagudo urged his readers to shed all vestiges of colonial oppression that had bound them. "Only the holy dogma of equality can protect mankind from the distinctions, many times damaging, that nature, fortune, or anti-social traditions have placed among them. . . . Oh liberty, when will I see your throne rise above the ruins of tyranny?"[11] While many such statements were mostly symbolic—for even most reformers were not advocating a complete transformation of society—revolutionary juntas did enact several progressive reforms dealing with socioracial relations. In 1812, a government decree officially abolished the slave trade (although this ban was subverted). The 1813 Law of Free Birth assured that children of slaves would be born free, thus sounding the eventual death knell of slavery. Manumission also became easier and more common.[12] One of the most liberal reforms was the 1821 law that declared universal male suffrage, which significantly increased voting rights in Buenos Aires and other cities, much to the chagrin of conservative critics.[13] In the military, black officers were recognized as equal to white officers of equal rank. The military in general provided a mechanism of social mobility for Afro-Argentines, who flocked to the army as a way to achieve freedom from slavery or to boost their social position.[14] Indeed, soldiers' wages during the wars of independence and the civil wars that followed provided welcome income to the lower classes, including the many Afro-Argentine servicemen.[15] In addition, ethnic associations such as the Naciones Africanas (African Nations) were organized and became increasingly active in providing social and cultural benefits to their members.[16]

These "nations" gained strength during the rule of Juan Manuel de Rosas (1829–52). Rosas made special efforts to recruit the support of Afro-Argentines, his wife maintained contact with leaders of different Afro-Argentine groups, and his daughter Manuelita was even known to participate in Afro-Argentine dances. The official mouthpiece of the

Rosas government, *La Gaceta Mercantil*, praised Afro-Argentines as "valiant defenders of liberty who have won fame and glory in a hundred battles," adding that "General Rosas so appreciates the mulattos and morenos that he has no objection to seating them at his table and eating with them."[17]

In other respects, however, the persistence of racism against Afro-Argentines, Indians, and gauchos showed regrettable continuities with the colonial past. When news of patriot victories arrived in Buenos Aires from the interior, reports of the heroics of the "gaucho" were edited by porteño newspapers. In place of "gaucho," editors substituted "*campesinos patrióticos*" (patriotic country-folk). Since gauchos of this time were known to be of mixed European, black, and Indian blood, such deletions helped silence the contribution of these ethnic groups in later history and memory.[18] Discrimination persisted in other areas as well. Integration did occur in the military, but only among white and Indian units. Afro-Argentines remained segregated.[19]

Despite their valiant service in the armed forces, many of the liberal elite would come to denigrate and ignore the presence of blacks in Argentina. This was especially true of the liberal unitarians exiled during Rosas' dictatorship. Of course they loathed Rosas himself, but they loathed the blacks even more for supporting him. The unitarians forgot that the Afro-Argentines had also supported the ouster of the English and, later, the May Revolution. For Esteban Echeverría, one of the main mouthpieces of the group of liberal intellectuals known as the Generation of '37, the Afro-Argentines' support of Rosas was a sign of their inferiority. In his short story *El matadero*, Echeverría portrays grotesque images of black and mulatto women awash in a sea of mud and blood as they bicker over the innards of animals at the slaughterhouse. For Echeverría and his cohorts, this mire of blood and filth characterized the barbaric nature of the Rosista government and its popularity among the masses.[20]

Nearly 100 years after Echeverría, another Argentine intellectual weighed in on Rosas and his loyal black supporters. In his *Cosas de negros*, originally published in 1926, Vicente Rossi was ahead of his time in recognizing the cultural contributions of Afro-Argentines. At the same time, however, Rossi revealed the persistence of racist views, as seen in his explanation of the origin of blacks in the world. Rossi first tried to explain why blacks existed in the first place, a puzzling question for Rossi and others since God made man in His own "white" image. He offered a

hypothetical addition to the creation story in Genesis to solve the puzzle. From the dark dust of the earth, God created man and woman starting with the feet and moving up. Before finishing the head, God gave His creations the breath of life. But before God finished the head and other final details, the couple ran off into the jungles, "still the color of the dust." There they multiplied, which is why, according to Rossi, blacks have perfect bodies, imperfect heads, and above all, black skin. God then proceeded to create the Adam and Eve of the Old Testament.[21] Turning to more recent matters, Rossi also portrayed Rosas as a scheming manipulator of Afro-Argentine loyalty. Rosas was raised among blacks, and he used them to "guarantee his personal defense and tranquility." He even used one mulatto known as Biguá as a type of court jester to entertain foreign visitors.[22]

Overall, Rossi recognized that whether it was at the hands of Rosas or the liberals who despised him, the Afro-Argentines suffered under the brutal yokes of servitude and ingratitude. The black race, according to Rossi, had suffered tortures of such savagery that even they, being savage, could not comprehend them. Furthermore, this torture came despite the many contributions the blacks had made to Argentine culture. "The white man shed the tears of the black man by teaching him to suffer; the black man shed the tears of the white man teaching him to laugh, leap, and dance. Still today the white man dances what the black man taught him."[23] Even though Rossi represented a view still bound by past prejudice, he offered a more sympathetic treatment of the African plight in the Americas. "[The African] has fulfilled his promises to all, but no one has fulfilled their's with him. All races are debtors to the black race." The whites had exacted an inhuman price from the blacks, who had given up their blood, their virtue, and their labor, all for what ended up to be a morally bankrupt civilization.[24]

The disenso cases also reflect continuity and change in racial attitudes. As the following cases demonstrate, after independence, parents continued to use the colonial Pragmatic on Marriage to rationalize race-based oppositions. In 1828, José Calleja and Marina García faced stiff opposition from her parents because José had African ancestry. In a letter to the court, Marina's father wanted to be sure that the witnesses testified that José was the son of Juliana Bennett, a parda and former slave. Before things proceeded much further, José decided to end his relationship with Marina and drop his case. According to José, his decision came after "wise persons" had convinced him that "duty" required that he desist in

his attempt to marry Marina.[25] Although some legal and social reforms may have given José and his fellow compatriots of mixed racial backgrounds new social status, his cultural "duty" was still mired, at least in this case, in traditional ideas of race relations.

The story of Juan Lamas and Justa Arnold reveals even more about societal attitudes toward race and class in marriage disputes. This story is set in the town of San Miguel del Monte in the early 1830s, located to the southeast of Buenos Aires amidst the vastness of the pampa (it was also the birthplace of Juan Manuel de Rosas). In 1833, Juan Lamas was working, probably as a ranch hand, for the son of Magdalena Arnold. As time passed, Juan developed an intimate relationship with Magdalena Arnold's daughter Justa. Juan later recalled that their relationship started out proper enough, but "eventually degenerated into carnal relations." Justa ended up pregnant. The couple hoped to marry, not only to symbolize their love, but also to legitimize their unborn child. But Justa's mother, Magdalena, vehemently opposed the marriage because her family was white and Juan was a mulatto. With their child's due date drawing near, and without hope of dissuading Magdalena from her intransigence, Juan and Justa decided to take desperate measures. On the night of 24 July 1833, under the cover of the cold, damp darkness of the pampean night, Juan saddled his horse, and the two rode out of town. They rode toward a horizon that, they hoped, would allow them a life together. The horizon of the pampas can seem endless, however, and even unreachable, and so it was for the young couple's hopes when authorities in the next town detained them and sent Justa back to Monte.[26]

Failing in their escape, Lamas pinned his hopes on the more mundane legal process. In court, he tried to focus on the welfare of his lover and their child, both of whose futures were now in jeopardy. According to Juan, Magdalena Arnold had prohibited her daughter from ever seeing him again; and to make matters worse, as soon as the baby was born, Magdalena was going to send it immediately to the Casa de Niños Expósitos (the house for abandoned children). Juan and others probably understood that sending the child to the Casa would be a virtual death sentence. Child mortality rates in nineteenth-century Buenos Aires orphanages, where many abandoned children ended up, usually hovered around 50 percent and could rise as high as 70 percent during some years.[27] Faced with the prospect of losing his companion and their unborn child, Juan persevered in his appeals. "Is the power of a capricious

mother enough to block a union that the laws, religion, and the honor and happiness of two unfortunate souls clamor for?"

After the baby was born, Justa tried to insert her self-described "feeble voice" into the fray in a letter to the judge, in which she promised to deliver a version of the story much different from her mother's. "My firm and spontaneous will is to marry Lamas," which desire should be strengthened "by the consideration that I have given birth to Lamas' *hijo natural*" (natural child). Justa was referring to the hierarchy of illegitimacy that dated back to the medieval Spanish law codes. [28] "Natural children" did not carry the same social stigma as children that came from adultery, incest, or a child from a union with someone from a religious order. Natural children could become legitimate if their parents married. [29] Justa's predicament made marriage to Lamas absolutely necessary, for she saw it as the only avenue to "restore my honor and give me the chance to marry, which would be difficult for me to do otherwise." Marriage to Lamas was her best opportunity to establish any semblance of a normal life. No marriage meant that her honor, and that of her family, would be forever tainted.

But Magdalena Arnold did not flinch in the face of these sentiments. For her, Juan Lamas was a lazy mulatto, completely "unworthy of all social consideration" and unfit to marry her daughter. "How does he dare think to marry a young woman of pure lineage from a family known for its impeccable conduct?" Lamas, she argued, should not be rewarded for his crime. "What benefit could possibly be derived by the legitimation of a little child by a lazy man who is destitute of any possession, and who is also a mulatto? This would only heap disgrace upon disgrace." As far as Magdalena was concerned, the damage was already done, and the only option left was to salvage what remained of the future. It was not much, but by not marrying Juan, Justa would be "less unfortunate" than if she married him.

During the presentation of witnesses, Lamas tried to provide evidence of his white racial background and good conduct. For reasons that became clear later in the case, Lamas focused on his *paternal* lineage. His father, Lamas asserted, had served as a soldier in a frontier regiment that excluded blacks, which proved that his father was not of African descent. Lamas presented numerous witnesses who attested to his family's honor and who confirmed that his father's regiment excluded people of color. In short, Juan Lamas attempted to identify himself on the basis of his father's lineage, without reference to his mother's line.

Magdalena Arnold, however, moved in for the genealogical kill by immediately targeting Juan's maternal line. Magdalena's most important witness, 83-year-old Vicente Gonzáles, testified that he had "always heard from the residents of these parts that the Lamas family were mulattos. . . . Besides their color, which is a strong indicator, there was also a woman named 'auntie Chabela,' [who] was more black than parda, and she was the mother of the wife of Antonio Lamas, hence, the grandmother of Juan Lamas." In addition to exposing the full nature of Lamas's racial background, Gonzáles contrasted the hardworking and reputable Arnold family with Lamas's degeneracy. Magdalena Arnold was very generous and frequently welcomed the "traveler, the poor, and downtrodden" into her home. However, the old man continued, that generosity could also attract malicious visitors who, in a pointed reference to Lamas, "do not respect the laws and duties of society." Gonzáles concluded his testimony saying that it would be a crime to pollute an honorable family with the likes of Juan Lamas. In the end, the judge ruled against Juan, Justa, and their young child.[30]

This case provides a panoramic view of important social and racial attitudes of the nineteenth century. Racial discrimination in marriage choice persisted and could still be a successful move for parents who did not want their children marrying a darker partner. From a broader social perspective, the ill-fated relationship began when the ideal seclusion of Justa was violated by a social inferior. For Juan and Justa, marriage was a viable solution to their illegitimate predicament, as it was for many couples in the same position. However, as 83-year-old Vicente Gonzales pointed out in his testimony, Juan Lamas was a racial and social inferior, a position deftly played by Magdalena Arnold.

It is also significant that Lamas tried to identify himself as white based on his father's lineage. In this sense the case of Juan Lamas helps address one of the riddles of Argentine history: the disappearance of the Afro-Argentine population. As late as 1838, Afro-Argentines made up 25 percent of the total population of Buenos Aires. By 1887, they accounted for less than 2 percent. In his classic book *The Afro-Argentines of Buenos Aires*, George Reid Andrews outlines four theories put forth by scholars to explain the decline: war, intermarriage, disease, low birth rates, and the end of the slave trade. All these reasons are part of the answer, but Andrews also looks to other factors.[31] One of the main reasons the black population declined was the use of the term *trigueño* (wheat-colored) in the census records, which allowed numerous blacks to be reclassified

as nonblacks in the census. For some, this served as an "escape" from being labeled as Afro-Argentine. In a larger sense, Andrews argues, the new terminology helped to "erase" blacks from the national identity in an effort to fulfill the dream of a "white" Argentina.

Was Juan Lamas trying to "escape" his identity? Lamas and his family may have fallen into a racial gray zone, where they could have passed as either whites or mulattoes, depending on the criteria of the observer. Lamas was hoping for the *possibility* of flexibility in racial classification, which could allow offspring of mixed marriages to be categorized according to either their father or mother's racial identity. The possibility of flexibility, however, depended on who was doing the categorizing, and in this case, Magdalena Arnold proved inflexible in her assessment of Juan Lamas's lineage. If Lamas was trying to reclassify himself, had he bought into the ideology of racial hierarchy of the white elites? Was he ashamed of his African heritage, or was this a strategic move he hoped would allow him to marry his beloved Justa? These are important but difficult questions to answer.

Cases like that of Juan Lamas were surely considered, at least in the abstract, by some of the leading intellectual figures of the nineteenth century. In this context, different levels of racial mixture were discussed in terms of their benefits and detriments to the nation. Domingo Sarmiento argued that mulattos had the "hot blood of the Africans," tempered by "the organization of his mind [which] links him to the European family." This mix, according to Sarmiento, allowed the mulatto to achieve progress unthinkable for a pure African.[32] Juan Bautista Alberdi also favored race mixture because he believed that white genes would dominate the inferior darker genes and bring about "the unlimited betterment of the human race." Bartolomé Mitre likewise sustained the view that mulattos were superior to more pure Africans because they "have assimilated the physical and moral qualities of the superior race."[33] These ideas all send a similar message: race mixture led to a whiter and more civilized population. But the problem for Sarmiento and others, of course, was that the blacks were in Argentina at all. In one of his later works, Sarmiento wrote that "the introduction of the black into the Americas was the most harmful thing that could have been done to the well being of this area."[34]

Trying to sort out the relationship between personal choices like those of Lamas, legal realities like those employed by Magdalena Arnold, intellectual currents like those manifested in Sarmiento's writings, and the

overarching social hierarchy speaks to the difficulty of understanding racial and ethnic identity in nineteenth-century Buenos Aires and in Latin America today. Writing in the 1920s, Vicente Rossi argued that blacks in Buenos Aires came to believe that their social condition was "just and natural" and that they willingly "sacrificed" even their "right to think" to the "whims of their lords and masters."[35] Later historians have argued that in Argentina and elsewhere in the region, the idea of the social hierarchy was so powerful that people of color bought into the idea of their inferiority.[36] Whatever the case, many persons of mixed blood, both of African and Indian descent, attempted to "move up" in the racial categorization that privileged white over black and brown. Color was indeed "in the eye of the beholder."[37] And when Magdalena Arnold beheld the countenance of Juan Lamas, she saw only a mulatto unworthy of marrying her daughter, even if it meant breaking her daughter's heart.

While it is not surprising, and even expected, that racial prejudices continued, the independence era produced an increasingly powerful antislavery agenda, and Afro-Argentines benefited from increased freedom and economic status by way of their service in the military and through their own economic successes. A comparison of the disensos involving racial inequality from the late colonial period and the national period also demonstrates an increased freedom for couples to pursue interracial marriages. In the colonial period, race was the most frequent argument in disenso cases, as well as the most successful since parents won in approximately 50 percent of the cases when they used the race argument. In the national period, on the other hand, racial opposition in marriage decreased in importance significantly as the success rate declined from 50 percent in the colonial period to 20 percent in the national period. These numbers do not reflect a visible break between the liberal period of 1810–30 and the more conservative rule of Juan Manuel de Rosas, pointing to a continuity, in this specific regard, between these two periods. These numbers are also consistent with trends that appear in marriage records of the time, which also reflect an increase in interracial marriages. In 1810, of a total of 1,055 couples surveyed, almost 87 percent of the spouses were of the same race. In 1827, that percentage had declined to 73 percent.[38] In all, the evidence suggests that racial inequality was less of a barrier after independence than it was during the colonial period, and interracial marriages increased as a result. While interracial marriage played a major role in the recategorization and "disappearance" of Afro-Argentines, George Andrews maintains that this racial mixture

and recategorization is a point that "can only be argued" but "never be irrefutably proven, since the only conclusive proof, exhaustive family histories which would demonstrate racial change in porteño society over several generations, is unobtainable."[39] The disensos help answer at least a part of this question because they provide evidence of the courts granting more freedoms to interracial couples throughout the nineteenth century.

The case of María Rodríguez and Andrés Lorea provides additional insights into the changes in attitudes toward interracial marriage. María's life until 1832 had been full of hard knocks, and through it all she had not found an opportunity to marry. As she recounted to the judge, "I can truly say that I have been able to survive only by making a great sacrifice of my time, even of those moments normally set aside for rest." Things began to look better for her when a man unexpectedly entered her life. "Under these circumstances, and after the flower of my youth has wilted, I have been fortunate enough to have Andrés Lorea, a free pardo, ask for my hand in marriage." Through the whole process, María's mother, Isidora Luna, disapproved of the proposed union because of Andrés' African ancestry. But for María, pure blood had little meaning if it meant starving to death. "The purity of my blood cannot put food on my table," she told the judge. "It is true that the purity of my blood is well known. But if my lineage is well known, so is the fact that I am destitute and lack the means to survive." Moreover, her intended husband had other qualities that made him a worthy mate. "My future groom, though pardo, is of proven character. And, as an employed wagon driver, he is in the position to provide for all of my wants and needs in a decent and comfortable manner." Although María never revealed her age, she obviously felt she was past her marriage prime, and Andrés' marriage proposal seemed to be her last chance to marry, and an unexpected one at that. "At my age, all of the natural inducements capable of persuading a man to marry me have disappeared. . . . I have a scant and humble education and my family has been mired in misery since the death of my father." Her arguments persuaded the judge, who granted the couple the right to wed.[40]

One of the more significant elements here is the tension between two different discourses of societal order—one racial, the other economic. Traditionally, and especially in light of the colonial pragmatic, one discourse of order was racial order through the maintenance of pureblooded family lines. From this perspective, Andrés Lorea would

have polluted María's pure blood. In their defense, however, María used a discourse of economic order: a poor white family, barely able to make ends meet, was being offered a boost up from a more wealthy mulatto. María's mother, however, clung to her racial purity, something that many poor whites cherished as their "most precious and inalienable asset, an inheritance which entitled them to unquestioned legal superiority over non-whites."[41] In the end, María and Andrés presented a well-developed argument of economic stability, order, and love that was convincing to the judge.

This case also reflects the growing concern of parents and judges regarding the economic stability of a prospective suitor and his ability to support a family and less regard for racial or social status. From the late 1820s on, economic concerns replaced race as the main reason for parental opposition in the disensos. In one revealing case, a father had blocked his son's wedding plans because he wanted him to accumulate more wealth before getting married. In a rare explanation of his views, the judge, Manuel Antonio Castro, sympathized, in general terms, with the father's concerns about the follies of unwise marriages:

> Suppose my own young son of nineteen years of age, having no position, nor occupation, and without any means of income, asks for my permission to marry a young woman also nineteen years old, with no patrimony, no dowry, nor fortune, such that from the moment of marriage she must be maintained by her husband; [furthermore,] both have only a mediocre education. I can see that if they marry today, tomorrow they will not have enough to eat, to wear, or a home to live in, except by the uncertain and precarious way of favors that others might provide. I cannot help but fear that this marriage will turn miserable, that my son and his wife will become victims of poverty, or that—in the event of being unable to provide for life's bare necessities—the marriage will dissolve, and that the couple will fall into the abyss of depravity. Would I grant him my permission? No, I would not grant it: I would attempt to moderate his passion in order to try to prevent such a thoughtless relationship and its sad consequences, which, if they occur, would dishonor my family, and would harm also the state.[42]

The judge understood the father's view, but disagreed with his extreme position in the case. The young man did not need the financial security demanded by his father. Instead, the judge ruled, he could marry

as long as he found a job that could provide "food and the bare necessities of life" for his family. "My intention," the judge added, was for the boy to prove he could support a family by getting a job. "I hoped that his affection would give him the incentive to find it."[43] So the judge and the father disagreed over the financial prerequisites for marriage. The judge thought that providing for a family meant the *bare necessities of life*, while the father wanted his son to have a bigger financial cushion before he married. The judge's argument also reveals that, from the state's point of view, marriages should proceed as long as the suitor had the basic capacity to support his future family. If a man marrying without the ability to support his family hurt the state, it also followed that a man capable of supporting his family with the basics of life would enter into a marriage that would benefit the state, even if parents disagreed.

Similar attitudes are clear in the case of José Peralta and his girlfriend Eugenia Burgos. Eugenia's mother, Ana María, contended that José did not have any money to support a family and that she and her daughter already suffered in poverty. Although José argued that he was a "hard-working man," the judge decided not to grant judicial license for the marriage until José established himself financially. Later, José returned to court, claiming that he had a benefactor who had already outfitted him with 300 pesos and would increase it to 800 if needed. "With this capital, and with my honor and work ethic, which Doña Ana María would not deny, for they are public knowledge," José claimed that he could now support a family. Given the new evidence in favor of José, the judge cleared the way for the couple to wed.[44]

The case of Amond Amondsen, a poor Lutheran from Denmark, provides another example of a judge's views on financial stability. Amond hoped to wed Sofia Hartwig, who was Catholic. Her father, Nelson Hartwig, did not like the idea of his daughter marrying a Lutheran, and he also questioned Amondsen's financial ability to support a family. When the judge probed him about his economic situation, Amond did not hide the fact that he was a poor man. However, he did demonstrate that he was a hard worker and could provide for a family. Satisfied with Amondsen's argument, the judge granted the couple permission to wed. As he did, the judge gave Sofia's father an admonition, or perhaps a ray of hope: "As Don Nelson Hartwig surely knows himself, the honorable poor frequently make of themselves rich men."[45]

Like parents, judges were concerned about the economic stability of couples and, over time, the power of racial opposition declined as eco-

nomic factors took center stage. It may be plausible to argue here that many parents may have used "class" arguments as a metaphor for "racial" arguments. While it is difficult to prove or disprove that parents used such strategy, even if they did, judges most often disagreed with parents' money-based arguments and ruled overwhelmingly in favor of the couples, as long as the basic necessities of life were looked after.

Judges played an even greater role in decisions where only the law—not any family members—stood in the way of a couple trying to marry. Some cases indicate that officials needed to be sure that mixed couples had permission to marry from their parents. Antonio de Avendaño, a white, found himself in this position when he tried to marry Martina Alsiña de Quevedo, a *parda*. He discovered that he needed permission from the court to carry out a marriage between racial unequals, even if no family member objected to the union. After making sure that no family lived in the area, the court gave him permission to marry. [46] A similar case involved Juan Martínez de Sosa, also white, and his intended bride, María de los Santos Ogorman, a *parda*. When the court made sure that Juan had no family in the city who might want to oppose the marriage, and that he had no outstanding debts in the city, the judge granted him permission to marry.[47] With no family opposition, as far as the judges were concerned, these unions of racial unequals were valid, and in the eyes of the state, even beneficial.

These and other cases allow for a brief return to the discussion of honor from the perspective of the mid nineteenth century. In the colonial period in Argentina and elsewhere, honor was claimed mainly by the elites. Nevertheless, working-class males in Buenos Aires had adopted the concepts and symbols of personal honor in their interpersonal relations by the late-eighteenth century, even though the idea of plebeian honor, or the "poor but respectable man" was not accepted by elite groups. [48] As the nineteenth century progressed, however, the idea of the "poor but respectable" man and woman had some resurgence. Judge Castro's emphasis on a suitor providing only the "bare necessities of life," along with another judge's comment that "the honorable poor frequently make of themselves rich men" are indications of such sentiment.[49] While the term "honorable poor" may have been a conflict in terms for some members of society, especially during the late colonial period, such a definition became more common after independence.

Ideological Influences and Practical Concerns

The reasons for the increased freedom in marriage choice for interracial couples, indeed for all couples, are not self-evident and are likely the result of a combination of ideological influences and pragmatic concerns. After May of 1810, revolutionary ideals of freedom and equality inspired antislavery and other socially progressive legislation, such as the abolition of social titles.[50] The increased mobilization of the masses after independence made the common folk more aware of these ideas. One contributor to *La Prensa Argentina* complained about the audacity of the lower classes, who felt that the new egalitarianism allowed them to transgress traditional social boundaries. One observer noted that even the "most eminent citizens" of the city could not travel in the capital without "being splashed with mud by a cart-driver or jostled by a horseman," who thought that it "was one of the rights supposedly derived from equality."[51] Popular literature, such as the emerging genre of *gauchesque* poetry, also glorified nonwhites, at least symbolically, in the struggle for independence.[52]

Given these diverse currents of thought, it is plausible that the concept of the traditional racial hierarchy, as supported by colonial attitudes and laws, did not remain unscathed, at least for certain segments of the population. In his 1812 discourse on citizenship, for instance, Bernardo de Monteagudo argued in favor of more racial equality. Whoever met the qualifications for citizenship should be a citizen of the nation, he argued, "with no distinction between a European, Asian, African, or indigenous American."[53] Another opponent of traditional discrimination was José Fortunato Silva, who in 1833 found himself embroiled in a marriage dispute. For him, the old concept of *limpieza de sangre* had lost its symbolic power and was just a vulgar attempt to categorize people.[54]

While ideological developments had an important impact on family disputes, practical concerns of the emerging Argentine state also came to bear on marriage conflicts. In disenso and other family-related cases, judges based their rulings on existing laws, but they interpreted and applied those laws for the good of the state. A disenso case from 1851 reflects those growing needs and how they affected marriage choice. The case presented a familiar conflict: a white girl, Robustina Belmonte, trying to marry someone of African descent, Matías Almeida. Robustina was an orphan, and Juana Alvarado had cared for her since 1838. Juana opposed the unequal marriage and invoked the pragmatics in her defense. But the judge, apparently more interested in hearing about Matías's character

and current employment, ordered him to provide evidence that he could support a family. Matías complied satisfactorily. The judge then issued his ruling, stating that the boy's evident "moral and industrial capacity" made him worthy to marry Robustina. The judge also added an illuminating commentary to the ruling: the court should "be in the business of propagating legitimate unions in the poorer classes."[55] The judge's commentary points to the vital concern that confronted the leaders of an emerging Argentine nation, which *helps* to explain the increase in freedom for couples, interracial and otherwise: the need to propagate marriages in order to populate the new nation with stable, legitimate families.

From the earliest days of the republic, leaders from Buenos Aires and many other provinces understood that they had a very large country but a very small population. To progress as a nation, they needed to increase their population. Juan Bautista Alberdi's idea of *gobernar es poblar*—to govern is to populate—reflected that concern and inspired the large projects of attracting immigration to Argentina in the mid- to late-nineteenth century.[56] But these ideas had important antecedents. Evidence from the early political record of the republic demonstrates that concerns about increasing the population were present soon after independence. In 1814, for example, an assembly of provincial delegates called on ecclesiastical and government officials to make special efforts to facilitate marriages "in light of the necessity to increase the population in the Americas." The issue of marriage and population came up again during the Congress of 1817 when Bernabé Aráoz, the governor of Tucumán, in a reference to conflicts related to the royal Pragmatic on Marriage, asked whether priests could marry a couple against the will of their parents when the parents' dissent was based on inequality of lineage or economic status. For the governor, the issue was of utmost importance because "the fundamental base of a state is the propagation of the human race, and the universal way of doing that is to promote marriages."[57] The governor's concern about the validity of parental opposition, and the need to facilitate marriages to increase the population, challenged implicitly the colonial pragmatics on marriage and the attitudes that supported them. He was worried that the old laws might impede couples from getting married and thus hurt the state. Later governments also attempted to promote family formation and population growth. The various laws issued after independence that banned marriages between porteño women and Spanish men were done away with by 1821. In ad-

dition, important changes with regard to freedom of religion promoted interfaith marriages during the 1820s, and by the 1830s interfaith unions were heavily supported by the government. This was an important step in fusing new Protestant elements in the population with the Roman Catholic porteños.[58]

Serious discussion of marriage and family issues also occurred in the field of jurisprudence. In his courses on civil law at the University of Buenos Aires Law School throughout the 1820s, Pedro Somellera taught his students that many fathers used the old laws, such as the Pragmatic on Marriage, as a mask to hide their tyrannical actions. Such laws, he affirmed, needed to be reformed.[59] It would be a mistake to underestimate the impact of Somellera's reformist ideas on the young lawyers and future politicians that passed through his salons.[60] Undoubtedly, many of his students went on to careers in the courtrooms of Buenos Aires.

Conclusion

When the Argentine government finally got around to implementing a new civil code in 1870, parents still had the right to block the marriages of their minor children. However, the colonial Pragmatic on Marriage did not survive the new codification. The legitimate reasons for parental opposition were more clearly laid out in the new code. While the ambiguous "inequality" of the colonial pragmatic was understood by many parents to include racial inequality, the new civil code did not mention race or "inequality" of any sort. The legitimate reasons for opposition outlined by the new code included legal impediments, sickness, bad behavior, criminal record, and inability to support a family.[61] This last reason is not surprising, given the growing concern for financial stability in the *disenso* cases. As María Rodríguez pointed out, it became increasingly more important to put food on the table than to measure the purity of one's blood. Although further study is needed to trace racial discrimination in marriage after 1871, the new code did not seem to provide the leeway that the colonial pragmatic did for parents wishing to oppose marriages on the basis of racial inequality.

While the Afro-Argentine population was in serious decline by the 1870s, perhaps making racial opposition obsolete, the process of intermarriage between whites and blacks that contributed to the decline of the Afro-Argentines was accelerated by a post-independence relaxation of the *application* of the colonial laws intended to prevent such intermarriage. Either way, the new civil code reflected changes occurring in

porteño society since 1810. The leaders of an emerging Argentine nation faced the difficult task of building a country out of a heterogeneous population, and marriage and family played an integral part in that project. Equipped with strains of liberal thought and a healthy dose of pragmatism, post-independence governments passed new legislation that brought new status to ethnic minorities. However, the writings of Sarmiento and others are reminders that the more sinister purpose of whitening the country through immigration, and perhaps by intermarriage, was also a pragmatic concern.[62]

Nevertheless, liberal ideals, combined with the practical need to populate the country with legitimate and economically viable families, brought a *greater measure* of freedom for couples to marry despite differences in social and racial status. As the judge in an 1846 disenso case put it, the nation had an interest in preventing "the grave repercussions against the state from impeding honest marriages, or of allowing marriages to take place without the proper liberty."[63] This judge's decision, along with the decisions of many others, helped bridge the gap between important *aspects* of revolutionary ideology and the everyday lives of citizens on the ground in Buenos Aires, a ground nevertheless still cluttered by traditional prejudices that continue to privilege white over black. Many traditional prejudices also continued regarding women in porteño society.

6. *Crude and Outdated Ideas*
Attitudes toward Women

"We are entering a new era of Liberty, and [men] have no right whatso-
ever to exclude us from it." So wrote the female editors of *La Camelia*
in 1852. The fall of Juan Manuel de Rosas had initiated the so-called era
of Liberty, and with the help of their own newspaper, these women were
going to make sure they had a place in the new order. The women con-
tinued their editorial lamenting that men saw women as mere vehicles of
reproduction. "All this resonates with our ideas, with our belief—*Man
has forever abused his strength and our weakness.*" Although men's his-
toric abuse of women was enough to have extinguished all good relations
between the sexes, these women were not going to allow that to happen.
On the contrary, they pledged, women would continue to exhibit their
natural qualities of tenderness, compassion, benevolence, and love. To
do otherwise would "violate the sentiments with which the Creator has
adorned our sex."[1]

This remarkable editorial illustrates the tenacity of women dissatis-
fied with their historic lot in life, but it also shows that in many ways they
held just as tenaciously to some traditional female roles. *La Camelia*, and
other female literary activity, symbolize both the persistence of tradi-
tional attitudes about gender and the new ideas and roles emerging in the
nineteenth century. Women were active in shaping their own agendas,
and although they still worked within a male-dominated society, women
found men willing to help them push back certain barriers to female
activity. Argentine politicians and intellectuals, women included, faced
the hard task of building a new nation, and, they all understood, women
would have to play a major role in that project. As a result, women
became more visible in education, literature, and the national discourse
in general.

Women through History

Assessing changes in attitudes toward women is a complex task, for one must consider numerous variables. Is the woman married or single? Is she the mother of children? Does she work in the home or in public? Is she older or younger? The chapters thus far have portrayed young women (and men) gaining more freedom to choose the mate of their choice after independence, but what about women in other aspects of life and in other stages of the life cycle?

Over time scholarship on the subject has run the spectrum from seeing women as powerless subjects to casting them as active agents in their own destinies. Traditional views of women relegated them to the domestic world of the home. As Asunción Lavrin has pointed out, "*lo femenino*" (the feminine) was "*lo doméstico*" (domestic).[2] This stereotypical enclosure also extended into the ways women were included and excluded in written history. Women were largely ignored in the histories of the nation written in the nineteenth and early twentieth centuries. In the early twentieth century Antonio Dellepiane tried to remedy the problem. "Historians talk of men perhaps too much, and of women less than they should." For him, women exercised an undeniable influence in history, although Dellepiane, speaking from the 1920s, could not help but still envision that influence as it pertained to men. "A certain mother explains a certain son; a certain wife makes comprehensible the events that she inspired or instigated with her husband; a certain government official would have conducted his life and public policies in a different manner if he had had a woman at his side." In 1923 Dellepiane published *Dos patricias ilustres*, in which he narrated the lives of two Argentine women in order to "discern the characteristics of 'the great Argentine lady'" who would represent the superior woman that encompassed a "beautiful eugenic synthesis": the tenderness and grace of the southern Europeans with the strong character of the Nordic races. Although Dellepiane still spoke from a traditional mindset, an exquisite revelation of the attitudes of his time, he nevertheless recognized, and tried to rectify, the gendered imbalance of the historical record.[3] In recent years female historians have taken much of the initiative in placing women in their appropriate place in the national history.[4]

Persistent Patriarchy

Throughout history, female identity was closely tied to the ideal of patriarchy, which was long supported by laws and customs from ancient times

to the present. In nineteenth-century Buenos Aires fathers and husbands still exercised substantial control over their wives and children, leading some to see the theoretical possibility of "patriarchal absolutism."[5] Indeed, laws regarding women and family life remained largely unchanged from the colonial period into the nineteenth century.[6]

Besides the traditional legal codes, patriarchs had additional control mechanisms at their disposal. One of these was the Casa de Ejercicios of the Roman Catholic Church. More extensive information on the Casa de Ejercicios (or "the Casa") is unavailable because ecclesiastical records were burned in Argentina in 1955. Nevertheless, readers can glean references to the Casa and its functions from civil cases. Ideally, the Casa de Ejercicios was a place of spiritual seclusion, but much depended on why someone went there, and if she wanted to be there in the first place. For some couples seeking to marry against the wishes of their parents, the Casa de Ejercicios might provide a refuge from abusive parents.[7]

But the Casa also had a darker side, at least from the perspective of the women forced into seclusion there. Readers will remember that Mariquita Sánchez's father put her in the Casa in an attempt to subdue her romantic rebellion in 1801. Likewise, Gervasio Arzac and his wife Urbana hoped that the Casa de Ejercicios would reform their rebellious daughter, Ortensia. According to her parents, Ortensia had scandalized her family and community by defying their authority and causing them immense pain, suffering, and tears. What made matters worse, the resourceful Ortensia made a daring run to the Defender General of Minors in hopes that she could name her own guardian and become free of her parents' tutelage. The battered parents finally turned to the courts for help. Gervasio and Urbana informed the judge that whatever she had told the Defender General of Minors could be nothing more than a pack of lies, for since she was a child her parents had been unable to cure her of her nasty habits of deception. Gervasio added that it would be a gross violation of paternal rights to allow his daughter to name her own guardian. Instead, he suggested that Ortensia be sent to the Casa de Ejercicios, where she could "practice and receive examples of penitence and contrition." Ortensia, however, firmly opposed being sent to this "prison." One daughter's prison, however, was an attractive alternative for her parents. "The place is not a prison, as she alleges," the parents argued; rather, it was a place to learn penitence and "repent of one's shortcomings, which, if sincere, is never too late to accomplish." While the Defender General of Minors did not recommend granting Ortensia

her wish to name a guardian, he did advise the judge to investigate allegations that her father was mistreating her before a final decision was made. In the meantime, the judge still ordered Ortensia to the Casa de Ejercicios on a provisional basis to avoid "scandal and violence."[8]

Skepticism over the role of the Casa de Ejercicios was also found elsewhere. In 1818, *El Censor* published a scathing critique of the Casa.

> An avaricious, barbarian, and cruel father, acting on his own authority has sentenced his daughter to a perpetual confinement in the House of Retreat, only because she wishes to marry a good, hard working, but poor man. This is her entire crime, for which she has been de facto sentenced to that incarceration since May of 1816. . . . How has this barbarian of a father been able to usurp the higher dominion of the legislator, which is represented by the Congress, and been able to hand down such a heavy-handed sentence on his own and kept his daughter there for the last twenty months? How was it possible for the woman in charge of the Retreat to permit her entry without approval of the ecclesiastical or secular judges? Why did she not report the case to the authorities?[9]

Pedro Ferreyro also hoped to use the Casa to control his rebellious daughter, who had attempted to flee her father's house and live with another family. Ferreyro sent her to the Casa de Ejercicios, "to make her honor her responsibilities" and "because she had disobeyed paternal authority," all of which might be remedied if she spent time doing some "exercises" in the Casa. [10] The Casa could also be used as a threat by the judge if a woman did not comply with his suggestions. In a divorce case between Senovia Arias and her husband Rafael Stuard, the judge threatened Senovia with being sent to the Casa. The two had a stormy relationship, and Senovia accused her husband of being a drunk and a wife-beater. Such was his mistreatment that her sister took her away and placed her in the house of a friend. Rafael then accused his wife of immoral behavior with the man of the house in which she was staying. In trying to reconcile the couple, the judge ordered Senovia to stay away from the other man's home, and if she violated the order, she would be "punished and sent to the Casa de Ejercicios."[11] He also ordered Rafael to refrain from all ill-tempered behavior and prepare himself to return to conjugal life.

It is noteworthy that the judge did not outline any punishment for Rafael, if by chance he violated the judge's ruling. This inconsistency

points again to the gendered double standard in the legal and cultural discourse in Buenos Aires and Latin American society in general. There was no similar institution for wayward men. If they had committed a crime, men would be imprisoned (in fact, Rafael had gone to jail for hitting his wife on the steps of the ecclesiastical court). However, women could also go to jail for violating the law, but men were not forced into the restrictive environment of the Casa de Ejercicios as were their female counterparts.

This highlights an apparent contradiction in Hispanic society. On one hand women were upheld as the moral and ethical superiors of men, the guardians of the hearth, the keepers of spiritual and sexual purity. At the same time women could be seen as morally feeble and vulnerable to sin (remember the case of Camila O'Gorman who had been deceived by the wiles of the decadent priest Ladislao). A scenario played out by the editors of the weekly *El Observador Americano* in 1816 helps to perhaps clarify this contradiction and explain the double standard. As was more and more the case after 1810, women were expressing their dissatisfaction with traditional social norms. The editors decided to calm this swell of discontent with the following paternal advice: "Imagine a city where the weaknesses of the women were as common and tolerable as they are, unfortunately, among the men. What would happen? Unfortunate souls!" The fate of such a place, they continued, would be complete social destruction—men without education, children without parents, citizens without virtue, a nation without industry, population, or strength. The list went on until the editors could stand it no longer. "Enough! It is impossible to write these lines without trembling." Some women, the editors explained, claimed that the emphasis on female honor and spirituality was "a virtue purely for the convenience of men, and that men had abused their greater strength to subjugate women to this yoke." According to *El Observador*, "Such a pretense is notoriously irrational." The editors insisted that under close examination, those laws were for the benefit of all society, especially women. If women did not take care of the home, what would happen to society?[12]

The editors were essentially arguing that the family was the heart of Hispanic society, and women were the heart of the family. Women might have been, on the whole, physically weaker than men, but the editors and others would have argued that women were capable of higher levels of spirituality. The point was not the relative spirituality of women, per se, or the relative moral depravity of men (as admitted by the editors of *El*

Observador). What was at stake was the spiritual and moral fiber of the nation. It was the nation that was vulnerable to vice and corruption, and it would be more vulnerable if both sexes were allowed to act with the moral impunity that had so far been tolerated only in men. By admitting masculine moral incapacity while at the same time pleading for national moral security, the editors of *El Observador*, and perhaps Hispanic men in general, were unwilling to match the type of commitment and values that they sought to impose on women for the good of the nation.

Women in the Revolution
Although the independence era did not offer a radical liberation for women, it does represent an important phase in the evolution of female gender roles. These changes are evident in women's activities in the revolution, their contributions to literature, and their involvement in civil actions. As in other Latin American countries, Argentine women took an active part in most phases of the revolution. For Argentina, female mobilization had an important beginning with the English invasions of 1806–7. At times, women actually fought. During one battle, Manuela Pedraza fought the English invaders alongside her husband, who was killed by an enemy bullet. Without hesitating, Manuela grabbed her husband's gun and killed an English attacker. She took the felled-Brit's weapon and later presented it to the new viceroy. Marina Céspedes would later capture twelve English soldiers in her home. Some women also fought in the wars against Spain. *La Prensa Argentina* urged women to take an active part in the revolt, even if it meant combat. "If it pleases you [women], follow the example from the successes of Cochabamba, of the twelve *matronas* who served so well in the artillery."[13]

Most women, however, supported the revolution in other ways. A "Letrilla" from *La Lira Argentina* further demonstrates the inclusion of women in the revolutionary discourse of the time, although in a traditional role as a nurse to a wounded soldier:

The bloody fight,
the pleasant sex
prepares olive oil
for their sweet purpose.
With her white hand,
she later presents it,
and while she does,

the soldier replies:

Daughters of the Nation,
Receive my affection.[14]

Women were also employed symbolically during the Revolution. *La Prensa Argentina* published an eyewitness account of revolutionary activity in Venezuela during 1815. "Many pregnant women have been split open for the purpose of exterminating the caste of independent Americans. Various women were tied to trees, their arms lifted up over their heads, and in this posture they were beaten to death. Their arms were then cut off and left dangling from the trees in the form of a cross. . . . Women and young girls from the most respected families are taken by force to the [Spaniards'] camps, where the soldiers satisfy their most brutal passions with them. What is worse, the family members of those unfortunate women are forced to witness it. Afterwards, they are killed."[15] Even if some atrocities were exaggerated, they did occur, and women participated in the conflict as victims as well.

Women were also adept at applying gendered encouragement to their male compatriots. In one popular account from the English invasions, a woman chastised Argentine soldiers after the English had captured the city. "Gentlemen, you should have let us know beforehand that it was your intention of surrendering Buenos Aires, for I swear by my life that, upon finding that out, we women would have gone into the street and driven the English out of here with stones."[16] During the wars against Spain, one group of women, led by Casilda Igarzábal de Rodríguez Peña, encouraged Coronel Saavedra to fulfill his duties. "Coronel, there is no time to vacillate. The country needs you to save it. You have seen what the people want, and you cannot turn your back on us."[17]

In addition, women lent considerable moral and material support to the revolutionary cause. Women served as nurses and camp followers during the wars. Money and jewelry donated by female patriots helped finance and equip the members of San Martín's crossing of the Andes. In addition, intellectual gatherings led by women were common. The soirées hosted by women became the sites of revolutionary planning. Behind the beautiful dancing in these salons lay the makings of patriotic flags and firing squads. As one contemporary female observer stated, "The Argentine woman will make her house and even her soul the intimate corner from which the decisions of the nation will emerge." One might use the image of salon dancing to capture the essence of

women's activity in this regard. The feminine figure that emerges from the revolutionary milieu is somewhere between the minuet—a traditional, graceful dance—and the rigadoon—a fast paced, quick-stepping dance. Women participated in the independence movements in traditional ways (the minuet) but also in more political affairs that went beyond their traditional domestic role (the rigadoon).[18] Juana Manuela Gorriti praised women for their selfless sacrifices in the revolutionary wars as well as in the damaging civil wars that followed independence. "Daughters of the River Plate, guardian angels of that Eden sown with tombs, given over for so long to appalling slaughter, there is nothing comparable to your evangelical charity and your sublime abnegation." Women forgot their own suffering as they helped others. Mothers who grieved their lost sons and husbands silenced their own sobs "in order to find gentle words of hope for a prisoner." Women who had been left without homes of their own were quick "to rescue the dying from the buzzard's claws, and you bandage his wounds with your own clothing. May God bless you, and bear you in mind in the hour of redemption of our unfortunate nation."[19]

As women fought for and contributed to the cause of national independence, they laid claim to a greater stake in the new nation. What has been concluded for Colombia can also be said for Argentina: female activity in the revolution, and the revolution itself, "subtly repositioned women within the newly emerging Republic."[20]

Female Education

One important aspect of this subtle repositioning was female education, which became more of a priority after 1810. As with the education of children, promoting female education was not a new idea. The Enlightenment in Europe, Spain included, had made female education one of its main components. In 1739, Benito Feijoo wrote *La defensa de la vindicación de la mujer*, in which he echoed centuries-old arguments that women were not intellectually inferior to men but only lacked the appropriate education.[21] The Spanish Bourbons also made efforts to reform female education. In 1768, Charles III issued a decree that "the education of the youth should not be limited to the boys because the girls need education as well, since they are to become mothers of families. It is certain that the way to form good habits depends principally on primary education." Consequently, he ordered that girls' schools be established.[22]

Some historians have used this and other evidence to question the

stereotype of the uneducated woman of the colonial period. In his *La cultura femenina en la época colonial* (Feminine Culture of the Colonial Period), Guillermo Furlong argued that women had significant educational opportunities during most of the colonial period. One of the most overlooked sources of education were private homes where women, known as "amigas," taught young girls of different social classes. In private homes as well as convents, girls and young women were taught to read, write, sew, "and other tasks appropriate to their sex." Furlong also provided numerous examples of intelligent and literate women who actively participated in colonial society and helped lay the foundation for the revolutionary movements of 1810 and afterward.[23] One of those educated women, Mariquita Sánchez, might well have disagreed with Furlong's interpretations. Speaking of the women or her era, Mariquita wrote that "all we knew was to go to mass and pray, to arrange our clothes, and to mend and sew."[24] Mariquita surely exaggerated to make her point—for she and many of her female friends were well educated—but her statement, she felt, fit the reality of most women in her time. For his part, Furlong's attempt to balance the historical record bordered on the hyperbolic extreme. Was his an attempt to raise the stature of women in Argentine history, or was it an apology for traditional society? Whatever the case, most women, then and now, most likely would have agreed with Mariquita's view.

A few private schools for girls did exist in colonial Buenos Aires, but even they sought aid from the government to stay open. These petitions sometimes took the form of requests for particular types of students. Some school officials asked that Indian girls be brought to the school for education. In 1801, for instance, Sor Bortolina requested that some "*Indiecitas*" (little Indian girls) be sent to her school to receive education. The nun added that resources at the school were in a "deplorable state of necessity." That the petition for Indian students came in the same breath as a complaint about the lack of resources illustrates perhaps the true purpose behind Bortolina's request: that the Indian girls would be used as laborers at the school. Indian girls and other nonwhites were destined for service-oriented activities, even within the context of supposed equality of these schools. The only regular public school for girls that had any kind of continuity between the colonial and national periods was the Colegio de Huerfanas (School for Orphan Girls) run by la Hermandad de la Caridad (Sisterhood of Charity), which was established in the mid-eighteenth century.[25]

Although colonial officials sought to promote female education in some respects, the ideal did not find fruition during the colonial period.[26] Literate and educated women lived in the viceroyalty, but their numbers remained confined to elite circles. Not until after independence did female education begin to grow. Contemporary newspapers of the revolutionary era promoted this new avenue for women. In announcing the forthcoming publication of their new weekly paper in 1816, the editors of *El Observador Americano* announced that female education would be one of their main themes. The series of articles, they hoped, would serve to motivate women to pursue their education as well as "offer occasion to our legislators to broaden the destiny of this beautiful half of our species."[27] And what was the rationale behind this initiative? Educating females was a key to building a new nation. The editors asked readers the following question: "Why should women feel loyal to a country that ignores them," while "even the most stupid of men enjoy liberties denied to women?"[28]

Even later feminists might have been pleased with such sentiments, but then the editors opened their mouths again. The editors of *El Observador Americano* still showed strong paternalistic colors even as they pushed for new levels of female emancipation. "We should begin our work by showing women their vice-ridden customs that they should correct. . . . We will do what we can to discover the ruinous consequences that they bring upon themselves." *El Observador* made it clear that men should be in control of this new education, and that women would follow "the plans that we propose."[29]

While the attitudes expressed in *El Observador* surely fell short of the hopes and expectations of many women of the time, its editors still deserve credit. It would be misguided to expect porteño men in the early nineteenth century to have pushed for more progressive changes. As they stood, these ideas represented important shifts in the perception of women's rights as members of a new nation, shifts that would open more doors to women in the future. After all, the editors did advocate a certain equality between men and women. "The most reasonable thing is to surmise that neither men nor women exceed each other in talents." The paper continued by admonishing women to read good literature instead of the common novels so popular in the day.[30] Though decidedly paternalistic, these men saw themselves raising the status of women to a more equal state with men, even if the men had to expose women's "vice-ridden customs" and "ruinous behavior."

The first edition of *El Observador* delivered on its promise. The 19 August issue equated female education with national civilization and progress. A nation of uneducated women, on the other hand, symbolized oppression, which had been the object of the Spanish monarchy during the colonial period. By purposefully neglecting female education, Spain had sought to "eternalize the bondage" of the Americas. With independence now a reality, female education "will become a bastion of strength for the defenders of the Nation." Among other benefits, educated women would better the reputation of the country as a whole, making it more enticing to immigrants who would, it was hoped, flock to Argentina. "What glory would be ours, what happiness for our dear Nation, if the kind women of Argentina, open to prudent advice, taught us brilliant lessons with their example! What would our country lack in attracting the thousands of useful immigrants."[31] For the editors of *El Observador*, women's key role in nation building seemed like more than just the traditional reference to women's importance as Republican Mothers who would raise patriotic children for the good of the nation.[32] Women's roles would broaden as their education contributed to a progressive Argentina and strengthen the nation by attracting foreign immigrants.

One female reader, a certain Emilia P., was encouraged by the editorials and responded favorably in a letter to the editor. "I have already begun to read more useful books than novels," she wrote, showing her familiarity with the paper's running concern. But she also had some suggestions for the newspaper. Emilia briefly recounted how, on the first pleasant afternoon of spring, she and her mother had gone for a walk in the plaza of Retiro. As they walked by a group of young men, all from distinguished and reputable families, she heard one of them make "a million comments, all directed at what he called my '*hermosura*' (beauty), but none regarding my abilities, culture, or education."[33] The experience reminded Emilia of something she had witnessed during the holiday celebrations at the cathedral. There, the brightest and most educated young men of the city would gather to inspect the procession of young ladies going to mass. "But in their comparative examination," they only paid attention to the women's "beauty, the air of their walk, their manner of dress, and the nicety of each woman." Emilia's complaint was that the young men "prefer the merits of our figures over that of our intellectual abilities." In her eyes, this left young women in a quandary: "What should we cultivate in this case, letters or fashion? . . . Where should we seek our future, which misfortune has placed in the

hands of [men's] capricious desires?" Emilia agreed with the attempts to improve female education, but, she added, perhaps it was more important to "first reform the education of the young men, who will be our husbands."[34] Emilia exhibited the deeper understanding that for many men, the young women of Argentina were objects that would adorn the domestic mantlepiece.

The editors quickly responded with another editorial that offered Emilia a compromise of sorts. In no way did they want to detract from female beauty. "What we require of women is not so much that it will destroy your beauty and delicate nature." If men choose looks over intellect, they would have to justify it themselves. However, the editors insisted, even the most extravagant men did not prefer intellect over beauty, given equal circumstances. The young men who peppered her with comments during her walks around town had done the best they could, since they did not have the opportunity to "discover your talents."[35] The editors did not explain what they meant by "given equal circumstances," but the gist of their response was, in short, that women would do well to cultivate both beauty *and* intellect.

The educational ideals expressed by *El Observador* and its readers began to take concrete shape during the 1820s. By 1823, female education became a priority for the government, and Bernardino Rivadavia put the newly formed Sociedad de Beneficencia in charge of it. That year, the first girls' school maintained with community funds was established. After 1823, more schools for girls were set up. Rivadavia deserves much of the credit for inspiring these reforms. As one scholar has noted, "if you know a man 'by his fruits,' it is undoubtable that [Rivadavia's] work in the field of female education had a great impact, one that endured long after his government."[36] Rivadavia himself stated that keeping women in ignorance was something "entirely opposed to their future and destiny." In his mind, women deserved an education just as much as men did and, as a result, the number of female students rose steadily throughout the 1820s.[37]

Domingo Sarmiento furthered the cause of female education. Inspired by what he saw in the United States, Sarmiento helped reform education in other Latin American countries before returning to Argentina after the fall of Juan Manuel de Rosas in 1852. Back in Argentina Sarmiento opened school doors to women more than ever before. His vision was that women teachers would be the key to Argentina's future progress. Sarmiento himself stated that these "adept young women owe

me a lot," because "I have removed many obstacles from their path to enter into schools."[38] However, Sarmiento was not without paternalistic traits. In his speech at the inauguration of a school for girls in his home province of San Juan, Sarmiento declared that "it is never too early to give habits of order, cleanliness, thrift, docility, and submission" to women.[39]

Sarmiento agreed with Jean Jacques Rousseau that women and families were integral to healthy societies. "Man cannot lower woman without himself falling into degradation," he wrote in 1841. "By elevating her he improves himself. Societies are turned into brutes in her arms, or they are civilized at her feet. Let us take a look around the globe: we can observe these two great divisions of the human race, the Orient and the West. Half of the ancient world remains motionless and without thought, under the weight of barbarous civilization: women there are slaves. The other half marches toward equality and light: women are freed and honored." Sarmiento's commentary on Corinne, one of the characters created by the French writer Madame de Stael, spoke of additional emancipation for women. Corinne was a powerful and independent character, stronger and smarter than the males that surrounded her. "Might she not be a prophesy," Sarmiento asked, "of the future position afforded to women by centuries more ordered, more perfect, more egalitarian for the weak and the strong, for men and women, than ours?"[40] Sarmiento also offered strong support to women writers. Speaking of Eduarda Mansilla, he observed that she had fought for ten years to "enter, as any other writer or reporter, into that heaven reserved for the chosen *macho* ones."[41]

Women and Literature

Even as female education received more emphasis, women were already making strides in the literary sphere on their own. In a literary world traditionally dominated by men, women had difficulty carving out their own space and identity, especially because women's traditional role was in the home and not in the publishing house. A male critic's later praise of a promising nineteenth-century female writer highlights the problem of identity. She was not a common "female scribbler," and although she was a "woman in her sex" she was "a man in her spirit."[42]

Women had occupied important roles as *subjects* in early national literature written by men. The story of Lucía Miranda, one of the earliest Spanish colonists, became one of the founding myths of Argentina.

Taken away from her husband and into captivity by an Indian chief, Lucía later chose to die instead of giving herself fully to her captor. The story, in various forms, has been interpreted as one of struggle to maintain familial honor, but in the larger setting, the story sets the stage for the struggle between civilization and barbarism that occupied national leaders throughout the nineteenth century and beyond.[43]

Women's growing activity in literature and journalism after 1830 reflected their broader participation in the construction of national life and their struggle for political and legal rights. In so doing they did not reject what they saw as their essential nature as women but, rather, aimed their social and historical commentaries toward garnering more justice and equality for women as mothers and citizens of the nation.[44]

Juana Manuela Gorriti, an Argentine who lived between Buenos Aires, Lima, and La Paz, became one of the best-known writers of her time. Exiled with her family under the Rosas regime in 1831, Gorriti moved to Bolivia where, at fourteen years of age, she married Manuel Isidro Belzú, an army officer and future dictator of that country. While in Bolivia Gorriti exhibited many of the traits of her fellow countrywomen in Argentina. "In honor of [my new Bolivian friends], I organized a literary society which I named 'The Gentlemen of the Golden Spurs,' which gathered weekly for programs of readings, music and speech giving. All this, spiced with occasional forays into criticism, rich in spiritualism and in explorations of new horizons."[45]

After Gorriti returned for a visit to Argentina in 1842, she recorded her experience, which she later published in *Sueños y realidades* (Dreams and Realities). Coming home after years of exile was a powerful moment. "My eyes gazed in indescribable delight and indescribable pain, at that enchanted panorama which, constantly present in my memory, unfolded itself before me." She thrilled at seeing the hills and meadows covered with flowers "that I used to skip about gathering." Manuela recalled how her mother worried so much for the welfare of her children. "She still did not perceive the black cloud of griefs and tears suspended above those smiling faces. How merciful You are, My God, when You hide the future from us! Thus she enjoyed long happy days among the flowers that hid the abyss that has devoured us." The black clouds and devouring abyss surely represented the rise of Juan Manuel de Rosas and her family's sufferings in exile. "Ah! Only the exile, the invalid, the orphan and the pilgrim can appreciate what is most noble, generous and tender in the souls of my beautiful compatriots. Anyone in power finds

them proud and untamable because, like the locked cover of the Holy Book, they guard the treasures of their heart for the helpless."[46]

After 1830, women also began making a more direct literary contribution by asserting their own voice through journalism. Female journalism during this period reveals that, much more than appendages to their men, women created their own sense of community and took part in the political and cultural formation of the Argentine nation.[47] Women attacked the secular power of the Roman Catholic Church; they debated domestic social policy, including the effects of positivism as well as women's relationship to scientific advancement; and in general, they defended women's rights of public expression.[48] This was a delicate balancing act since even the fiercest advocates of women's rights also believed that women should preserve their femininity and avoid appearing too masculine. That meant juggling the idea that women had the right to express their own ideas along with the view that women should be "angels" in the home. One newspaper editorial captured a part of that juggling act. "Egotism is a trait of men; abnegation is the essence of women. . . . In all aspects of a woman's life, one sees traces of abnegation. She never has her own will: as a girl she sacrifices her desires to the whims or caprices of her parents, as a wife she sacrifices them to her husband or the love of her children."[49]

The first female-edited paper, La Aljaba, began in 1830, after Rosas came to power.[50] La Aljaba focused mainly on domestic issues. In their opening prospectus, the editors stated that since La Aljaba belonged to its female readers, it would present a feminine discourse, and "say nothing that will offend your delicate nature." The paper would abandon the concerns of Mars, the god of war, in favor of topics "more fitting to the orbit of female duty, showing you the pillars of religion, the August temple of morality, and all of the paths that will lead you therein."[51] The editors continued by quoting an old sage who once remarked, "If you want to know the men of a nation, first get to know its women." Hopes for the paper's impact ran high: "Oh, what a monument I would raise to my Aljaba if her arrows, drenched in the honeyed liqueur of truth, sweetly and gently penetrated the hearts of the fair sex of Argentina!!!"[52]

Although the paper exalted the ideal of the Republican Mother by promising to remain within the realm of the domestic, it also provided some wider social criticism that was not so traditional. The paper advocated female education in the sciences and rejected the idea that education corrupted women. The poor state of female education was one

of most serious of the "infinite grievous injuries inflicted on us by our oppressors." Many times women were even prohibited from learning the alphabet, because some men believed that women who knew how to read and write were immoral. "Can a man demonstrate his stupidity any more effectively?" asked the editors. To say that knowledge corrupts young women is "the biggest piece of nonsense in a disordered brain. Not only should mothers attend to the education of their daughters, but they should assure that mothers are getting a quality education."[53]

While *La Aljaba* was not a radical proponent of feminist thought, it did attempt to bolster women's stature in Rosista society and challenge oppressive ideas of gender relations, especially regarding education. One last example of *La Aljaba*'s social criticism takes aim at one of the root causes of female subordination to men: the Biblical interpretation that women were intellectually inferior to men because of Eve's transgression in the Garden of Eden. "Have not men seen the equality, equity, and justice in God's words when he speaks to two beings which he made in his image?"[54] *La Aljaba* ran for just three months after which it was shut down, an act attributed to the conservative Rosas regime.

After the fall of Rosas, female journalism became more aggressive and expansive. *La Camelia*, which appeared in 1852 and was most likely edited by Rosa Guerra, brought a more strident voice for women's rights. Like other women before them, the editors of *La Camelia* continued revising the creation story from Genesis. "The Old Testament teaches us that God created woman, not from the dust as he did Adam, but from the rib of a man. We also know that Eve was His final creation. Hence, no one can accuse us of being vain if we sustain that she was. . . . *the more perfect.*" Accompanying their provocative rhetoric, the authors of *La Camelia* showed how their feminist discourse encompassed, and even celebrated, many traditional aspects of femininity, saving their scorn for what they perceived as social injustices. Like many of her contemporaries, Rosa Guerra found inspiration in the writings of Rousseau. She agreed with the French master that "tenderness, compassion, benevolence, and love are the sentiments [a woman] experiences, and those that move her most frequently." But women's nature contrasted sharply with men's abusive character, which threatened to destroy women's lives, "casting seeds at the roadside of a fertile earth that should produce flowers instead of thorns." The editors concluded their essay with the words of Jesus as he lay on the cross: "Forgive them Lord, for they know not what they do."[55] The authors of *La Camelia* acknowledged and celebrated their feminine

roles but forcefully demonstrated that passivity and submission were not included in their list of female virtues. One of many possible readings of this text is that these women were proud of their femininity, but their frequent reference to Scripture indicates that they wanted men to exhibit a truly Christian masculinity that reflected the equality of God's human creation.

La Camelia also ventured into the realm of social critique through fashion. By the 1850s petticoats were in fashion and became a subject of discussion in the city. In a letter to the editor on 22 April 1852, "a few subscribers" lamented the widespread use of large petticoats. "This fashion is very pernicious. Besides being ridiculous, it does not benefit the girl that wears them at all." In addition to the discomfort of wearing them, the petticoats were so large that they created logistical problems in the streets and in homes. Women bumped into posts and scraped the sides of buildings when walking down the sidewalk. Furthermore, in a comfortable house, only two petticoat-clad women could fit on a sofa, while at a soirée, three or four couples waltzing took up the whole room. "All of this is due to that article of clothing that our fellow countrywomen wear, even though we are in the heat of summer, for no other reason than it being in style." The authors of this piece could think of "a thousand reasons" why such a "terrible fashion" should be changed. "Finally," they concluded, "we hope that the beautiful Argentines will exhibit more prudence and thrift, and fewer petticoats."[56]

While one can see this purely as a statement of fashion, the paper's editors may have printed this editorial with other critiques in mind. "As Montesquieu wrote a *Spirit of Laws*, so could I write a *Spirit of Clothes* . . . for neither in tailoring nor in legislating does man proceed by mere Accident, but the hand is ever guided on by mysterious operations of the mind."[57] So wrote the nineteenth-century Scottish historian and essayist Thomas Carlyle as he pondered the political and cultural significance of clothing. In this regard, a commentary on fashion can take on ideological implications. The attack on large petticoats becomes a feminist discourse that attempts to free the female body from impractical and ornamental clothes that symbolically kept it bound. The article can also be seen to question, though perhaps not repudiate, blindly following European fashion in a new world where European clothes did not make much sense. Just as large petticoats did not fit in the sweltering humidity of Buenos Aires, neither might certain aspects of European social and political culture.

La Camelia also fought for the value of female intellectual integrity over physical beauty. "Without being young and pretty, neither are we old and ugly," its editors declared. According to Francine Masiello, it was in *La Camelia* and the other female-edited papers that, for the first time, "the feminine body, fashion, taste, and language of women, and how men perceived these elements" became public discussion.[58] These ideas show a continuity with Emilia P.'s editorial from *El Observador Americano* forty years earlier when she complained about men only being interested in her beauty and not her intellectual ability. Now the debate was being carried on by women on their own terms in their own work.[59]

Under the direction of Juana Manso de Noronha, the *Album de Señoritas*, beginning in 1854, was the most hard-hitting women's periodical of its time. Manso took advantage of her world travels, much of which she did while exiled during the Rosas years, to enrich her publication. In the first edition, Manso outlined the purpose of her paper: "To emancipate [women] from crude and outdated ideas that have prevented them from using their intelligence, that have subjected their liberty, and even their conscience, to arbitrary authority that opposes nature itself." Manso wanted to prove that a woman's intelligence, "far from being absurd, or a defect, a crime or a foolish expression" was her best attribute. Intelligence was the "true source of her virtue and of domestic happiness because God is not contradictory in his works, . . . for God made [men and women] equal in their essence."[60]

The *Album de Señoritas* offered opinions and critiques on a wide range of issues. Manso initiated a more direct and aggressive attack on European-centered themes in favor of American subjects. "The American element will dominate exclusively in these articles," Manso stated in the inaugural issue on 1 January 1854. "We will leave Europe and its secular traditions, and when we travel, it will be to admire the robust nature and the imponderable riches of our continent. [In Europe] lies the thought of man and the dust of thousands of generations! Here, the thought of God—pure, grandiose, primitive—which is impossible to think of without being inspired."[61] At a time when many Argentine political leaders and intellectuals looked to Europe for inspiration and population, Manso at least recognized that America, in its broadest sense, held value for Argentine society.

Manso also eagerly expressed her views regarding the social and political problems of the day. This included criticizing the continued efforts

to conquer the Indian tribes of the pampa. Ironically, it was Governor Rosas, the reason for Manso's exile, who had achieved a tenuous peace with the Indians of the frontier. After the fall of Rosas, his successors in Buenos Aires violated the alliances and treaties Rosas had brokered with the Indians, and a new era of hostilities erupted in 1854 and 1855.[62] It was this new outbreak of conflict that provided the context for Manso's article. "Could there be ways of persuading those unfortunate [Indian] souls other than with saber and lead?" she asked. "Is it not possible to conquer all of those hearts for God, those intelligences for society, and those hands for the development of our uncultivated deserts? Yes, we believe that this can be done, and this armed expedition should be the last to embark against the Indians."[63]

The Roman Catholic Church and its relations with the state were also subjects of Manso's pen. When a religious argument erupted between Catholics and Protestants in Buenos Aires, Manso feared that her country would return to the brutal past of the Rosas regime. "What!? After twenty years of iron dictatorship, after twenty years of political inquisition, are we condemned to see the unfurling of the Catholic banner, black and embedded with bones and skulls? What is this, marching in front of *los autos de fe* and the inquisitorial tortures? Or are we in a *free country* where the *liberty of conscience* is not a vain word and without philosophical sentiment?" Manso believed that the Church had strayed from its traditional purpose and spirit. "Don't you know that between Catholicism and Christianity there is an abyss!!! Do not provoke a fight, because you will lose! Respect the freedom of conscience . . . because there are no more Holy Alliances of popes, cardinals, and kings— delinquents all!"[64]

Continuing her attack on Church policies, Manso claimed that "fanaticism is dead and cannot be resurrected. The true Christian spirit is resplendent over bickering, ambition, and human combinations." She urged Roman Catholic leaders to focus on the "true spirit" of religion as outlined by Christ in the Gospel of St. Matthew. "Go and preach that the kingdom of God is at hand. . . . Do not possess gold nor silver in thy purse. . . . Do not prepare for the way, not two tunics, nor shoes, nor walking stick. . . ."[65] This was a clear reference to the idea that the Church should retreat from the political and economic affairs of the country and concentrate on its spiritual duties, sentiments shared by many liberals since the early nineteenth century and before.

Like some of the other female journalists discussed above, Manso

cherished important elements of femininity, which, in her case, included motherhood. She did not find a contradiction between her feminist activism and this aspect of her female identity. In January of 1854, Manso's young son was very ill, and the stress affected her writing. She confided to her readers that "before being a writer, I am a mother, and this charge brings immense responsibility and gives me serious duties."[66] Less than a month later, her son's death left her in the pit of despair. "I now labor here over the epitaph of my beloved son, whose premature death is one more deception of life for his mother, one more drop of bitterness in the chalice, one more thorn in the soul! . . . *Adios*, readers." Her depression brought on intense introspection and self-criticism. "Forgive me if, being accustomed to writing in another language, I did not use a pure tongue; if my scant intelligence did not create anything useful for you, and if my style does not have the fluidity and freshness of others. It was not desire that I lacked, but each person *is as they are, not as they should be*."[67] Despite these self-effacing remarks, Manso's is among the brightest and most lucid female voices of the nineteenth century.

Female literary activity reveals a space women found and exploited to insert their voice into debates ranging from the domestic sphere—such as motherhood, femininity, and fashion—to the public and even the national sphere, as seen in the articles on Indian policy and church-state relations. While much of society saw the role of women being mainly one of the Republican Mother raising moral children to populate the new nation, this vital female role served as a springboard for female intellectual debates that touched on the very nature of the new Argentine nation and its future direction.

New spaces for women in literature represented a vital but symbolic form of power in the abstract world of literature. Although female-edited newspapers did not last long, those same women remained active in their writing for male-edited publications. By the early 1870s, *La Ondina del Plata*, though edited by a man, featured women's writing and stayed in circulation for four years.[68] Women were also active and present in other spheres of society. How did female agency play out in the tangible world, in the institutional and legal arenas of Buenos Aires?

Institutional and Legal Presence

In conjunction with the increase of literary activity, women gained stature in more institutional forms as well. The progress in female education discussed earlier is one important area of progress. The founding of

the charity organization the Sociedad de Beneficencia in 1823 is another example of increased institutional power for women. Writing of the Sociedad's foundation, the weekly *El Centinela* declared that "at last a step has been taken in Buenos Aires to remedy an abuse that, for centuries, has been an affront to the human race. For that is how we classify the degradation in which one half of our kind has buried the other. Women have always been the victims of male pride and selfishness."[69] In the official dedicatory speech of the society, the secretary of government and minister of external affairs declared that the main goals of the society were to perfect morals in the country and to cultivate the spirit of *el bello sexo* (the fair sex). "In all countries it has been a great injustice not to put women on the same plane as men." He also encouraged women to continue to move into areas previously dominated by men, and to remember that productive women would be true companions to men. The minister concluded by reminding Argentine women that "the country expects a great deal from you. May my last words remain eternally in your hearts, as is the prosperity of the country which you are to serve."[70]

Women also appeared to be taking more initiative in legal actions as the nineteenth century progressed. In the disenso cases, for instance, women increasingly took the lead in bringing their cases to court. When Marcelina Maldonado's mother opposed her marriage to Blas Olariaga, Marcelina initiated the suit herself. She told the judge that, "in my humble opinion, I do not find her reasons just," and thus asked that the judge grant her permission to marry.[71] Over time, the number of women initiating disenso suits grew. In the 1810s, one case was initiated by a woman. The 1820s and 1830s had four cases each decade. During the 1840s, however, that number jumps to eight, and four cases were initiated by women in the first three years of the 1850s. While these numbers cannot provide conclusive proof of all female legal action, they do suggest a rise in female legal activity in the disensos. Patriarchal control over marriage pertained more to the control of women than of men. Men usually postponed marriage until after they reached the age of majority, when they no longer needed parental permission to marry. Hence, marriage controls, including the Pragmatic on Marriage, did not apply to men as much as they did to women, who more frequently married as minors. In a very real sense, the increased freedom to marry found in the disenso cases represented a victory (though not a complete one, of course) of single women over patriarchal authority. Ironically, it is during the 1840s that women are the most active, during the height of the dictatorship of Juan

Manuel de Rosas. By this time couples were winning a larger majority of cases.

Women also frequently initiated child custody suits and had done so during the colonial period as well. One particular child custody case from 1845 offered a radical critique of the traditional patriarchal order while promoting the rights of motherhood. The case involved Damiana Vidal, narrated in part in chapter 2, who was trying to gain custody of her son, Ignacio Lara Jr. In his will, her husband had placed their son in the custody of another woman, and after her husband's death, Damiana went to court to fight for custody of her son. The judge ruled that the father's last wish should be honored.[72]

Damiana's appeal to the judge challenged the traditional conception of patriarchal power and proposed that women receive more rights over their children. Damiana's plea to the judge reveals both the submissive nature that women were expected to possess, as well as the agitation against those norms. She told the judge that she could not understand why her petition was rejected, since it was based on her natural right as a mother. While her husband was alive, she had allowed her maternal rights to be "suffocated for so long out of marital respect and to maintain, at all costs, that matrimonial harmony so recommended by our church and vital to the conservation of the fundamental institution of the family." After her husband died, Damiana thought that would all be over and that she could be with her son again.[73]

The judge, however, ruled to uphold the dead husband's will. For Damiana and her lawyer, the very thought that her dead husband could still control custody of her son seemed unnatural and absurd. "By chance have we returned to the antiquated jurisprudence of Rome, where fathers could treat their children like they were owned objects? Which of our codes, your honor, contains laws that sanction a father's giving up of his children, violating maternal rights in the process? Long gone is that era of barbarism, when the father was a despotic sultan and could do with his children whatever he desired. Today, paternity excludes domestic absolutism, and jurisprudence recognizes inalienable and sacred rights in all family members. Giving up a child, trampling the rights of the mother, is a throwback to the infancy of the world!"[74] Taking this line of argument, the remnants of Roman law that endowed fathers with quasi-absolutist rights and remained in place in Argentine law were outdated. Although we do not know the end of this case, what is striking is the strong and vociferous defense of maternal rights that questioned the

interpretation and the extent of traditional patriarchal authority as it was still upheld in Buenos Aires. Whether it was an Enlightenment-inspired rant against abusive patriarchal authority in custody suits or challenging paternal opposition in disenso cases, women powerfully demanded their rights in court, even during the height of the Rosas regime, renowned for its conservative nature.

Many conservative observers disapproved of any changes in gender relations after independence. That some felt the need to express their opposition to transgressive behavior is itself evidence that changes were indeed occurring. Critics focused on women who broke the bounds of the domestic and entered into the public sphere, and those critics resorted to traditional legal and cultural mechanisms to keep women in their proper place. One disgruntled observer of porteño society commented that "it is shameful, and in every sense scandalous, the free manner in which a considerable number of patrician young women express themselves with attention to matters of politics which the worthy sons of the fatherland have made possible through their personal sacrifices."[75] Women who ventured to become writers for a public audience also became targets. Lucio Mansilla, ironically the brother of the famous female writer Eduarda Mansilla, expressed his indignation regarding women writers in the following manner: "When will our families in America become convinced that female writers are dangerous, and that achievement in other areas is much more important than graceful writing, such as knowing how to sew, iron, and cook?"[76]

The question of women's legal rights was another point of contention. In some instances the nineteenth century was one of retrogression for women because the new civil code of 1869 codified female inferiority by, among other things, making married women unable to represent themselves in court.[77] In some cases, then, the proverbial glass of the nineteenth century was half empty in terms of progress for women. At the same time, however, some jurists sought to strengthen women's legal rights in other areas. Manual J. Navarro, for example, used his law school dissertation to argue that women should be given the right to adopt children, and that they had the same capacity as men to raise those children. "It is a philosophical spirit that guides me to demonstrate the injustice of the laws still in effect. . . . A woman, by her nature, and on the basis of our civil law, is equally or better prepared than a man to exercise the right of adoption." Women had great capacity to raise children and teach them appropriately, and hence should be granted

this fundamental right.[78] The "advances and retreats" in the nineteenth century are reminders of the vastness and complexity of studying gender relations.

Conclusion

Many traditional attitudes regarding women and gender continued after independence. Women were still seen primarily as mothers whose true place lay within the confines of the home, and women were subjected to strict legal codes that subordinated them to men. Nevertheless, independence ushered in new and more open attitudes toward women that increased during the nineteenth century. Both men and women understood that mothers would play a key role in shaping the new nation after independence. Female writers and journalists supported the ideal of women as Republican Mothers—women who needed to be educated in order to raise loyal citizens of the nation. As Juana Manso reminded her readers, "And don't think that *the family* is not of great weight in the balance of nations, nor that the demoralization and the unjust backwardness of its individuals does not influence collective society for good or bad."[79] The rise of female education, demanded by women and instituted by Rivadavia, Sarmiento, and others, had a direct correlation with the later rise of feminism in Argentina and other Latin American nations.[80] Indeed, Buenos Aires was the cradle of feminist movements in the region and boasted some of the first female professionals.[81] Women's voices also became more common and powerful in the legal arena as women challenged traditional ideas about patriarchal control over marriage choice and child custody.

While these changes do not reflect a radical revolution in female rights, they do show that popular attitudes and practices were changing. New attitudes influenced the interpretation and implementation of legal codes from the colonial period and demanded that some of the old laws be changed. As Francine Masiello has argued, "When the state finds itself in transition from one form of government to another, or from a period of traditionalism to a more modernizing program, we find an alteration in the representation of gender. A different configuration of male and female emerges, modified according to the historical period and the nature of national crisis."[82] The sizeable project of building that new republic in Argentina included important contributions from women both as Republican Mothers *and* active participants in the discourse of national development.

Epilogue
An Old and a New Beginning

In the 1850s and 1860s, Argentina experienced another important tran-
sition. Juan Manuel de Rosas fell from power in 1852 at the hand of his
former ally, General Justo José Urquiza, governor of the Entre Ríos pro-
vince. Urquiza was promptly elected president of the Argentine Confed-
eration with its new Constitution of 1853. Buenos Aires initially refused
to join the other provinces but finally united with the Confederation
under the leadership of Bartotlomé Mitre in 1861; Mitre was later elected
as president of a united Argentina (1862–68). As Mitre and the other
framers of the new order considered their tasks, many traditions of the
past remained with them.

Some of these evidenced themselves when Mitre's government de-
cided Argentina should at last have its own code of laws. The man given
the task of writing the new civil code was the respected jurist Dalmacio
Vélez Sarsfield. As he went about his work, Vélez Sarsfield drew inspira-
tion from Hispanic tradition as well as from numerous European law
codes. Many of the new codes aroused the ire of reformers who had
hoped for a more progressive set of laws. For instance, many wanted
Argentina to follow France and other modern nations by instituting civil
marriage, but to their dismay Vélez Sarsfield left marriage for Argentine
Roman Catholics in the hands of the Church. "People who follow the
Catholic faith," he reasoned, "could not pursue a civil marriage. It would
lead to a perpetual concubinage condemned by their religion and by
the traditions of the country. The law that authorizes such marriages
in our society would ignore the mission of laws in general, which is
to support and strengthen the power of tradition, not to corrupt and
enervate them. It would serve to incite Catholics to disregard the pre-
cepts of their religion without providing anything favorable to the family
and the nation."[1] Vélez Sarsfield's idea that laws should bolster custom
highlighted the great tension between traditionalism and modernity,

between persistence and change, felt in Argentina and throughout Latin America in the nineteenth century.[2]

That tension also existed in the porteño family, the basic building block of the nation. Colonial law codes remaining in place after independence perpetuated many attitudes and norms of family life. Patriarchal power over wives and children persevered in many ways as it had in the past. Traditional ideals of family life also helped smooth the transition from colony to nation. An honorable family was one with legally married parents who raised their children properly, according to their social status. Old habits of racial and class discrimination also survived the transition to nationhood. The persistence of old ways serves as a reminder that the May Revolution represented only the beginning of a nation-building process.[3]

Alongside these continuities emerged changes that significantly altered porteño society. Enlightenment-inspired ideas of reform were powerful in the eighteenth century in Spain and its American colonies, but independence energized many of these ideas and created a dynamic new arena for their implementation.[4] The May Revolution of 1810 and the Declaration of Independence in 1816 brought with them new expectations and hopes. While the struggle for nationhood was long and hard, the dream of a unified nation animated the thoughts and actions of leaders and commoners in Buenos Aires and elsewhere from the earliest days of the May Revolution.[5] That dream, both pragmatic and ideological, was to build a strong independent nation that possessed the freedom, liberty, and equality of an American republic.

A new nation required a new identity. An identity built on consensus was as elusive for Argentina as it was for many nations in the Americas. Identity was always fragile and contested, as the federalist-unitarian conflicts bitterly revealed. Nevertheless, the political realities of independence, beginning with the fight against the British and then against the Spaniards, mobilized and unified the masses more than ever before. The Enlightenment ideals of liberty and equality contributed to the abolition of social titles, military and ecclesiastical privileges, the slave trade, and eventually slavery itself. Gauchesque poetry, new educational curricula, new rituals and celebrations were also part of a budding national identity. Society became more secular after independence, and interfaith marriages more common. The neo-Egyptian obelisk erected in the Plaza de Mayo and the new façade on the Cathedral provided

further indication that porteños were searching for a new identity that was not Spanish.

The monumental task of nation-building also required strong families to populate the nation with responsible citizens. Although this study focuses on the region of Buenos Aires, porteños took part in national debates over issues of family and nation, and parents, children, judges, and lawyers frequently referred to the nation as a beneficiary or victim of state policies and familial behavior.[6] In this context the state sought to protect children and assure that they were raised in such a way that, at least, would not undermine national stability and, at most, would produce individuals capable of contributing to society. Educational curricula demonstrated an increased focus on the importance of children and showed the early stages of an interventionist state that would bloom more fully in the late nineteenth and early twentieth centuries. As declared by figures ranging from governor Aráoz of Tucumán to judges in the civil courts of Buenos Aires, the need to populate the nation with good citizens meant that the state should facilitate the formation of stable families. Hence, couples received more freedom in court to marry the mate of their choice, despite parental opposition, and despite social and racial differences that had been bolstered by the late colonial Pragmatic on Marriage. Suitors could be deemed worthy even if they were poor or of mixed blood as long as they were honorable and hard-working, for as the judge said of Amond Amondsen, "the honorable poor frequently make of themselves rich men."[7] Indeed, Marquita Sánchez's recollection from the 1860s was accurate: "Oh youth of today! If you only knew of the suffering of the youth of yesteryear, you would know how to appreciate the happiness you enjoy!"[8] The combination of ideological and practical concerns after independence moved Argentina toward a more modern nationhood and porteños toward a more modern family structure.[9]

For women in particular, new ideas had been fermenting since the revolutionary wars that expanded the rights of men to include discussion of the rights of women.[10] The stature of women increased as they came to be valued as mothers of a robust citizenry. Women therefore needed to be emancipated, through education, from the outdated ideas inherited from centuries of Spanish colonialism. The women who benefited from Bernardino Rivadavia's and Domingo Sarmiento's educational reforms provided groundwork for change later in the century. Although women were still on the edges and margins of society as they were in other American nations, in many respects, as the nineteenth

century progressed, they took a more active role in society.[11] Whether it was a woman writing a newspaper editorial praising the idea of female education and lamenting male preoccupation with physical beauty; or Juana Manso heading up her own periodical; or Damiana Vidal fighting for the custody of her child against her dead husband's will, women entered into public debate and into the public sphere more than ever before.[12] Although the new civil code restricted women's legal rights and thus did not live up to the expectations of some reformers, women in Argentina rallied to form some of the first feminist movements in Latin America.

The aspirations for change held by many citizens in Buenos Aires had their parallel in the legal world of Buenos Aires. Soon after the May Revolution, jurists began crying for legal reform. By the late 1860s, as publication of the new civil code drew near, the debate had grown significantly, especially as it became evident that Vélez Sarsfield was clinging to tradition perhaps too longingly. In his 1867 law school dissertation, Leopoldo Basalvibaso denounced Vélez Sarsield's new code because, in his mind, it bound Argentina too tightly to its colonial heritage. Our laws should not "sustain and promote the power of tradition, when those traditions are the legacy left us by the fanaticism of the *conquistadores* and the law codes of monarchy." Reflecting on the impact of the May Revolution, Basalvibaso wrote that "it is true that the *conquistadores* of South America left these people with the [Trojan Horse] of Catholicism. But it is also true that the Revolution of Independence that shattered the chains that tied us to Spain, also broke the preponderance of Catholicism."[13]

Basalvibaso envisioned independence as a rupture that called for new laws to fit the new republic. His call joined a chorus of other reformers, beginning with the May Revolution of 1810, who wanted to bring Argentina's legal and social realities up to date with its political status as an independent nation. Among that chorus was Bernardo Monteagudo, who argued in the early nineteenth century that Argentina needed to "erase the vestiges of domination." His contemporary Mariano Moreno suggested that Argentines remember the old laws as "a monument to our degradation." Another critic pointed out how colonial laws were made without any input from local Argentines. Even during the time of Rosas, critics were free to attack much of the old order. In 1830, one newspaper commented that the current laws had been "sanctioned during the time of Spanish barbarism and despotism." In 1834, Gregorio Alagón wrote

that the old Spanish laws should be abandoned because they were made "for a people whom Spain wanted to keep down in slavery and obscurity of ignorance."[14]

In 1843, Bernardo Irigoyen summarized the issue well. "Laws should change in harmony with the inclinations and maturity of a nation. If a people exchange their bondage for liberty, either gradually or through violence, the laws should also change. Nothing is more difficult than trying to reconcile the laws of tyrants with the existence and happiness of a free people . . . A free, independent, and enlightened people like ours cannot be completely happy while being governed by laws born in obscurity and ignorance, fashioned by men with ideas and feelings contrary to ours that belonged to a time when it was a crime to espouse the noble principle of equality." The old laws may have helped "guide men through the darkness of the past, but in a century full of light like the present, those laws only serve to retard our progression on the path of truth. . . . There is not one point of harmony between us and the laws that govern us."[15]

Examining the material from the civil cases along with the views of Bernardo Irigoyen and others reveals a fascinating and important connection between the theoretical and intellectual world of jurisprudence and the everyday life of citizens in Buenos Aires; between what lawyers, judges, and politicians thought about the laws governing society and how those laws affected the lives of porteños. Societal attitudes and practices often change before laws change, and although certain laws were abolished after 1810 that explicitly contradicted revolutionary ideology, the vast majority of colonial statutes remained in place in the new republic. During the transition period from colony to nation, the *interpretation* and *application* of many old civil laws began to change under the pressure of new social and political realities.[16] Men, women, mothers, fathers, and children all told their stories in court. Lawyers helped argue the cases, and judges passed the final rulings, frequently in the name of benefiting the nation. Although tension between old ways and new ways persisted, as the nineteenth century progressed, reformist views from behind the tribunal benches, and from the classrooms of the University of Buenos Aires' law school, coalesced with the wills and desires of everyday people who also wanted to challenge tradition.

Among them were couples like Francisco Armero and María de la Encarnación. In 1818, they had been engaged for some time, waiting patiently for María to reach the legal age of marriage—twelve. When

her birthday finally arrived, her parents withheld their consent. In their eyes, María was too young. Undaunted, an anxious Francisco went to court, where he recognized a parent's right to oppose a marriage, but only if that opposition was "just and rational." Speaking of the colonial Pragmatic on Marriage, the young suitor then added an ideological twist to his argument that revealed part of the Enlightenment's influence in Buenos Aires. Francisco contended that the royal decrees on marriage sent to the Americas by the "old Spanish government" should be obsolete in the new republic, for such regulation "opposed the natural liberty of mankind to choose freely his way of life."[17] The judge agreed and granted them permission to wed.

Independence did not erase the legacies of colonial society. However, the May Revolution ushered in a process of practical and ideological nation-building that significantly altered relationships of family and nation. As Alexis de Tocqueville observed of another revolutionary society, the American Revolution brought more equality within families in the United States. In its own unique way, Argentina also participated in the grand experiment of freedom in the Americas. After 1810, the "natural liberty" so eagerly sought by Francisco Armero and his twelve-year-old fiancée María had *begun* to displace the former attitudes and laws of the "old Spanish government" and society.

Francisca Canicoba and her ugly suitor Gumesindo Arroyo also confronted old laws and attitudes. Francisca and Gumesindo are, perhaps, unlikely figures with which to begin and end this story. They were not famous politicians or thinkers, and according to Gumesindo, he was not even that ugly, at least when compared to Francisca's father. Yet in some ways Gumesindo and Francisca are perfect for the role. His homely appearance in court testified of the literal and figurative buffeting of an everyday life caught between love, gender, and an emerging nation-state. Nonetheless, Francisca and Gumesindo withstood their trials with dignity, hard work, and honor. Francisca, a strong-willed woman, bravely resisted her father's patriarchal prerogative so that she and Gumesindo could fashion a life together. Francisca's predicament laid out an important dilemma for her time, and for all time: Should she sacrifice her personal happiness and give into patriarchal authority? Should she concede to the unreasonable and irrational opposition of her father and perhaps preserve some familial harmony, or should she challenge her father in court to marry the man she loved? Her self-fulfilling answer, and that of the many others who challenged legal, cultural, and political traditions,

points to a society in transition from a colony toward a modern nation. The uniqueness of Gumesindo's case as an ugly suitor only highlights the common character of his and Francisca's lives, which they, along with hosts of other common people, navigated through the ideals and realities of daily life in Buenos Aires.

Notes

Abbreviations

AGN TC Archivo General de la Nación. Tribunales Civiles.

AHPBA Archivo Histórico de la Provincia de Buenos Aires, "Ricardo Levene."

Introduction

1. AHPBA 7.5.15.20. Francisca Canicoba. Sobre disenso. 1842.

2. Nelly Porro and Susan Socolow have both conducted excellent studies that analyze the late colonial period but do not extend into the national period. See Nelly Porro, "Los juicios de disenso en el Río de la Plata. Nuevos aportes sobre la aplicación de la Pragmática de hijos de familia," in *Anuario Histórico Jurídico Ecuatoriano* 5 (1980): 193–229 (Quito, Ecuador: Corporación de estudios y publicaciones); and Susan M. Socolow, "Acceptable Partners: Marriage Choice in Colonial Argentina, 1778–1810," in *Sexuality and Marriage in Colonial Latin America*, ed. Asunción Lavrin, 209–46 (Lincoln: University of Nebraska Press, 1989). For work on similar cases in colonial Mexico, see Patricia Seed, *To Love, Honor, and Obey in Colonial Mexico: Conflicts over Marriage Choice, 1574–1821* (Stanford: Stanford University Press, 1988). Studies that go into the national period include Mark D. Szuchman's "A Challenge to the Patriarchs: Love Among the Youth in Nineteenth-Century Argentina," in *The Middle Period in Latin America: Values and Attitudes in the 17th-19th Centuries*, ed. Mark D. Szuchman, 141–66 (Boulder CO: Lynne Rienner Publishers, 1989), and Carlos Mayo, "Un loco amor. Romances juveniles perseguidos (para una historia del amor en la sociedad rioplatense) (1770–1830)," *Investigaciones y Ensayos* 49 (1999): 487–506. Ricardo Cicerchia has also used civil and criminal cases to examine the continuities in the family between the late colonial and national periods. See Hector Ricardo Cicerchia's *La historia de la vida privada en la Argentina* (Buenos Aires: Troquel, 1998) and his "*La vida maridable*: Ordinary Families in Buenos Aires (Argentina, 1778–1850)," Ph.D. diss., Columbia University, 1995.

3. The doctrine of marriage as a sacrament that needed to be entered into

freely was solidified during the Council of Trent in the mid sixteenth century. For more discussion on this matter, see Daisy Rípodaz Ardanaz, *El matrimonio en Indias: realidad social y regulación jurídica* (Buenos Aires: Fundación para la Educación, la Ciencia, y la Cultura, 1977), 261. See also Seed, *To Love, Honor, and Obey.*

4. The Pragmática sanción para evitar el abuso de contraer matrimonies desiguales can be found in Richard Konetzke, *Colección de documentos para la historia de la formación social de Hispanoamérica* (Madrid: Consejo Superior de investigaciones científicas, 1962), 3:406–13.

5. This distinction was important for the city of Buenos Aires, where colonial censuses reveal a population made up overwhelmingly of whites and blacks with very little Indian presence, at least officially. See Marta Goldberg, "La población negra y mulata de la ciudad de Buenos Aires, 1810–1840," *Desarrollo Económico* 16 (April–June 1976): 61.

6. Hugh Cunningham, "Histories of Childhood," *American Historical Review* 103, no. 4 (October 1998): 1203.

7. For an excellent discussion of this subject for the colonial period, see Viviana Kluger, *Escenas de la vida conyugal: Los conflictos matricmoniales en la sociedad rioplatense* (Buenos Aires: Editorial Quorum, 2003). See also María Selva Senor, "La construcción de la 'familia ideal.' La familia segun los jurisconsultos de la Universidad de Buenos Aires, primera mitad del siglo XIX," paper presented at 51 Congreso Internacional de Americanistas, Santiago, Chile, July 2003.

8. As Patricia Seed noted, "words, sentences, and phrases can have more than one meaning and more than one interpretation simultaneously." See Patricia Seed, "Colonial and Postcolonial Discourse," *Latin American Research Review* 26 (1991): 183.

9. Family history in Latin America has expanded markedly over the last few years. Pioneering works include Daisy Rípodas Ardanaz, *El matrimonio en Indias: realidad social y regulación jurídica* (Buenos Aires: Fundación para la Educación, la Ciencia, y la Cultura, 1977). Pilar Gonzalbo Aizpuru has conducted extensive seminars on family studies in Mexico that have produced numerous and useful edited volumes: *La familia en el mundo iberoamericano* (with Cecilia Rabell) (México City DF: Instituto de Investigaciones Sociales, 1994); *Género, familia, y mentalídades en América Latína* (San Juan PR: Editorial de la Universidad de Puerto Rico, 1997); *Familia y educación en iberoamérica* (México City DF: El Colegion de México, 1999; *Familias iberoamericanas. Historia, identidad y conflictos* (México City DF: El Colegio de México, 2001) published by El Colegio de Mexico. Mark Szuchman has produced pathbreaking scholarship

on the family in Argentina. See his *Order, Family, and Community in Buenos Aires* (Stanford: Stanford University Press, 1988). José Luis Moreno used similar sources to look at issues of illegitimacy and children in family life. See his *Historia de la familia en Río de la Plata* (Buenos Aires: Editorial Sudamericana, 2004); "La infancia en el Río de la Plata: Ciudad y campaña de Buenos Aires 1780–1860," *Cuadernos de Historia Regional* 20 (1998): 83–118, and "Sexo, matrimonio y familia: la ilegitimidad en la frontera pampeana del Río de la Plata, 1780–1850," *Boletín del Instituto de Historia Argentina y Americana Dr. Emilio Ravignani*, no. 16/17 (1998): 61–84. Silvia Mallo has also looked at divorce cases during the late colonial and early national periods in the Río de la Plata. Silvia Mallo, "Justicia, divorcio, alimentos, y malos tratos en el Río de la Plata, 1766–1857," *Investigaciones y Ensayos* 1991: 373–400.

10. As quoted in Szuchman, *Order, Family, and Community*, 101.

11. As Asunción Lavrin has noted, "the state and the church have also seen the family as the locus of moral and political socialization." See Asunción Lavrin, "Introduction: The Scenario, the Actors, and the Issues," in *Sexuality and Marriage in Colonial Latin America*, ed. Asunción Lavrin, 1.

12. Elizabeth Kuznesof has argued that, while social class serves as a major unit of analysis for many scholars in other fields, in Latin America it should be the family, since the family "is that central complex of relationships" that "make societal sense out of seemingly impersonal phenomena" ranging from politics to economics to gender relations. See Elizabeth Kuznesof, "The Family and Society in Nineteenth-Century Latin America: An Historiographical Introduction," *Journal of Family History* 10, no. 3 (1985): 220.

13. Alexis de Toqueville, *Democracy in America*, trans. George Lawrence, J. P. Mayer, ed. (New York: Anchor Press, 1969), 587.

14. Mark D. Szuchman suggested some "deceptively simple" questions as backdrops for his pathbreaking study in Argentine family history: How did families make it through the turbulent era of civil war and nation-building? What strategies did they follow to bring order in a time of disorder? How were family and politics related? See Szuchman, *Order, Family, and Community*, 11. This study is a continuation of Szuchman's discussions.

15. For a recent discussion of these issues, see Victor Uribe-Uran, "Introduction—Beating a Dead Horse?" in *State and Society in Spanish America during the Age of Revolution*, ed. Victor M. Uribe-Uran, xi–xxi (Wilmington DE: Scholarly Resources Inc., 2001); Jeremy Adleman, "The Problem of Persistence in Latin America," in *Colonial Legacies: The Problem of Persistence in Latin American History* (New York: Routledge, 1999), 1, 10; Kenneth J. Andrien and Lyman L. Johnson, eds., *The Political Economy of Spanish America in the Age of Revolu-*

tion, 1750–1850 (Albuquerque: University of New Mexico Press, 1994); Jonathan Brown, "The Bondage of Old Habits in Nineteenth-Century Argentina," *Latin American Research Review* 21, no. 2 (1986): 3–4.

16. See José Carlos Chiaramonte, *Ciudades, provincias, Estados: Orígenes de la Nación Argentina (1800–1846)* (Buenos Aires: Ariel Historia, 1997).

17. John C. Chasteen, "Patriotic Footwork: Social Dance and the Watershed of Independence in Buenos Aires," in *State and Society in Spanish America during the Age of Revolution*, ed. Victor M. Uribe-Uran, 188.

18. William B. Taylor directly challenged the concept of the Age of Revolution and made a case "for returning one series of events—the independence Wars—to a prominent place in the chronology of Latin American social history." Taylor is not calling for a return to traditional political histories. Rather, he wants a more "connected history" that approaches "larger relationships and processes in history as a whole, as 'bundles of relationships,' to use Eric R. Wolf's expression." See William B. Taylor, "Between Global Process and Local Knowledge: An Inquiry into Early Latin American Social History, 1500–1900," in *Reliving the Past: The Worlds of Social History*, ed. Olivier Zunz, 121–25, 133, 171 (Chapel Hill: University of North Carolina Press, 1985).

19. Susan Socolow's comparison of Buenos Aires and Córdoba (see her "Acceptable Partners"), and other comparative studies, serve as reminders of the powerful regionalism in Argentine society, and the conclusions drawn in this book reflect an assessment of Buenos Aires and its surrounding jurisdiction.

20. Similar to Christine Hunefeldt writing of the Peruvian case, I do not suggest that patriarchy was dismantled. Instead, its power was challenged, and in relative terms declined from its previous position under colonial rule. See Christine Hunefeldt, *Liberalism in the Bedroom: Quarreling Spouses in Nineteenth-Century Lima* (University Park: Pennsylvania State University, 2000), 111.

21. Paul J. Vanderwood argues that political systems do influence societal development and vice versa, which is why historians have been encouraged to "get the politics back into social history." Putting politics back into social history lends credence to a renewed focus on the independence era. This is not a return to "old-fashioned" political history, which focuses on elite institutions. "Instead, the focus is on how political institutions are reflected in social relationships, which brings us back to the political process and the state." See Vanderwood's "Studying Mexico's Political Process," in *The Evolution of the Mexican Political System*, ed. Jaime Rodriguez O., 266–67 (Wilmington DE: Scholarly Resource Books, 1993).

1. Buenos Aires

1. This book focuses on the port city of Buenos Aires and the surrounding towns within its jurisdiction. The region known as the Río de la Plata includes this area, but it also extends to the other side of the river to present-day Uruguay and up the river into the littoral provinces of Entre Ríos, Santa Fe, and Corrientes of modern-day Argentina, and thus evokes a much larger territory than is covered here.

2. Raquel Prestigiacomo and Fabian Uccello, *La pequeña aldea: Vida cotidiana en Buenos Aires, 1800–1860*, (Buenos Aires: Eudeba, 1999), 39–40.

3. See Carlos Morel's drawings, *Vista de una casa desde el río* and *Las lavanderas*, in José Luis Lanuza, *Pintores del Viejo Buenos Aires* (Buenos Aires: Ediciones Culturales Argentinas, 1961), 32.

4. Sometimes when a doctor was ready to leave a home, he would ask the lady of the house to please check to see if his horse was outside. As cited in Prestigiacomo and Uccello, *La pequeña aldea*, 47–48.

5. "An Englishman," *Five Years' Residence in Buenos Ayres, During the Years 1820–1825*, as cited in Jorge Fondebrider, ed., *La Buenos Aires ajena: Testimonios de extranjeros de 1536 hasta hoy* (Buenos Aires: Emecé, 2001), 95.

6. Samuel Haig, *Sketches of Buenos Aires, Chile and Peru* (1829) as cited in *La Buenos Aires ajena*, ed. Jorge Fondebrider, 85.

7. Referring to *peinetas*, apparently a highly ornamental and elaborate comb. As quoted in Cicerchia, *Historia de la vida privada*, 119.

8. See the works of C. H. Bacle, *Extravagancias de 1834. Peinetones en el teatro*, in Lanuza, *Pintores*, 26–27.

9. Prestigiacomo and Uccello, *La pequeña aldea*, 37–38.

10. Prestigiacomo and Uccello, *La pequeña aldea*, 38.

11. One estimate of the population in Buenos Aires in 1810 is 70 percent whites, 30 percent blacks and mulattoes, and about 0.5 percent Indians and mestizos. See Marta B. Goldberg, "La población negra y mulata." See also Marisa M. Díaz, "Las migraciones internas a le civdad de Buenos Aires," *Boletín del Instituto de Historia Argentine y Americana Dr. Emilío Ravignani* 16/17 (1998).

12. A military report from May of 1847 showed the danger. That year, José Baldevenito and his squadron of men pursued a band of Indians who had been raiding in the area. The mounted Argentines overtook a group of ten Indians, killed two of them, and rescued a young white boy who had been a captive since he was a child. The boy, who spoke little Spanish, then revealed a disturbing plan. The great Araucanian chief Calfucurá had invited various tribes to join him in a major invasion of the region. AGN TC Cámara de Apelaciones. Sala X. 17.8.1.

13. See Vidal's *Indios pampas en una tienda* (1818) in Bonifacio del Carril and Aníbal G. Aguirre Saravia's *Iconografía de Buenos Aires: La ciudad de Garay hasta 1852* (Buenos Aires, Municipalidad de la Ciudad de Buenos Aires, 1982), 200.

14. Kristin Jones claims Indians were partially integrated into the economy and that they traded at frontier *pulperías* (taverns/general stores) and dealt in cattle with Chilean markets. This economic activity caused labor shortages in the Indian economy, leading to raids for female captives (*cautivas*) to perform these tasks. Indians were exterminated because they refused to become rural proletariat, and they represented a nonwhite autonomous group. For more on this subject, see Jones's "Calfucurá and Namuncurá: Nation Builders of the Pampas," in *The Human Tradition in Latin America: The Nineteenth Century*, ed. Judith Ewell and William H. Beezley, 175–86 (Wilmington DE: Scholarly Resources Books, 1987).

15. As cited in Prestigiacomo and Uccello, *La pequeña aldea*, 40. *Pulperías* are often seen as more of a rural phenomenon, but they were located in the city as well. For two colorful examples from the city, see the works of Bacle (*Pulpería*) and Isola (*Pulpería en la calle Potosí*) in Carril and Saravia, *Iconografía de Buenos Aires*, 203, 207.

16. See Ricardo Salvatore's excellent study, *Wandering Paysanos: State, Order, and Subaltern Experience in Buenos Aires During the Rosas Era* (Durham NC: Duke University Press, 2003). For an excellent discussion on the different definitions of the gaucho, including debates over the origin of the word "gaucho" itself, see Richard W. Slatta, *Gauchos and the Vanishing Frontier* (Lincoln: University of Nebraska Press, 1992), chap. 1. The ruling elites saw the gaucho as an enemy of their vision of a modern Argentina. The gauchos were targeted by legislation that curbed their freedom to move about the frontier, and Argentine liberals hoped that the millions of immigrants coming to Argentina would displace the gauchos as rural laborers. In the early twentieth century, however, those very European immigrants, by their sheer numbers and their ideological baggage brought from the Old World, threatened to overrun Argentine culture. Ironically, it was only then that the Argentine elites reclaimed the gaucho as the symbol of the Argentine nation. For more in this, see Slatta, *Gauchos*, chap. 11.

17. Susan Socolow does a fine job in showing a more complex picture of gaucho life in her "Women of the Buenos Aires Frontier, 1740–1810 (or the Gaucho Turned Upside Down)," in *Contested Ground: Comparative Frontiers on the Northern and Southern Edges of the Spanish Empire*, ed. Donna J. Guy and Thomas E. Sheridan, 67–82 (Tucson: University of Arizona Press, 1998). For more on the gaucho and on these debates, see Ricardo Rodríguez Molas, *Historia social del gaucho* (Buenos Aires: Marú, 1968).

18. In this plaza, independence was declared in 1810, Juan Domingo Perón and his wife Evita addressed their followers in the 1940s and 1950s, and in this plaza, to this very day, the Mothers of Plaza de Mayo march to protest the thousands who disappeared during the military dictatorship of the 1970s.

19. For more excellent discussion on *carretas*, see Prestigiacomo and Uccello,*La pequeña aldea*, 84–89.

20. See Carlos Sempat Assadourian, *El sistema de la economía colonial: mercado interno, regiones, y espacio económico* (Lima: Instituto de Estudios Peruanos, 1982), 18–19.

21. Jonathan C. Brown, *A Socioeconomic History of Argentina* (Cambridge: Cambridge University Press, 1979), 21.

22. Brown, *A Socioeconomic History of Argentina*, 22, 26.

23. Brown, *A Socioeconomic History of Argentina*, 30.

24. For more on commerce during the late colonial period, see Susan M. Socolow, *The Merchants of Buenos Aires, 1778–1810: Family and Commerce* (Cambridge: Cambridge University Press, 1978).

25. Mariquita Sánchez, *Recuerdos del Buenos Aires virreinal* (Buenos Aires: Ene Editorial), 65–66.

26. As quoted in John Lynch, *The Spanish American Revolutions, 1808–1826* (New York: W. W. Norton & Company, 1986), 42.

27. Lynch, *The Spanish American Revolutions*, 42.

28. Lynch, *The Spanish American Revolutions*, 53.

29. As quoted in Lynch, *The Spanish American Revolutions*, 55.

30. As quoted in Lynch, *The Spanish American Revolutions*, 57.

31. Lynch, *The Spanish American Revolutions*, 57.

32. Hence, Argentina's day of independence is 9 July 1816. However, 25 May 1810, the day of the May Revolution, is also seen as an independence day.

33. This division corresponds roughly with the conflict in the United States only a few years earlier, when federalists argued for a stronger national government and antifederalists wanted more states' rights. That the federalist position in Argentina actually matched with the antifederalists in the United States serves as a reminder that the definitions of terms need to be contextualized.

34. For more on the economic issues of this period, see Miron Burgin's *The Economic Aspects of Argentine Federalism, 1820–1852* (Cambridge MA: Harvard University Press, 1941).

35. For more on sheep production, see Hilda Sábato, *Agrarian Capitalism and the World Market: Buenos Aires in the Pastoral Age, 1840–1890* (Albuquerque: University of New Mexico Press, 1990).

36. For more on the continuities and changes in the economy during this pe-

riod, see Jorge Gelman, "Producción y explotaciones agrarias bonarenses entre la colonia y la primera mitad del siglo XIX. Rupturas y continuidades,"*Anuario del* IEHS *"Profesor Juan C. Grosso"* 12 (1997): 57–62.

37. For more on the development of Argentina and the world economy, see Jeremy Adleman, *The Republic of Capital: Buenos Aires and the Legal Transformation of the Atlantic World* (Stanford: Stanford University Press, 1999); *Frontier Development: Land, Labor, and Capital on the Wheatlands of Argentina and Canada, 1890–1914* (Oxford: Clarendon Press, 1994). See also James R. Scobie, *Revolution on the Pampas: A Social History of Argentine Wheat* (Austin: University of Texas Press, 1964); Carl Solberg, *The Prairies and the Pampas: Agrarian Policy in Canada and Argentina, 1880–1930* (Stanford: Stanford University Press, 1987); Peter H. Smith, *Politics and Beef in Argentina: Patterns of Conflict and Change* (New York: College University Press, 1969).

38. For more on Rivadavia's reform measures, see David Bushnell's *Reform and Reaction in the Platine Provinces* (Gainseville: University of Florida Press, 1983), esp. chap. 2.

39. Domingo F. Sarmiento, *Life in the Argentine Republic in the Days of the Tyrants: Or, Civilization and Barbarism*, trans. by Mrs. Horace Mann (New York: Hafner Publishing, 1971), 88.

40. Apparently, both Rosas and Dorrego disliked each other. When asked about Rosas's desire to govern the province, Dorrego said: "As long as I live this gaucho rogue will never set up his roasting spit in Government House." For this and more on the rise of Rosas, see John Lynch, *Argentine Dictator: Juan Manuel de Rosas, 1829–1852* (Oxford: Clarendon Press, 1981), 36.

41. As Lynch pointed out, Rosas's military experience "had secured a virtual monopoly of military power in the countryside. His peaceful negotiations on the frontier had gained him Indian friends, allies, and recruits. His achievements had also won him the respect of the *estancieros*, who basked in unwonted peace and security. The provincial caudillos preferred him to the unitarians of the Rivadavian persuasion. And he had a popular base in the pampas" (Lynch, *Argentine Dictator*, 38).

42. Rosas's terror inspired exaggerated and paranoiac imitation and conformity. The sight of people scurrying around trying to get the perfect length of ribbon to wear might have been comical. But, Sarmiento warned, "do not laugh at the sight of such degradation. Remember that you are Spaniards, and that the Inquisition educated in Spain! We bear this disease in our blood." See Sarmiento, *Life in the Argentine Republic*, 141, 142. "And this was the people who once forced eleven thousand English to surrender in the streets, and who afterward sent five armies against the Spaniards!" lamented the great educator

from exile. For further discussion of the importance of fashion in the period, see Salvatore, *Wandering Paysanos*, chap. 4.

43. Burgin, *Economic Aspects*, 17, 104–9.

44. Burgin, *Economic Aspects*, 287.

2. Lineage, Morality, and Industry

1. See Siete Partidas, partida 6, titulo 19, ley 16. (There are seven "*partidas*," which were then broken down into general sections and specific laws. Citations hereafter will be as follows: *Partida 6.19.16*.

2. AGN TC Tribunales Civiles legajo B-28, expediente no. 6. Doña Damiana Bidal contra Doña Aurelia Frias sobre la entrega de un hijo. 1845.

3. For looks at questions of legal continuities in Argentina, see Osvaldo Barreneche, *Dentro de la ley*, TODO (La Plata: Ediciones al Margen, 2001), and "Crime and the Administration of Criminal Justice in Buenos Aires, Argentina, 1785–1853," Ph.D. diss., University of Arizona, 1997; and Socolow, *The Bureaucrats of Buenos Aires, 1769–1810: Amor al Real Servicio* (Durham NC: Duke University Press, 1987).

4. As quoted in Marilyn Stone, *Marriage and Friendship in Medieval Spain: Social Relations According to the Fourth Partida of Alfonso X* (New York: Peter Lang, 1994), 1.

5. As quoted in Méndez Calzada, *La función judicial en los primeros épocas de la independencia: estudio sobre la formación evolutiva del poder judicial argentino* (Buenos Aires: Editorial Losada, 1944), 128.

6. According to legal historian Abelardo Levaggi, the approach to the old laws during the first half of the nineteenth century was to keep them, unless they directly conflicted with new principles, and proceed with a gradual reformation. See Abelardo Levaggi, *Manual de historia del derecho argentina, tomo I* (Buenos Aires: De Palma, 1986–91), 203. Nevertheless, there were many who despised the old Spanish laws and looked forward to the day when they could be replaced with Argentine laws.

7. *Partida 4.17.1*.

8. See Marilyn Stone, *Marriage and Friendship in Medieval Spain*, 99.

9. One definition of patriarchalism, according to Elizabeth Kuznesof, is "the principle that any group, familial or otherwise, will form a hierarchy from the lowest or youngest up to one senior figure under whose protection and dominance it stands and through whom advancement is obtained." See Kuznesof, "Family and Society in Nineteenth-Century Latin America," 216.

10. Richard Boyer, "Women, *La Mala Vida*, and the Politics of Marriage," in *Sexuality and Marriage in Colonial Latin America*, ed. Asunción Lavrin, 252–55.

11. See María Beatriz Nizza da Silva, "Divorce in Colonial Brazil: The Case of São Paulo," Ruth Behar, "Sexual Witchcraft, Colonialism, and Women's Powers," as well as Boyer's "*La mala vida*" in *Sexuality and Marriage in Colonial Latin America*, ed. Asunción Lavrin.

12. Mark Szuchman, for example, has argued that patriarchy provided continuity in a time of chaos and crisis in the Río de la Plata during the tumultuous years of civil war before national unification. See Szuchman, *Order, Family, and Community*, 12–13.

13. AGN TC A-62, no 6. Don Antonio Acuña con Doña Carmen Silva reclamando una hija. 1849.

14. This official was *el Defensor General de Menores*, or Defender General of Minors, and will be discussed more specifically later in this chapter.

15. AGN TC A-62, no. 6. Don Antonio Acuña con Doña Carmen Silva reclamando una hija. 1849.

16. See *Partida* 4.20.4.

17. *Partida* 4.19.

18. *Partida* 4.19.2.

19. AHPBA 7.5.14.63. Jaime Campos con Eusebia Pon. 1851.

20. AGN TC B-32, no. 7. Doña Hilaria Bejarano, pidiendo se le restituyesan y entreguen sus cuatro hijos arrebatados por el Juez de Paz de San José de Flores. 1849.

21. AGN TC C-4, no. 22. María Juana Coronel con Don Ignacio Torrado, sobre la entrega de una hija. 1804.

22. *Partida* 6.16.16. All guardians are admonished to teach their *mozos* to read and write, then a trade "according to their [guardian's] situation, wealth, and power."

23. AGN TC B-18, no. 13. Josefa Burgois contra Juana Ponce de León sobre reclamo de una hija. 1834.

24. Lyman Johnson and Sonya Lipsett-Rivera, eds., *Faces of Honor: Sex, Shame, and Violence in Colonial Latin America* (Albuquerque: University of New Mexico Press, 1998), 2. Ramón Gutiérrez has also argued in the case of colonial New Mexico that "honor was a polysemic word embodying meaning at two different but intrinsically interrelated levels, one of status and one of virtue." *When Jesus Came, The Corn Mothers Went Away: Marriage, Sexuality, and Power in New Mexico, 1500–1846* (Stanford: Stanford University Press, 1991), 177.

25. Ann Twinam, *Public Lives, Private Secrets: Gender, Honor, Sexuality, and Illegitimacy in Colonial Spanish America* (Stanford: Stanford University Press, 1999), 32.

26. For similar arguments in the Peruvian case, see Sarah Chambers, *From*

Subjects to Citizens: Honor, Gender, and Politics in Arequipa, Peru, 1780–1854 (University Park: Pennsylvania State University Press, 1999), 4–5.

27. For an in-depth discussion on *limpieza de sangre*, see Twinam, *Public Lives, Private Secrets*, 41–48.

28. *Limpieza de sangre* meant that one was free from the blemishes of "Moors, Jews, or heretics or, in the colonies, Indians or blacks." See Ann Twinam, "Honor, Sexuality, and Illegitimacy in Colonial Spanish America," in *Sexuality and Marriage in Colonial Latin America*, ed. Asunción Lavrin, 123.

29. Lyman L. Johnson, "Dangerous Words, Provocative Gestures, and Violent Acts: The Disputed Hierarchies of Plebeian Life in Colonial Buenos Aires," in *The Faces of Honor*, ed. Johnson and Lipsett-Rivera, 148.

30. AHPBA 7.5.14.14. Román Martínez con Francisco González. 1827. *Truquos* is still played today.

31. AHPBA 7.5.14.14. Román Martínez con Francisco González. 1827.

32. AHPBA 7.5.15.29. Jacinto Melo. Sobre disenso. 1822.

33. *Partida 4.*

34. *Partida 4.2.1.*

35. *Partida 4.2.3.*

36. AGN TC A-99, no. 2. Doña Juana Almada contra Don Toribio Aráoz sobre divorcio. 1862. For more discussion on different models of motherhood in Buenos Aires, see Donna J. Guy, "Mothers Alive and Dead: Multiple Concepts of Mothering in Buenos Aires," in *Sex and Sexuality in Latin America*, ed. Daniel Balderston and Donna Guy, 155–73 (New York: New York University Press, 1997).

37. José Luis Moreno has argued for two familial models: the ideal family that followed traditional societal norms as espoused by the Church and the state, and the real family characterized by premarital sexual relations and high levels of illegitimacy. See Moreno, "Sexo, Matrimonio y familia," 83.

38. As in many of these cases, the final judgment is not recorded. AGN TC B-30, no. 9. Don Rafael Barrios con Tránsito Benítez sobre entrega de menor. 1848.

39. Unfortunately, the case is water damaged and no end is visible. AGN TC C-35, no. 21. Doña Joaquina Castañeda con Doña Isidora Oliden sobre el Patronato de una niña llamada Eladia Iglesias. 1832.

40. The age of the young girl is not given, and she may have been under three years of age, when mothers did have preferential rights to their children. AGN TC C-52, no. 3. Don Domingo Caraballo con su esposa Luisa Ramírez, sobre entrega de su hija. 1841.

41. AGN TC A-99, no. 2. Doña Juana Almada contra Don Toribio Aráoz sobre divorcio. 1862.

42. See Steve J. Stern, *The Secret History of Gender: Women, Men, and Power in Late Colonial Mexico* (Chapel Hill: University of North Carolina Press, 1995).

43. AGN TC A-99, no. 2. Doña Juana Almada contra Don Toribio Aráoz sobre divorcio. 1862.

44. AGN TC B-32, no. 7. Doña Hilaria Bejarano [*sic*], pidiendo se le restituyesan y entreguen sus cuatro hijos arrebatados por el Juez de Paz de San José de Flores. 1849.

45. AGN TC B-32, no. 7. Doña Hilaria Bejarano [*sic*], pidiendo se le restituyesan y entreguen sus cuatro hijos arrebatados por el Juez de Paz de San José de Flores. 1849.

46. Nevertheless, as mentioned earlier, the state sought to take care of these persons and their offspring as seen in child custody, divorce, and *alimentos* (plaintiffs seeking money for food, usually a woman seeking money from the father of her children).

47. As with the 1822 case cited in Cicerchia, *Historia de la vida privada*, 80.

48. AGN TC B-31, no. 13. Petrona Bengolea, parda libre, contra Doña Nicolasa Bengolea sobre la entrega de una chica hija suya. 1848.

49. For more on infanticide, see Kristin Ruggiero, "Honor, Maternity, and the Disciplining of Women: Infanticide in Late Nineteenth-Century Buenos Aires," *Hispanic American Historical Review* 72, no. 3 (1992): 353–73.

50. See Donna J. Guy's "Women, Peonage, and Industrialization: Argentina, 1810–1914," *Latin American Research Review* 25, no. 3 (1985): 69–72.

51. Illegitimate unions, and hence illegitimate children, were on the rise in the early nineteenth century. See Moreno, "Sexo, matrimonio, y familia," 66.

52. Lavrin, "*Lo femenino*," 159.

53. This was true elsewhere in Latin America. For a Peruvian example, see Hunefeldt, *Liberalism in the Bedroom*, 184, 207.

54. The custom was evident throughout Latin America. For a Mexican example, see Sonya Lipsett-Rivera, "The Intersection of Rape and Marriage in Late-Colonial and Early-National Mexico," *Colonial Latin American Historical Review* 6, no. 4 (Fall 1997): 580.

55. See John R. Gillis, *For Better, For Worse: British Marriages, 1600 to the Present* (New York: Oxford University Press, 1985).

56. AGN TC C-17, no. 1. Elías Calderón con Josefa Rojas sobre una hija natural, 1819. Josefa argued that, with her father, Adriana would be "exposed to the very dangers that Calderón claims to be saving her from." Apparently, Josefa came to take the children away, an act protested by Elías, but there is no end recorded in the case.

57. AGN TC C-4, no. 22. María Juana Coronel con Don Ignacio Torrado, sobre la entrega de una hija. 1804.

58. In these public spaces, women were seen as vulnerable to male advances. Nevertheless, as Asunción Lavrin has argued, they could still maintain their dignity and morality, though with perhaps more difficulty. See her "*Lo femenino,*" 159.

59. This con:eption of the street pervaded Latin American and other societies. One Peruvian man went as far as taking his wife's clothes to prevent her from going into the street. See Hunefeldt, *Liberalism in the Bedroom,* 327.

60. See AGN TC C-19, no. 20. Autos seguidos entre el capitán graduado reformado Don Manuel Caballero y su mujer Doña Tránsito Córdoba, sobre la entrega de una hija. 1822.

61. For more on this see Susan M. Socolow, "Women and Crime: Buenos Aires 1757–97," in *The Problem of Order in Changing Societies: Essays on Crime and Policing in Argentina and Uruguay, 1750–1940,* ed. Lyman L. Johnson, 1–18 (Albuquerque: University of New Mexico Press, 1990).

62. For more on violence and the defense of honor, see John C. Chasteen's "Violence for Show: Knife Dueling on a Nineteenth-Century Cattle Frontier," in *The Problem of Order,* ed. Lyman L. Johnson, 53–54.

63. AGN TC C-50, no. 20. Doña María Ramona Cabral, sobre la entrega de una hija. 1842.

64. AGN TC A-65, no. 9. Doña Encarnación Alegre con Doña Pascuala Ramírez sobre la entrega de una chica. 1851. In another case, Mercedes Platona went to court to get her children back because their guardians had mistreated them. The couple had sent the oldest child "out into the street alone, in addition to making her carry heavy rugs (*alfombra*). The judge asked the girl regarding the matter and she answered that "she was fine at the house where she was, and that she only carried carpet once, and no one had obligated her to do it." AGN TC A-39, no. 3. El Defensor General de Menores por los de esta clase Toribia y Pablo Alvin con Doña Luiza Lisas. 1835.

65. AGN TC C-4, no. 22. María Juana Coronel con Don Ignacio Torrado, sobre la entrega de una hija. 1804. The final outcome of the case is unknown. Mark Szuchman has also argued that the putting-out system may have given children more freedom to pursue a variety of activities, including romantic attachments. See his *Order, Family, and Community,* 72.

66. AGN TC C-50, no. 1. Doña Francisca Cariaga con Doña Angela Gómez sobre le entrega de su hija Doña Adela Dorrego. 1841.

67. As quoted in Christine Hunefeldt, *Liberalism in the Bedroom,* 155.

68. Moreno, "Sexo, matrimonio, y familia," 68.

69. Moreno, "La infancia," 83.

70. See, for example, the case of Dolores Anchel who was trying to get the father of her child to help pay for the child's upbringing. AGN TC A-45, no. 9. Doña Dolores Anchel protegida por el Ministerio General de Pobres, pidiendo un hijo suyo con Don Manuel Lacalle, y que este le de alimentos para criarlo. 1836.

71. Cicerchia, "*La vida maridable*," 88.

72. Cicerchia, "*La vida maridable*," 136.

73. *Partida* 4.17.8.

74. AGN TC A-39, no. 3. El Defensor General de Menores por los de esta clase Toribio y Pablo Alvin con Doña Luiza Lisas. 1835.

75. By pursuing their cases in court, these women, according to Ricardo Cicerchia, "did not seem to play the part required of them by their marginalization. On the contrary, they confronted what they perceived as unjust, demanding judicial intervention" using their "public credibility" as mothers. The parties who had cared for the children in the meantime, however, argued that once the child had been raised to be productive, mothers wanted to regain custody in order to cash in on the child's labor. See Ricardo Cicerchia, "Minors, Gender, and Family: The Discourses in the Court System of Traditional Buenos Aires," *The History of the Family: An International Quarterly* 2, no. 3 (1997): 342–43. Cicerchia called this process a type of "popular Malthusianism" in "Las vueltas del torno: claves de un Malthusianismo popular," in *Mujeres y cultura en la Argentina del siglo XIX*, ed. Lea Fletcher, 196 (Buenos Aires: Editora Feminaria, 1994).

76. AGN TC B-34, no. 7. Saturnina B contra Isabel Izquierdo sobre la entrega de un hijo. 1850. There is no recorded end of this case.

77. *Partida* 4.20.4.

78. AGN TC C-43, no. 21. Don Manuel Castillo con Don Macario Falcón reclamando dos hijas de su esposa. 1835.

79. AGN TC A-46, no. 2. Fortunata Alfonso con Don Mariano Rodríguez sobre la entrega de una hermana. 1837.

80. AGN TC C-52, no. 15. Don José Cuello con Don Juan Landon, sobre la entrega de un menor. 1843.

81. AHPBA 7.5.15.26. Concepción Alvarez. 1843.

82. AGN TC B-32, no. 9. Don José Balbino con Don José Baliato sobre la devolución de un niño. 1849.

83. After the biological father testified that he also wanted the boy back in the care of his mother, the judge ordered Josefa Alarcón and Juan Barragán to arrange an amicable return of the boy and that Barragán be recompensed for

his pains. AGN TC A-47, no. 8. Doña Josefa Alarcón con Don Juan Barragán sobre la entrega de un hijo. 1837.

84. Conde, on the other hand, claimed that he took care of the kids because they were living together for a long time until they finally separated four years ago. AGN TC C-25, no. 3. Doña María Magdalena Conde, reclamando a un niño su hijo Don Juan Andrés Conde. 1826.

85. AGN TC A-45, no. 9. Doña Dolores Anchel protegida por el Ministerio General de Pobres, pidiendo un hijo suyo con Don Manuel Lacalle, y que este le de alimentos para criarlo. 1836.

86. For more on this discussion, and for an excellent anthology on the role of children in Latin America, see Tobias Hecht, "Introduction," in *Minor Omissions: Children in Latin American History and Society*, ed. Tobias Hecht, 3 (Madison: The University of Wisconsin Press, 2002).

87. As quoted in Cicerchia, *Historia de la vida privada*, 76.

88. Ricardo Güiraldes, *Don Segundo Sombra* (Buenos Aires: Centro Editor de América Latina, 1979), 9–10. Güiraldes's novel, originally published in 1926, is the first classic gaucho novel of Argentina.

89. For more on this idea, see Cicerchia, "Vida Familiar y practicas conyugales. Clases populares en una ciudad colonial, Buenos Aires, 1800–1810." *Boletín del Instituto de Historia Argentina y Americana Dr. E. Ravignani* 3, no. 2 (1900): 91–109.

3. "Accept Us as Free Men"

1. AHPBA 7.5.14.85. José Jesús Nazareno y López con Bonifacia Ruíz Moreno. 1825. Nevertheless, a few years later, Argentine officials began courting Spaniards, and other Europeans, as part of an attempt to attract, in the words of the liberal ideologue Juan Bautista Alberdi, a "people of better quality," to Argentina. See José C. Moya's *Cousins and Strangers: Spanish Immigrants in Buenos Aires, 1850–1930* (Los Angeles: University of California Press, 1998), 49.

2. Hugo Raul Galmarini, "Los españoles de Buenos Aires despues de la Revolución de Mayo: La suerte de una minoría desposeída del poder," *Revista de Indias* 46:562–63.

3. Chiaramonte, *Ciudades, provincias, Estados*, 38.

4. Victor Táu Anzoátegui, *La codificación en la Argentina (1810–1870): Mentalidad social e ideas jurídicas* (Buenos Aires, 1977), 65–67.

5. Tulio Halperín-Donghi, *Politics, Economics, and Society in Argentina in the Revolutionary Period*, trans. by Richard Southern (New York: Cambridge University Press, 1975), 167.

6. Chasteen, "Patriotic Footwork," in *State and Society in Spanish America*

during the Age of Revolution, ed. Victor M. Uribe-Uran, 179, 183, 187. For more on dance and national identity, see Chasteen's *National Rhythms, African Roots: The Deep History of Latin American Popular Dance* (Albuquerque: University of New Mexico Press, 2004).

7. Jorge Anaya, *Historia del arte argentino* (Buenos Aires: Emecé, 1997), 17.

8. Anaya, *Historia del arte argentino*, 17–18. Indeed, the Cabildo was remodeled later in the nineteenth century to rid it of its Spanish colonial style. In the early twentieth century, it was remodeled again to return it to its traditional Hispanic style.

9. Bartolomé Hidalgo, "Cielito a la independencia" and "Cielito patriótico," in *Cielitos y diálogos patrióticos* (Buenos Aires: Centro Editor de América Latina, 1979), 13–14, 18.

10. Bartolomé Hidalgo, *Antología de la poesía gauchesca*, 77–79, 83–85, as quoted in Nicolas Shumway, *The Invention of Argentina* (Los Angeles: University of California Press, 1991), 72–75.

11. For more on the significance of Hidalgo's writing, see Shumway's *Invention of Argentina*, chap. 3.

12. Esteban Echeverría, *La cautiva, El matadero, Ojeada retrospectiva* (Buenos Aires: Centro Editor de América Latina, 1979), 12–13.

13. See Domingo F. Sarmiento, *Life in the Argentine Republic in The Days of the Tyrants; Or, Civilization and Barbarism* (New York: Haffner Publishing, 1971), 21–22.

14. Lynch, *The Spanish American Revolutions*, 277.

15. Halperín-Donghi, *Politics, Economics, and Society*, 165–66.

16. Lyman L. Johnson, "Distribution of Wealth in Nineteenth-Century Buenos Aires Province: The Issue of Social Justice in a Changing Economy," in *The Political Economy of Spanish America*, ed. Andrien and Johnson, 203. Nevertheless, after the rise of Rosas to the governorship, Johnson found that social inequality grew. However, although inequality grew, the poorer sectors of society were still increasing their wealth in ways that make the Río de la Plata region compare favorably to other frontier areas in North America. See Lyman L. Johnson, "The Frontier as an Arena of Social and Economic Change: Wealth Distribution in Nineteenth-Century Buenos Aires Province," in *Contested Ground*, ed. Guy and Sheridan, 181.

17. Szuchman, *Order, Family, and Community*, 100. For more on Artigas's conflicts with the leadership in Buenos Aires, see Nicolas Shumway, *Invention of Argentina*, chap. 3.

18. García Belsunce et al., *Buenos Aires, 1800–1830, tomo III: Educación y asis-*

tencia social (Buenos Aires: Ediciones del Banco Internacional y Banco Unido de Inversión, 1978), 24.

19. García Belsunce et al., *Buenos Aires, tomo III*, 23.

20. As quoted in García Belsunce et al., *Buenos Aires, tomo III*, 24.

21. As quoted in García Belsunce et al., *Buenos Aires, tomo III*, 29.

22. Bushnell, *Reform and Reaction*, 130.

23. Fransisco Majesté, "En materias mixtas, en casos dudosos, en que las dos potestades: civil y eclesiástica con igual derecho intervienen, deberá decidir el poder soberano." Diss., University of Buenos Aires, 1848.

24. Leopoldo Basavilbaso, "Tésis presentada y sostenida en la universidad de Buenos Aires por Leopoldo Basavilbaso para obtener el grado de doctor de jurisprudencia" (Buenos Aires: Imprenta del Siglo, 1867), 11–12.

25. AGN TC C-1, no. 11. Instancia promovida por Ambrocio Cuchabuy, sobre recaudar un hijo suyo nombrado Joséf de los Santos. 1801.

26. Juicio de disenso promivido por el alférez de fragata de la real armada, don Martín Jacobo de Thompson, as found in Antonio Dellepiane, *Dos patricias ilustres* (Buenos Aires: Imprenta y Casa Editora "Coni," 1923), 156. Much more will be heard of this case in chap. 5.

27. I did not find another reference to the cross until an 1861 child custody case.

28. García Belsunce et al., *Buenos Aires, tomo III*, 26–27.

29. *El Centinela*, no. 12, 1822, as reproduced in Senado de la Nación, *Biblioteca de Mayo. Colección de obras y documentos para la historia argentina*, 18 vols. (Buenos Aires: Imprenta del Congreso de la Nación Argentina, 1960).

30. As quoted in Slatta, *Gauchos*, 129, 127. The forced military draft in 1810 took so many men from the countryside that the wheat harvest was threatened.

31. AHPBA 7.5.14.7. José María del Corazón de Jesús con don Pablo García. 1828. In such cases, the father would many times be able to send someone authorized to act in his name in court (an *apoderado*).

32. As quoted in Szuchman, *Order, Family, and Community*, 101. These measures recalled earlier efforts to control the city after independence where local officials repressed unauthorized meetings in their jurisdictions. Male violators of this decree would be taken immediately to prison, regardless of "rank or privilege," while any female offenders would be sent to the House of Correction. As cited in Halperín-Donghi, *Politics, Economics, and Society*, 162.

33. AHPBA 7.5.14.6. Juan Alagón con Ubaldo Méndez. 1829.

34. *Partida* 4.2.15.

35. Rosas granted substantial freedoms to foreigners wishing to live and do business in Buenos Aires. Even during the Anglo-French blockades of the port

city, no foreigner registered a complaint for being harmed in any way because of their social status. See Claudio Panella, "Consideraciones acerca de los matrimonios entre católicos y protestantes en Buenos Aires (1826–1851)," *Temas de Historia Argentina* (1994): 18–19.

36. From 1833 to 1870, interfaith marriages needed the dispensation of the Church and the state. From 1870 to 1888, only ecclesiastical dispensation was required. After 1888, all impediments to interfaith marriages were removed. José M. Urquijo, "Los matrimonios entre personas de diferente religión ante el derecho patrio Argentino," *Conferencias y comunicaciones, folleto XXII*, Instituto de Historia del Derecho, 1948, 32–33, 45.

37. As quoted in Urquijo, "Los matrimonies," 16–17.

38. See Bianca Premo, "Minor Offenses: Youth, Crime, and Law in Eighteenth-Century Lima," in *Minor Omissions*, ed. Hecht, 130–31. For more discussion of Enlightenment thought regarding children in the Peruvian context, see Premo, "Children of the Father King: Youth, Authority, and Legal Minority in Lima," Ph.D. diss., University of North Carolina, Chapel Hill, 2001.

39. Family history is a growing field in Latin American history. Many works have dealt specifically with child custody cases in the nineteenth century. José Luis Moreno has looked at similar issues in his fine work. See his "La infancia en el Río de la Plata"; see also Hector Ricardo Cicerchia's, "*La vida maridable*"; see also the special journal issues dedicated to the topic. The *Journal of Family History*, for example, has at least three issues dedicated to the family in Latin America. See *Journal of Family History* 10, no. 3 (1985); 16, no. 3 (1991); 23, no. 3 (1998).

40. This school of thought is known as the "history of sentiments" school. See Phillip Ariés, *Centuries of Childhood* (New York: Vintage, 1962); Edward Shorter, *The Making of the Modern Family* (New York: Basic Books, 1975); and Lawrence Stone, *The Family, Sex, and Marriage in England, 1500–1800* (New York: Harper and Row, 1977). According to Hugh Cunningham, some of the debate may have been due to a misinterpretation or mistranslation of a key phrase from Ariés' work. In the French, he said that there was not a true "sentiment" of childhood, and that was translated into "idea" in English. See Hugh Cunningham's review essay, "Histories of Childhood," 1197.

41. Bruce Bellingham, "The History of Childhood Since the 'Invention of Childhood': Some Issues in the Eighties," *Journal of Family History* 13, no. 3 (1988): 348.

42. See Linda Pollock, *Forgotten Children: Parent-Child Relations from 1500–1900* (Cambridge: Cambridge University Press, 1983).

43. See Viviana Zelizer, *Pricing the Priceless Child: The Changing Social Value of Children* (New York: Basic Books, 1985).

44. *Partida* 4.19.1.

45. *Partida* 2.7.3.

46. AGN TC C-1, no. 11. Instancia promovida por Ambrocio Cuchabuy, sobre recaudar un hijo suyo nombrado Joséf de los Santos. 1801. Perhaps it is something more akin to the nationhood debate in Argentina. In the same way that our modern definition of a nation did not exist in the early nineteenth century, so, too, the modern conception of the state of childhood did not exist at that time. But it does not necessarily mean an absence of childhood as a held perception, and especially not an absence of love of children.

47. José Lius Moreno argues that as the nineteenth century progressed, a clearer definition of a separate childhood identity emerged. See Moreno, "La infancia," 83, 109.

48. AGN TC C-17, no. 1. Elías Calderón con Josefa Rojas sobre una hija natural. 1819.

49. AGN TC C-35, no. 21. Doña Joaquina Castañeda con Doña Isidora Oliden sobre el Patronato de una niña llamada Eladia Iglesias. 1832.

50. Margarita Zegarra, "La construcción de la madre y de la familia sentimental. Una visión del tema a través del *Mercurio Peruano*," *Histórica* 25, no. 1 (2001), 196–97.

51. *La Abeja Argentina*, Nd, 289–90. In Senado de la nación, *Biblioteca de mayo, Colección de obras y documentos para la historia argentina*, vol. 6 (Buenos Aires: Imprenta del Congreso de la Nación, 1960), 289–90.

52. See Fidel Cavia, "Es justo de desheredación de los hijos que se contraen matrimonios sin el consentimiento paterno, en la edad que la ley lo exige" (Disertación de jurisprudencia de la Universidad de Buenos Aires, 1864), 12. Portalis was imprisoned during the French Revolution, but under Napoleon was one of the main authors of the *Code Civil*, making him an ideal reference for reform-minded Argentines who looked to France, probably above other nations, as a model of development.

53. Szuchman, *Order, Family, and Community*, 170–72.

54. Szuchman, *Order, Family, and Community*, 155–56.

55. See García Belsunce et al., 103–7.

56. As quoted in Cicerchia, *"La vida maridable,"* 89.

57. For a case that shows how an abusive father lost *patria potestad* over his daughter, see AGN TC B-38, no. 1. Don Marcos Buireu con Don Pedro Ferreyro, sobre entrega de una hija. 1852.

58. AGN TC B-26, no. 6. Doña Juana Bernal sobre la entrega de una niña

llamada Carlota. 1842. This case also highlights the difficulty that women had in adopting children. Some reformers in the nineteenth century argued that women should be given the right to adopt and that they had the same capacity as men to raise children. Manuel J. Navarro, a graduate of the University of Buenos Aires law school, made just such an argument in his dissertation (to be discussed further in chap. 6). See his "Tésis de jurisprudencia en que sostiene que la mujer tiene las mismas o mejores aptitudes que el hombre para adoptar," 1850.

59. AGN TC C-115, no. 8. María de la Paz Canaveris con Cecilio Doncelas sobre reclamo de una hija. 1862.

60. AGN TC C-115, no. 8. María de la Paz Canaveris con Cecilio Doncelas sobre reclamo de una hija. 1862.

61. AGN TC S-16.058. Doña Melchora Suárez de Pazos, sobre la entrega de un menor. 1870.

62. Rómulo Avendaño, *Los expósitos. Tésis de jursiprudencia*, 1869, 7, 10, 11, 32.

63. For more on this office, see Donna Guy, *Sex and Danger in Buenos Aires: Prostitution, Family, and Nation in Argentina* (Lincoln: University of Nebraska Press, 1992).

64. See Donna J. Guy, "Emilio and Gabriela Coni: Reformers, Public Health, and Working Women," *The Human Tradition in Latin America*, ed. Beezley and Ewell, 233–34.

65. García Belsunce et al., *Buenos Aires, tomo III*, 387–88.

4. "If You Love Me"

1. Such is the suggestion of María Sáenz Quesada in her *Mariquita Sánchez: Vida política y sentimental* (Buenos Aires: Editorial Sudamericana, 1995), 33.

2. Manuel Azamor y Ramírez, *De matrimonio contrahendo insciis, inconsultis aut invitis parentibus* (c. 1795), as found in Rípodas Ardanaz, *Matrimonio en Indias*, 402.

3. Because of England's early development of liberal politics and industrial society, scholars of England have influenced this field of inquiry. Lawrence Stone argued that by 1800, English children had greater freedom to marry for love. Such freedom was characteristic of the modern family emerging in England on the heels of the Industrial Revolution. See Stone, *The Family, Sex, and Marriage in England*, 72. Stone has been criticized by others who fault his excessive reductionism. Alan Macfarlane and John R. Gillis represent the continuation of this debate. Macfarlane argues that even in preindustrial society children had considerable freedom to choose their mates. Gillis, on the other hand, finds that parents as well as communities had substantial control over

their children in traditional society and that control continued well into the nineteenth century. See Alan Macfarlane, *Marriage and Love in England: Modes of Reproduction, 1300–1840* (New York: Basil Blackwell, 1986), and John R. Gillis, *For Better, For Worse.*

4. Seed, *To Love, Honor, and Obey*, 7, 233–37. See also Socolow, "Acceptable Partners," 209–20. Other scholars have similar findings for Mexico. Silvia M. Arrom, for example, argues that patriarchy was already weakening and that the Bourbon reforms were an effort to prop up the faltering institution and stem the tide of growing individualism among children. See Silvia M. Arrom, "Perspectivas Sobre Historia de la Familia en Mexico," in *Familias Novohispanas: Siglos XVI al XIX*, ed. Pilar Gonzalbo Aizpuru, 398 (Ciudad de México: El Colegio de México, 1991). This provocative argument deserves more attention and calls for studies done on a larger scale to include pre-Bourbon reforms as well as post-independence data.

5. See transcription of Mariquita's disenso in Dellepiane, *Dos patricias ilustres*, 153.

6. They were married on 29 June 1805 in La Iglesia de la Merced by Fray Cayetano Rodriguez. See Sáenz Quesada, *Mariquita Sánchez*, 40.

7. Academia Nacional de Bellas Artes, *Historia general del arte argentino, tomo III* (Buenos Aires: Adacemia Nacional de Bellas Artes, 1982), 64.

8. AHPBA 7.5.15.56. Antonio Garmendia. Sobre disenso. 1825.

9. See Mariquita's disenso reproduced in Dellepiane, *Dos patricias ilustres*, 153.

10. AHPBA 7.5.15.52. Gabriel Casas. Sobre disenso. 1824. Gabriel claimed that Eulalia's mother was severely pressuring her daughter to desist from marrying him, even to the point of making her physically sick. When confronted by the court, however, her mother did not oppose the marriage.

11. AHPBA 7.5.17.50. Toribio Fernández y Carmen Figueroa. 1831.

12. AHPBA 7.5.16.2. Manuel Fernández con Deidamia Cullar. 1846.

13. AHPBA 7.5.16.2. Manuel Fernández con Deidamia Cullar. 1846.

14. AHPBA 7.5.15.51. Alejo Queral. Sobre disenso. 1824.

15. AHPBA 7.5.15.51. Alejo Queral. Sobre disenso. 1824.

16. Despite this moving plea, the judge ruled against the dissent. AHPBA 7.5.15.33. Francisca García. Sobre disenso. 1814.

17. The Pragmatic of 1776 was modified by later additions, such as the decree of 1803, which said that parents did not have to tell their children the reasons why they were opposing a marriage (although children could still take their parents to court). The 1803 decree also provided a new age scale for minors. According to the decree, a man under 25 needed his father's (if alive) permission,

while a woman needed it until she was 23. If only the mother was alive, then the respective ages for men and women dropped to 24 and 22. Orphaned children were required to obtain permission from one set of grandparents until the age of 23 and 21 for men and women, respectively. Individuals under the care of a tutor needed permission until age 22 (man) and 20 (woman). See Richard Konetzke, *Colección de documentos*, vol. 3, cédula from 1 June 1803. See also, Socolow, "Acceptable Partners," 213.

18. AHPBA 7.5.18.94. Pedro Freyre con Isabel Caballero. 1830.

19. The father greatly exaggerated the age discrepancy since Gregoria turned out to be in her early twenties. AHPBA 7.5.15.35. Francisco de Ayala. Sobre disenso. 1819.

20. AHPBA 7.5.15.61. Juan de O. Barreiro. Sobre disenso. 1827.

21. AHPBA 7.5.15.45. Manuel Ituarte. Sobre disenso. 1822.

22. AHPBA 7.5.15.56. Antonio Garmendia. Sobre disenso. 1825.

23. AHPBA 7.5.17.58. León Boissie y Máxima Sierra. 1831. The last known judgment was for the suitor to seek permission from her father.

24. AHPBA 7.5.14.75. Constantino Sosa con Juana Ferrer. 1851. Unfortunately, there is no final judgment in this case.

25. AHPBA 7.5.14.41. José León de la Cámara con Lucía Varela. 1828.

26. AHPBA 7.5.15.20. Francisca Canicoba. Sobre disenso. 1842.

27. See Chasteen, "Violence for Show," 47–64.

28. AHPBA 7.5.15.20. Francisca Canicoba. Sobre disenso. 1842.

29. Don Pedro Camps y Amirola contra su esposa Doña Dionicia Rey para el mal escándalo que da esta. AGN TC C-2, no. 10. 1802.

30. Don Pedro Camps y Amirola contra su esposa Doña Dionicia Rey para el mal escándalo que da esta. AGN TC C-2, no. 10. 1802.

31. Cavia, "Es justa de desheredación," 7.

32. Cavia, "Es justa de desheredación," 19–20.

33. AHPBA 7.5.15.56. Antonio Garmendia. Sobre disenso. 1825.

34. For more discussion on Rosquellas and the world of opera in Buenos Aires, see Academia Nacional de Buenos Aires, *Historia general del arte argentino, tomo III*, 60–67.

35. AHPBA 7.5.15.56. Antonio Garmendia. Sobre disenso. 1825.

36. AHPBA 7.5.15.51. Alejo Queral. Sobre disenso. 1824.

37. AHPBA 7.5.15.58. Fortunato Rangel sobre disenso. 1826.

38. AHPBA 7.5.15.58. Fortunato Rangel sobre disenso. 1826.

39. AHPBA 7.5.14.113. Francisco Ramallo sobre disenso. 1822.

40. AHPBA 7.5.14.32. Felipe Leyba. 1824.

41. AHPBA 7.5.14.2. Andrés Oporto con Gregorio de Campos. 1830.

42. AHPBA 7.5.14.2. Andrés Oporto con Gregorio de Campos. 1830.

43. AHPBA 7.5.14.29. Bárbara Benavente con Felipe Butes. 1827.

44. AGN TC M-16. Sometimes parents attempted to block a marriage, even though it was obvious that their son or daughter had the appropriate age to marry without paternal consent. María Francisca García's father, Pedro, tried to stop her from marrying Eugenio Penichón because he felt that the boy would not bring her happiness. However, her baptismal record revealed that she was 23 years old and out of the reach of patriarchal jurisdiction. The judge wasted no time in ruling against the father's dissent, noting that the girl was old enough to decide for herself. See AHPBA 7.5.15.33. Francisca García. Sobre disenso. 1814. In one instance, even being over the age requirement for parental permission did not help. The case of Pedro López, discussed earlier, ended with the judge ruling that the racial opposition against Pedro was rational, this despite the girl being 25 years old and supposedly free from parental interference in marriage. See AHPBA 7.5.15.62. Pablo López. Sobre disenso. 1827. As was noted above, the ruling in this case was later overturned because of parental neglect.

45. AHPBA 7.5.14.21. José Zacarías Alvarez con Concepción Génova. 1826.

46. AHPBA 7.5.16.5. Juan Carlos Torres y Petrona Pereyra. 1820.

47. Much has been written about Camila's affair. The narrative that follows has been taken from Jimena Sáenz, "Love Story, 1848: El caso de Camila O'Gorman," *Todo es Historia*, no. 51 (1971); Donald F. Stevens, "Passion and Patriarchy in Nineteenth-Century Argentina: María Luisa Bemberg's *Camila*," in *Based on a True Story: Latin American History at the Movies*, ed. Donald F. Stevens (Wilmington DE: Scholarly Resources, 1997); and Adriana Schettini, "Camila O'Gorman: la levadura de un amor prohibido," in *Mujeres argentinas: el lado femenino de nuestra historia*, prólogo por María Esther de Miguel (Buenos Aires: Extra Alfaguara, 1998).

48. As reproduced in Stevens, "Camila," 100–101.

49. *Camila*, a film by María Luisa Bemberg (1984).

50. John Masefield, "Rosas," in *A Poem and Two Plays* (London: Heinemann, 1919), 35–36.

51. See, for example, AHPBA 7.5.14.61. Benjamin Cueto con Rafaela Cueto, 1841, as well as AHPBA 7.5.14.84, 1850. Don José Balvino con Da Ascención Agualevada de Duelos.

52. As quoted in Lynch, *Argentine Dictator*, 240.

53. Lynch, *Argentine Dictator*, 241.

54. Schettini, "Camila O'Gorman," 359.

55. A good English standard for scholarship on Rosas is John Lynch, *Argentine Dictator* (1981). Volumes of scholarship in Spanish have dealt with the

Rosas legacy, both negatively and positively. For a useful anthology of anti-Rosas scholarship, see *La tiranía y la libertad: juicio histórico sobre Juan Manuel de Rozas*, ed. Bernardo González Arrilli (Buenos Aires: Ediciones Libera, 1970). A more balanced collection, both for and against, is *Con Rosas o contra Rosas* (Buenos Aires: Ediciones Federales, 1989).

56. Ricardo Salvatore offers substantial revision of traditional views of Rosas in his *Wandering Paysanos*. Regarding more continuity between Rosas's regime and his liberal predecessors, Victor Táu Anzoátegui found little change in the teaching of law after Rosas came to power. See his *La codificación*, 227. Jorge Meyer examines the importance of republicanism in the Rosas regime in his *Orden y Virtud: El discurso republicano en el régimen Rosista* (Buenos Aires: Universidad Nacional de Quilmes, 1995). Richard Slatta, also argues that "the polemic between Rosistas and liberals obscures significant continuities of Argentina's past. I found no sharp break in policies and attitudes between the Rosas era (1829–52) and the liberal elites that ruled before and after. Instead, I found long-term continuities. . . ." See Slatta's *Gauchos*, 3. Mark Szuchman also found similarities between the liberals and Rosas in that Rosas also prosecuted gauchos even though they were an important part of his support base. See Szuchman, *Order, Family, and Community*, 58.

57. AHPBA 7.5.16.10. Plácido Velázquez con María Fermina Cepeda. 1846.

58. As quoted in Szuchman, "A Challenge to the Patriarchs," 159.

59. AHPBA 7.5.17.21. Cándida Soto y José Merchante. 1824.

60. The total number of disenso cases used from the colonial period is 52. For the national period, I used 257 marriage conflict cases. These numbers reflect cases with known judgments. Of 177 cases with known judgments for the national period under study, 152 ruled in favor of the children and 25 in favor of the parents.

61. See Susan Socolow's "Acceptable Partners," and *The Women of Colonial Latin America* (Cambridge: Cambridge University Press, 2000), 177. Christine Hunefeldt also found that in nineteenth-century Lima, "paternal (or maternal) interference on marriage-related issues—including dissent—were increasingly ignored." See Hunefeldt, *Liberalism in the Bedroom*, 111. For similar arguments for late-colonial Mexico, see Seed's *To Love, Honor, and Obey*.

62. As quoted in Urquijo, "Los matrimonies," 16–17.

63. From Victor Táu Anzoátegui, *Las ideas jurídicas argentinas (siglos XIX–XX)* (Buenos Aires: Editorial Perrot, 1977), 46.

64. Many parents also opposed the newly imported English school system, the Lancaster Method, because it demanded complete subordination of the students. Parents feared that this level of devotion to school would undermine

parental authority. See Szuchman, *Order, Family, and Community*, 111–12, 155–56.

65. José Luis Moreno has argued that the rise in illegitimacy rates was, at least in part, a result of the revolutionary experience with its promises of liberty. See Moreno, "Sexo, matrimonio, y familia," 63.

66. Szuchman, "A Challenge to the Patriarchs," 146, 93.

67. Szuchman, *Order, Family, and Community*, 95.

68. Sánchez, *Recuerdos*, 59–60. It is difficult to measure how peoples in the past experienced their emotions. That Mariquita lacked passionate expression of her love for Martín in her disenso case of 1804 might lead some to conclude that the emotions she felt were other than romantic. Her later writing indicates otherwise, which, as Joan Scott argues, should warn against allowing the way we express our emotions today govern how we interpret the emotional experiences of past peoples. See Adela Pinch, "Emotion and History: A Review Article," *Comparative Studies in Society and History* 37, no. 1 (January 1995): 109.

5. "The Purity of My Blood"

1. AHPBA 7.5.17.18. Pascual Cruz y Josefa Barbosa. 1821. An earlier version of the material in this chapter appeared previously in Jeffrey M. Shumway, "The Purity of My Blood Cannot Put Food on my Table," *The Americas* 58, no. 2 (October 2001).

2. Between 1779 and 1810, for example, 16 of 51 disenso cases, or 32 percent, used racial "inequality" as an argument, and in 50 percent of those cases, judges ruled in favor of the dissenting parents. See the appendix in Nelly Porro's "Los juicios de disenso en el Río de la Plata." While the pragmatic was discriminatory, the colonial regimes did make limited efforts at social reform in race-related matters. In the late-Bourbon period, for example, free *pardos* were allowed to advance within the military. However, as David Bushnell points out, these measures "merely riddled the colonial Jim Crow laws with a few more exceptions" and should not be compared with "the virtual scrapping of those laws by the new governments" after 1810. See Bushnell's *Reform and Reaction*, 2.

3. Parents frequently used multiple reasons for opposing a union, and it is difficult to ascertain which of the arguments would be considered the primary argument. This chapter looks at all instances in which race was used to oppose a marriage.

4. For the persistence of racist views, as seen in the thought of future Argentine president Domingo F. Sarmiento, see Elizabeth Garrels's "Sobre Indios, Afroamericanos, y los racismos de Sarmiento," *Revista Iberoamericana* 63, nos. 178–79 (January–June 1997).

5. In 1912, for instance, Roberto Levillier argued that the role of blacks in Argentine colonial history was "restricted" and had little impact, this despite clear evidence that Afro-Argentines made up a high percentage of the population in the viceroyalty of the Río de la Plata. As cited in Donald Castro, *The Afro-Argentine in Argentine Culture: El Negro del Acordeón* (Lewiston: The Edwin Mellen Press, 2001), 26.

6. Early works on the Afro-Argentines include, among others, Vicente Rossi, *Cosa de negros* (Buenos Aires, Taurus, 2001; originally published in 1926); José Luis Lanuza, *Morenada* (Buenos Aires: Emecé, 1946). More recent works include Marta B. Goldberg, "La población negra y mulata de la ciudad de Buenos Aires, 1810–1840"; with Silvia Mallo, "La población africana en Buenos Aires y su campaña. Formas de vida y de subsistencia (1750–1850)," *Temas de África y Asia* (1993). See also Lyman L. Johnson, "Manumission in Colonial Buenos Aires, 1776–1810," *Hispanic American Historical Review* 59, no. 2 (1979): 258–79. For a classic book in English on the subject, see George Reid Andrews, *The Afro-Argentines of Buenos Aires* (Madison: University of Wisconsin Press, 1980). For an excellent treatment of the Afro-Argentines in the cultural context, see Donald Castro, *The Afro-Argentine in Argentine Culture*. See also Dina V. Picotti, ed., *El negro en la Argentina: presencia y negación* (Buenos Aires: Editores de América Latina, 2001).

7. As cited in Goldberg, "La población negra y mulata," 79.

8. As cited in Castro, *The Afro-Argentine*, 27.

9. The difference between Indians and blacks is also evident in the regulations on marriage. Although the Pragmatic on Marriage is not clear on this point, it appears that the "inequality" in the decree meant specifically African blood. The presence of Indian blood, however, did not justify opposition to a marriage. Juan Tomás Touvé of Paraguay, for example, claimed that his fiancée's father, Anastasio Sosa, opposed his daughter's marriage to Juan "without other reasons except that I am of Indian origin." Even "supposing that I was really an Indian, this is not an impediment, nor a rational opposition." The court agreed with his line of reasoning and approved his marriage. AHPBA 7.5.14.42. Juan Tomás Touvé con María Isabel Sosa. 1826. For a discussion of early colonial ideas about mixed marriages with Indians, see Rípodaz Ardanaz, *El matrimonio en Indias*, 230–38.

10. Socolow, "Acceptable Partners," 236.

11. Bernardo de Monteagudo, "Observaciones didácticas," as found in Chiaramonte, *Ciudades, provincias, Estados*, 362, 366.

12. Bushnell, *Reform and Reaction*, 8–14. Nevertheless, the slave trade continued under different guises until much later, at least until 1840. See also Miguel

Angel Rosal, "Negros y pardos en Buenos Aires, 1811–1860," *Anuario de Estudios Americanos* 51, no. 1 (1994): 165–84.

13. The law remained officially on the books until the early 1850s and, though never fully implemented, it did represent an amplification of legal rights quite unique in the Americas of the early nineteenth century. See Chiaramonte, *Ciudades, provincias, Estados*, 186–87.

14. See George Reid Andrews, "The Afro-Argentine Officers of Buenos Aires Province, 1800–1860," *Journal of Negro History* 61, no. 2 (Spring 1979): 85–100.

15. Lyman L. Johnson, "The Frontier as an Arena," 181.

16. See Marta Goldberg, "Las Afroargentinas, 1750–1850," in *Historia de las Mujeres en la Argentina*, ed. Fernanda Gil Lozano et al., 78 (Buenos Aires: Taurus, 2000).

17. These activities caused no small stir among the unitarian exiles, who now had even more evidence to show that Rosas was a barbarian and a tyrant. See Andrews, *Afro-Argentines of Buenos Aires*, 97.

18. See Castro, *The Afro-Argentine in Argentine Culture*, 4.

19. Bushnell, *Reform and Reaction*, 14.

20. Esteban Echeverría, *La cautiva, El matadero*, 77–78.

21. Rossi, *Cosas de negros*, 41.

22. Rossi, *Cosas de negros*, 84–85.

23. Rossi, *Cosas de negros*, 48–49.

24. Rossi, *Cosas de negros*, 227–28.

25. AHPBA 7.5.14.7. José María del Corazón de Jesús Calleja con Pablo Garcia. 1828.

26. AHPBA 7.5.16.32. Juan Lamas y Justa Arnold. 1834.

27. According to César García Belsunce and his team, child mortality in Buenos Aires orphanages was terrible. In 1822, 69 of 147 children who entered died (46.9 percent); in 1823, 78 of 124 (62.9 percent); 1824, 72 of 114 (63.1 percent); and in 1825, 83 of 119 (69.7 percent). See García Belsunce et al., *Buenos Aires, tomo III*, 371.

28. *Partida* 4.15.1.

29. See Ann Twinam, "Honor, Sexuality, and Illegitimacy in Colonial Spanish America," in *Sexuality and Marriage in Colonial Latin America*, ed. Asunción Lavrin, 119.

30. AHPBA 7.5.16.32. Juan Lamas y Justa Arnold. 1834.

31. Andrews, *Afro-Argentines of Buenos Aires*, 4–5.

32. As cited in Garrels, "Sobre indios," 106. See also Marta Goldberg, "Las Afroargentinas, 1750–1850," in *Historia de las Mujeres*, ed. Gil Lozano et al., 71.

33. As cited in Andrews, *Afro-Argentines of Buenos Aires*, 106.

34. As quoted in Castro, *The Afro-Argentine in Argentine Culture*, 51.

35. Rossi, *Cosas de negros*, 49.

36. See Lowell Gudmundson, "De 'negro' a 'blanco' en la Hispanoamérica del siglo XIX: la asimilación afroamericana en Argentina y Costa Rica," *Mesoamérica* 7, no. 12 (December 1986): 318, n. 15. Speaking of Brazil, Marió Bonatti, argues that centuries of slavery eroded the self-worth of Afro-Brazilians and weakened their identity, causing them to ascribe, to a certain degree, to the white man's racial and ethnic hierarchies. See Bonatti's *Negra bela raiz: A presença negra na formação do Brasil* (São Paulo: Editora Santuaria, 1991).

37. Many Peruvians of mixed racial heritage, for example, tried to get themselves classified as white, and "many who under legal examination might prove to be of mixed race were treated as Spanish in daily life." See Chambers, *From Subjects to Citizens*, 79, 87, 90.

38. See Cicerchia's, *"La vida maridable,"* 210–11.

39. Andrews, *Afro-Argentines of Buenos Aires*, 87–89.

40. AHPBA 7.6.17.54. María Rodríguez y Andrés Lorea. 1832.

41. Andrews, *Afro-Argentines of Buenos Aires*, 18.

42. *El Lucero*, July 19, 1830, as cited in Szuchman, "A Challenge to the Patriarchs," 160.

43. This case was reviewed in *El Lucero*, 17 and 23 July 1830. As cited in Szuchman, "A Challenge to the Patriarchs," 159.

44. AHPBA 7.5.14.105. José Peralta. Sobre disenso. 1825. The relative definition of "supporting" a family was also evident in the case of Julio Rosquellas and Benita Barreda. Benita's father objected to their marriage because Julio did not have the financial resources to sustain a wife and family. He made this charge even though Julio had ten to twelve thousand pesos between him and his mother, and another eight thousand pesos his father had promised him for his marriage. While a few hundred pesos was enough for some other suitors to please their perspective in-laws, several thousand was not enough for this perspective father-in-law to approve of Julio. AHPBA 7.5.14.26. Julián Rosquellas con Benita Barreda. 1828.

45. AHPBA 7.5.16.33. Amond Amondsen y Sofia Hartwig. 1844.

46. AHPBA 7.5.14.23. Juan Martínez de Sosa con María de los Santos Ogorman. 1825.

47. AHPBA 7.5.14.22. Joaquín Moreira. 1825.

48. Lyman L. Johnson, "Dangerous Words," in *Faces of Honor*, ed. Johnson and Lipsett-Rivera, 128.

49. AHPBA 7.5.16.33. Amond Amondsen y Sofia Hartwig. 1844.

50. See Bushnell, *Reform and Reaction*, 3.

51. As quoted in Halperín-Donghi, *Politics, Economics, and Society*, 167. For a useful listing of the reforms of the revolutionary juntas, see Bushnell, *Reform and Reaction*, 123–26.

52. See, for example, the use of the image of the Indian in Bartolomé Hidalgo's, *Antología de la poesía gauchesca*, 77–79, 83–85, as quoted in Shumway, *Invention of Argentina*, 73.

53. Bernardo de Monteagudo, "Clasificación de ciudadanos," as found in Chiaramonte, *Ciudades, provincias, Estados*, 357.

54. AHPBA 7.5.15.7. José Fortunato Silva. 1833.

55. AHPBA 7.5.14.58. Matías Almeida con Robustina Belmonte. 1851.

56. Donald Castro provides an in depth examination of the social and racial impact of the "to govern is to populate" doctrine throughout his *The Afro-Argentine in Argentine Culture*. For more on the impact of immigration, see Samuel Baily, *Immigrants in the Lands of Promise: Italians in Buenos Aires and New York City, 1870–1914* (Ithaca NY: Cornell University Press, 1999).

57. See Ricardo Levene, *Historia del derecho Argentino*, vol. 5 (Buenos Aires: Editorial Guillermo Kraft, 1945–1958), 101–2, 288–89, 298.

58. Urquijo, "Los matrimonios."

59. Pedro Antonio Somellera, *Principios de derecho civil: curso dictado en la Universidad de Buenos Aires, 1824* (Buenos Aires, 1939), 81.

60. Chiaramonte, *Ciudades, provincias, Estados*, 190.

61. See título I, capítulo III, artículo 16 in Dalmacio Vélez Sarsfield, *Código Civil de la Repúbica Argentina* (Nueva York: Imprenta de Hallet y Breen, 1870), 51.

62. Donald Castro has argued that the idea of "to govern is to populate" contributed to the Afro-Argentines being "disappeared," and turned in to "non-persons," which was worse than being marginalized. See Castro, *The Afro-Argentine*, vi, 149.

63. AHPBA 7.5.17.31. Juan de Sousa Araujo con Manuel de Sousa Araujo. 1846.

6. Crude and Outdated Ideas

1. *La Camelia*, 18 April 1852.

2. Asunción Lavrin, "*Lo femenino*: Women in Colonial Historical Sources," in *Coded Encounters: Writing, Gender, and Ethnicity in Colonial Latin America*, ed. Javier Cevallos-Candau et al. (Amherst: University of Massachusetts Press, 1994), 153.

3. Dellepiane, *Dos patricias ilustres*, 6, 9.

4. See, for example, the recent volume edited by Fernanda Gil Lozano, *Historia de las mujeres Argentinas*. Gil Lozano argues that women need to be seen as

"creative" in their responses to their social condition and not just inserted into the male-dominated histories. See her "Introducción," 16–18.

5. See Szuchman, "A Challenge to the Patriarchs," 148.

6. It was not until 1870 that Argentina promulgated a new civil code. The new code incorporated many aspects of the old laws, especially dealing with married women, and thus recodified some traditional ideas and practices. Other aspects of the new code reflected the changes that had been evolving throughout the century. The codes will be discussed further in the epilogue.

7. See, for example, AHPBA 7.5.14.52. Manuel Casas con Benjamina Monterroso. 1843. For examples of the Casa as a protection in the Mexican case, see Lee M. Penyak, "Safe Harbors and Compulsory Custody: *Casas de depósito* in Mexico, 1750–1865," *Hispanic American Historical Review* 79, no. 1 (February 1999): 85, 95.

8. AGN TC Leg A-55, no. 25. Don Gervacio Arzac y Doña Urbana Sánchez, pidiendo el depósito de su hija Doña Ortensia. 1847.

9. *El Censor*, 29 January 1818. As cited in Szuchman, "A Challenge to the Patriarchs," 152.

10. AGN TC B-38, no. 1. Don Marcos Buireu con Don Pedro Ferreyro, sobre entrega de una hija. 1852.

11. AGN TC S-16.049. Doña Senovia Arias con Don Rafael Stuard sobre divorcio. 1867.

12. *El Observador Americano*, 26 August 1816.

13. *La Prensa Argentina*, 6 January 1816. Undoubtedly this rhetoric was not meant to be taken literally. Nevertheless, it does reflect the desire to bring women into the revolutionary scene.

14. *La Lira Argentina, o colección de las piezas poéticas, dadas a luz en Buenos Ayres durante la guerra de su independencia* (Buenos Aires: 1824), 66.

15. *La Prensa Argentina*, no. 6.

16. Leonor Calvera, "Revoluciones, minué y mujeres," in *Mujeres y cultura*, ed. Fletcher, 167.

17. Calvera, "Revoluciones," 168.

18. Calvera, "Revoluciones," 168–69.

19. Juana Manuela Gorriti, *Sueños y realidades*, as quoted in *Magical Sites: Women Travelers in 19th Century Latin America*, ed. Marjorie Agosín and Julie H. Levinson, 50–51 (Buffalo NY: White Pine Press, 1999).

20. See Rebecca Earle, "Rape and the Anxious Republic: Revolutionary Colombia, 1810–1830," in *Hidden Histories of Gender*, ed. Dore and Molyneaux, 127.

21. For a "centuries-old" example from the year 1405, see Christine de Pizan's *The Book of the City of Ladies* (New York: Persea Books, 1982).

22. Belsunce et al., *Buenos Aires, tomo III*, 126.

23. Guillermo Furlong, S. J., *La cultura femenina en la época colonial* (Buenos Aires: Editorial Kapelusz, 1951), 121.

24. As quoted in Dellepiane, *Dos patricias ilustres*, 20.

25. Belsunce et al, *Buenos Aires, tomo III*, 130, 135.

26. Susan Socolow argues that, despite this renewed effort, female education still consisted mostly of education in the domestic arts. It was also prohibitively expensive. See Socolow, *The Women of Colonial Latin America*, 166–70.

27. "Prospecto de un nuevo periódico que se intitulará *El Observador Americano*" 1816.

28. *El Observador Americano*, 4 November 1816.

29. *El Observador Americano*, 19 August 1816.

30. *El Observador Americano*, 9 September 1816.

31. *El Observador Americano*, 19 August 1816.

32. The idea of Republican Motherhood was common in other revolutionary societies, namely the United States of America. See Linda K. Kerber, *Women of the Republic: Intellect and Ideology in Revolutionary America* (Chapel Hill: University of North Carolina Press, 1980), chap. 9. See also Nancy F. Cott, *The Bonds of Womanhood: "Woman's Sphere" in New England, 1780–1835* (New Haven CT: Yale University Press, 1997).

33. *El Observador Americano*, 7 October 1816.

34. *El Observador Americano*, 7 October 1816.

35. *El Observador Americano*, 21 October 1816.

36. Belsunce et al., *Buenos Aires, tomo III*, 141.

37. Belsunce et al., *Buenos Aires, tomo III*, 142, 169.

38. As quoted in Nestor Tomás Auza, *Periodismo y femenismo en la Argentina, 1830–1930* (Buenos Aires: Emecé Editores, 1988), 68.

39. Elizabeth Garrels, "Sarmiento and the Woman Question: From 1839 to the *Facundo*," in *Sarmiento: Author of a Nation*, ed. Tulio Halperin Donghi et al., 273 (Los Angeles: University of California Press).

40. Garrels, "Sarmiento and the Woman Question," 283. As Garrels deftly illustrates, like the issue of race, Sarmiento's views on women vary depending on which of his writings is being examined.

41. Auza, *Periodismo y femenismo*, 68.

42. As quoted in Bonnie Frederick, *Wily Modesty: Argentine Women Writers, 1860–1910* (Tempe: Arizona State University Center for Latin American Studies Press, 1998), 43.

43. Francine Masiello, *Between Civilization and Barbarism: Women, Nation,*

and Literary Culture in Modern Argentina (Lincoln: University of Nebraska Press, 1992), 37.

44. Mónica Szurmuk, *Women in Argentina: Early Travel Narratives* (Gainesville: University Press of Florida, 2000), 11–12.

45. From Juana Manuela Gorriti, *El mundo de los recuerdos*, as cited in *Magical Sites*, ed. Agosín and Levinson, 44.

46. As quoted in Agosín and Levinson, eds., *Magical Sites*, 50–51.

47. See Bonnie Frederick, *Wily Modesty*, 15.

48. Francine Masiello, *La mujer y el espacio publico: el periodismo femenino en la argentina del siglo XIX* (Buenos Aires: Feminaria Editora, 1994), 7–8. The citations below from *La Aljaba*, *La Camelia*, and *Album de Señoritas* come from the selections from these papers found in Masiello's edited volume.

49. See Frederick, *Wily Modesty*, 43–44.

50. The term feminist, however, was not coined until the late nineteenth century. Nevertheless, Auza refers to it as the first feminist periodical. One month earlier, a periodical entitled *La Argentina* began publication, supposedly by the pen of a woman writer. However, subsequent investigation revealed that a man was really the author of the paper. See Auza, *Periodismo y femenismo*, 23.

51. *La Aljaba*, "Prospecto," November 1830.

52. *La Aljaba*, 19 November 1830.

53. *La Albaja*, 23 November 1830.

54. Translated by the author from the Spanish quoted in Frederick, *Wily Modesty*, 18.

55. *La Camelia*, 18 April 1852.

56. *La Camelia*, 22 April 1852.

57. Thomas Carlyle, *Sartor Resartus: The Life and Opinions of Herr Teufelsdröck in Three Books* (Los Angeles: University of California Press, 2000; originally published in book form in 1836), 27.

58. As quoted in Masiello, *La mujer y el espacio público*, 14.

59. According to Bonnie Frederick, *La Camelia* shut down in three months after being harassed by a satirical newspaper, *El Padre Castañeta* (see Frederick, *Wily Modesty*, 20). Readers will recall that in 1830 *La Aljaba* was closed down after a short tenure in publication, but even in the liberal era of Argentina, things were not easy for female journalists.

60. *Album de Señoritas*, 1 January 1854.

61. *Album de Señoritas*, 1 January 1854.

62. See Kristin Jones, "Calfucurá and Namuncurá," 181.

63. *Album de Señoritas*, 29 January 1854.

64. *Album de Señoritas*, 12 February 1854.

65. *Album de Señoritas*, 29 January 1854.

66. *Album de Señoritas*, 29 January 1854.

67. *Album de Señoritas*, 17 February 1854.

68. See Frederick, *Wily Modesty*, 23.

69. *El Centinela*, 16 February 1823.

70. *La Abeja Argentina*, 142–47.

71. AHPBA 7.5.14.57. Petrona Belmonte con Blas Olariaga. 1849. The mother's reason was that Blas could not support a family. After witnesses confirmed that the boy was employed, the judge granted the couple permission to wed.

72. See *Partida* 6.19.16

73. AGN TC B-28, no. 6. Doña Damiana Bidal contra Doña Aurelia Frias sobre la entrega de un hijo. 1845.

74. AGN TC B-28, no. 6. Doña Damiana Bidal contra Doña Aurelia Frias sobre la entrega de un hijo. 1845.

75. As quoted in Szuchman, *Order, Family, and Community*, 119.

76. As quoted in Auza, *Periodismo y femenismo*, 69. Many porteños would have agreed with republican leaders in Colombia who had similar misgivings about active female participation in national life. Conservative Colombians tried to portray women in the revolution as innocent victims of royalist raping, or as symbolic supporters of the revolutionary cause, instead of active participants. By literally and symbolically confining women to these less threatening roles, post-independent leaders in Colombia hoped to keep women in their proper place. See Earle, "Rape and the Anxious Republic."

77. Dora Barrancos, "Inferioridad jurídica y encierro doméstico," in *Historia de las mujeres en la Argentina*, ed. Gil Lozano, 111–14.

78. See Manual Navarro, *Tésis de jurisprudencia en que sostiene que la mujer tiene las mismas o mejores aptitudes que el hombre para adoptar.* 1850. Nevertheless, Navvarro stopped short of claiming that women should have the right to exercise *patria potestad* as adoptive parents. Christine Hunefeldt also argues that in Peru throughout the nineteenth century, lawyers and judges became more sympathetic to the plight of women. See Hunefeldt, *Liberalism in the Bedroom*, 317.

79. As quoted in Frederick, *Wily Modesty*, 20–21.

80. Miller, *Latin American Women and the Struggle for Social Justice* (Hanover NH: University Press of New England, 1991), 35.

81. See Asuncion Lavrin, *Women, Feminism, and Social Change in Argentina, Chile, and Uruguay, 1890–1940* (Lincoln: University of Nebraska Press, 1995), 15.

82. Masiello, *Between Civilization and Barbarism*, 8–9.

Epilogue

1. Vélez Sarsfield as quoted in Leopoldo Basavilbaso, "Tésis Presentada."

2. Legal historian Abelardo Levaggi writes that Vélez Sarsfield was influenced by traditionalism (historicism) as well as by rationalism (the idea that laws should change a society). See Levaggi, *Manual, tomo I*, 215.

3. The idea of an Argentine "birth" has been questioned by José Carlos Chiaramonte in "La cuestión regional en el proceso de gestación del estado nacional argentino. Algunos problemas de interpretación," in *La unidad nacional en América Latina. Del regionalismo a la nacionalidad*, ed. Marco Palacio, 51–85 (México: El Colegio de México, 1983); "Formas de identidad en el Río de la Plata luego de 1810," *Boletín del Instituto de Historia Argentina y Americana, "Dr. E. Ravignani"* no. 1, 3ra. serie (1989): 71–92. See also Barreneche, *Crime and the Administration of Criminal Justice*, 18, 39.

4. See Táu Anzoátegui, *La codificación*, 65–67.

5. Pilar González Bernaldo, "La 'identidad nacional' en el Río de la Plata post-colonial. Continuidades y rupturas con el Antiguo Régimen," *Anuario del* IEHS *"Profesor Juan C. Grosso"* 12 (1997): 111–14.

6. González Bernaldo recognizes the profound continuities between colony and nation but questions whether or not those continuities denote a lack of any kind of national identity. "Supposing this says that we consider that 'national identity' implies a cultural homogeneity that can only be achieved by a modern nation-state." She acknowledges Chiaramonte's argument that the frequent political failures of the early years after independence did affect the national identity. However, she continues, those failures "do not nullify all identification with the nation. Instead, they force us to think of it in another way." González Bernaldo, "La identidad nacional," 122, 119. Túlio Halperín-Donghi has also argued that the lower classes may have entered the army eagerly for the wages it offered and not for nationalist reasons, as seen in the masses' "lackluster" performance at the Battle of Caseros in 1852. See Halperín-Donghi, *Politics, Economics, and Society*, 216.

7. AHPBA 7.5.16.33. Amond Amondsen y Sofia Hartwig. 1844.

8. Sánchez, *Recuerdos*, 59–60.

9. Initial findings indicate that in some important respects, the Hispanic family model does not fit the traditional "western" stereotype, especially during the colonial period. Patricia Seed and Susan Socolow, for example, argue that the rise of capitalism in the new world, instead of weakening patriarchal power, actually led the Bourbon monarchs to strengthen fathers in late-colonial Mexico and Buenos Aires. See Socolow, "Acceptable Partners," and Seed's *To Love, Honor, and Obey*.

10. Miller, *Latin American Women*, 39.

11. Linda Kerber also found the nineteenth century to be ambivalent for women in many respects, although the American Revolution did usher in new ideas that led to progress on some significant fronts. See her introduction to *Women of the Republic*.

12. See notes in chap. 6.

13. Basalvibaso, *Tésis Presentada*, 21, 22.

14. All of the above quotes are taken from Victor Táu Anzoátegui's *La codificación*, 69, 166, 167, 231–32.

15. Táu Anzoátegui's *La codificación*, 231–32, 240–41.

16. While these changes had significant impacts on many areas, porteño society was still a vast and complex phenomenon. A brief comparison between civil tribunals and criminal courts is illustrative. As with civil matters, early-national leaders in Argentina drew heavily on colonial criminal laws as they considered how to direct the nation-building in the new republic. Although liberal attitudes on criminal reforms were espoused on a theoretical basis, political realities and the task of maintaining social order postponed the implementation of those liberal principles until Argentina progressed to a more democratic society. In the meantime, heavy-handed justice was the order of the day. See Osvaldo Barreneche, *Dentro de la ley*, TODO, 15. Perhaps government officials were more willing to relax the traditional societal restraints in civil matters, such as the institution of marriage, than they were in questions of criminality. In short, the nation may have had more to gain by relaxing certain civil laws and more to risk by liberalizing the administration of criminal justice. With social order being such a high priority for the early leaders of the nation, such a distinction is logical. This difference is important because it points out the enormous complexity of assessing the impact of the May Revolution and nation-building.

17. AHPBA 7.5.15.24. 1818. Francisco Armero, sobre disenso.

Bibliography

Primary Sources
Alfonso the Wise, *Las Siete Partidas.*

Archivo General de la Nación. Tribunales Civiles. Buenos Aires, Argentina. Cited throughout as AGN TC.

Archivo Histórico de la Provincia de Buenos Aires, "Ricardo Levene." Real Audiencia y cámara de apelación de Buenos Aires. Disensos. La Plata, Buenos Aires province, Argentina. Cited throughout as AHPBA

Azamor y Ramírez, Manuel. *De matrimonio contrahendo insciis, inconsultis aut invitis parentibus* (ca. 1795).

Basavilbaso, Leopoldo. "Tésis presentada y sostenida en la Universidad de Buenos Aires por Leopoldo Basavilbaso para obtener el grado de doctor de jurisprudencia." Disertación de Jurisprudencia de la Universidad de Buenos Aires: Imprenta del Siglo, 1867.

Cavia, Fidel. "Es justa de deheredación de los hijos que se contraen matrimonios sin el Consentimiento paterno, en la edad que la ley lo exige." Disertación de Jurisprudencia de la Universidad de Buenos Aires, 1864.

Echeverría, Esteban. *La Cautiva. El Matadero. Ojeada retrospectiva.* Buenos Aires: Centro editor de America Latina, 1979.

Fondebrider, Jorge, ed. *La Buenos Aires ajena: Testimonios de extranjeros de 1536 hasta hoy.* Buenos Aires: Emecé, 2001.

Hidalgo, Bartolomé. *Cielitos y diálogos patrióticos.* Buenos Aires: Centro Editor de América Latina, 1979.

Konetzke, Richard, ed. *Colección de documentos para la historia de la formación social de hispanoamérica,* 3 vols. Madrid: Consejo Superior de investigaciones científicas, 1962.

La Lira Argentina, o colección de las piezas poéticas, dadas a luz en Buenos Ayres durante la guerra de su independencia. Buenos Aires, 1824.

Majesté, Fransisco. "En materias mixtas, en casos dudosos, en que las dos potes-

tades: Civil y Eclesiástica con igual derecho intervienen, deberá decidir el poder soberano." Disertación de Jurisprudencia de la Universidad de Buenos Aires, 1848.

Sánchez, Mariquita. *Recuerdos del Buenos Aires virreinal.* Buenos Aires: Ene Editorial, 1963.

Senado de la Nación. *Biblioteca de Mayo. Colección de obras y documentos para la historia argentina*, 18 vols. Buenos Aires: Imprenta del Congreso de la Nación Argentina, 1960.

Somellera, Pedro Antonio. *Principios de derecho civil: Curso dictado en la Universidad de Buenos Aires, 1824.* Buenos Aires, 1939.

Vélez-Sarsfield, Dalmacio. *Código Civil de la República Argentina.* Nueva York: Imprenta De Hallet y Breen, 1870.

Secondary Sources

Academia Nacional de Bellas Artes. *Historia general del arte argentino, tomo III.* Buenos Aires: Adacemia Nacional de Bellas Artes, 1982.

Adleman, Jeremy. *Frontier Development: Land, Labor, and Capital on the Wheatlands of Argentina and Canada, 1890–1914.* Oxford: Clarendon Press, 1994.

———. *The Republic of Capital: Buenos Aires and the Legal Transformation of the Atlantic World.* Stanford: Stanford University Press, 1999.

———, ed. "The Problem of Persistence in Latin America." In *Colonial Legacies: The Problem of Persistence in Latin America.* New York: Routledge, 1999.

Agosín, Marjorie, and Julie H. Levinson, eds. *Magical Sites: Women Travelers in 19th Century Latin America.* Buffalo NY: White Pine Press, 1999.

Anaya, Jorge. *Historia del arte argentino.* Buenos Aires: Emecé, 1997.

Andrews, George Reid. *The Afro-Argentines of Buenos Aires, 1800–1900.* Madison: University of Wisconsin Press, 1980.

———. "The Afro-Argentine Officers of Buenos Aires Province, 1800–1860." *Journal of Negro History* 61, no. 2 (Spring, 1979): 85–100.

Andrien, Kenneth J., and Lyman L. Johnson, eds. *The Political Economy of Spanish America in the Age of Revolution, 1750–1850.* Albuquerque: University of New Mexico Press, 1994.

Ariés, Phillip. *Centuries of Childhood.* New York: Vintage, 1962.

Arrom, Silvia. "Perspectivas Sobre Historia de la Familia en Mexico." In *Familias Novohispanas: Siglos XVI al XIX*, ed. Pilar Gonzalbo Aizpuru, 389–99. Ciudad de México: El Colegio de México, 1991.

Auza, Nestor Tomás. *Periodismo y feminismo en la Argentina, 1830–1930.* Buenos Aires: Emecé Editores, 1988.

Baily, Samuel. *Immigrants in the Lands of Promise: Italians in Buenos Aires and New York City, 1870–1914.* Ithaca NY: Cornell University Press, 1999.

Barrancos, Dora. "Inferioridad juridical y encierro doméstico." In *Historia de las mujeres en la argentina: Colonia y siglo XIX,* ed. Fernanda Gil Lozano et al., 111–29. Buenos Aires: Taurus, 2000.

Barreneche, Osvaldo. "Crime and the Administration of Criminal Justice in Buenos Aires, Argentina, 1785–1853." Ph.D. diss., University of Arizona, 1997.

———. *Dentro de la ley,* TODO: *La justicia criminal de Buenos Aires en la etapa formativa del sistema penal moderno de la Argentina.* La Plata: Ediciones al Margen. 2001.

Beezley, William H., and Judith Ewell, eds. *The Human Tradition in Modern Latin America.* Wilmington DE: Scholarly Resources Press. 1997.

Behar, Ruth. "Sexual Witchcraft, Colonialism, and Women's Powers." In *Sexuality and Marriage in Colonial Latin America,* ed. Asunción Lavrin, 178–208. Lincoln: University of Nebraska Press, 1989.

Bellingham, Bruce. "The History of Childhood Since the 'Invention of Childhood': Some Issues in the Eighties." *The Journal of Family History* 13, no. 2 (1988): 342–58.

Bonatti, Marió. *Negra bela raiz: A presença negra na formação do Brasil.* São Paulo: Editora Santuaria, 1991.

Boyer, Richard. "Women, *La Mala Vida,* and the Politics of Marriage." In *Sexuality and Marriage in Colonial Latin America,* ed. Asunción Lavrin, 252–86. Lincoln: University of Nebraska Press, 1989.

Brown, Jonathan. "The Bondage of Old Habits in Nineteenth-Century Argentina." *Latin American Research Review* 21, no. 2 (1986): 3–31.

———. *A Socioeconomic History of Argentina.* Cambridge: Cambridge University Press, 1979.

Burgin, Miron. *The Economic Aspects of Argentine Federalism, 1820–1852.* Cambridge MA: Harvard University Press, 1941.

Bushnell, David. *Reform and Reaction in the Platine Provinces: 1810–1852.* Gainseville: University Presses of Florida, 1983.

Calvera, Leonor. "Revoluciones, minué y mujeres." In *Mujeres y cultura en la Argentina del siglo XIX,* ed. Lea Fletcher, 166–75. Buenos Aires: Editora Feminaria, 1994.

Calzada, Méndez. *La función judicial en los primeros épocas de la independencia.* Buenos Aires: Editorial Losada, 1944.

Carlyle, Thomas. *Sartor Resartus: The Life and Opinions of Herr Tefelsdröckh in Three Books.* Los Angeles: University of California Press, 2000.

Castro, Donald. *The Afro-Argentine in Argentine Culture: El Negro del Acordeón.* Lewiston: Edwin Mellen Press, 2001.

Chambers, Sarah. *From Subjects to Citizens: Honor, Gender, and Politics in Arequipa, Peru, 1780–1854.* University Park: Pennsylvania State University Press, 1999.

Chasteen, John C. *National Rhythms, African Roots: The Deep History of Latin American Popular Dance.* Albuquerque: University of New Mexico Press, 2004.

———. "Patriotic Footwork: Social Dance and the Watershed of Independence in Buenos Aires." In *State and Society in Spanish America during the Age of Revolution,* ed. Victor Uribe-Uran, 174–91. Wilmington DE: Scholarly Resources Inc., 2001.

———. "Violence for Show: Knife Dueling on a Nineteenth-Century Cattle Frontier." In *The Problem of Order in Changing Societies: Essays on Crime and Policing in Argentina and Uruguay, 1750–1940,* ed. Lyman Johnson, 47–64. Albuquerque: University of New Mexico Press, 1990.

Chiaramonte, José Carlos. *Ciudades, Provincias, Estados: Orígenes de la Nación Argentina (1800–1846).* Buenos Aires: Ariel Historia, 1997.

———. "Formas de identidad en el Río de la Plata luego de 1810," *Boletín del Instituto de Historia Argentina y Americana, "Dr. E. Ravignani"* 3, no. 1 (1989): 71–92.

———. "La cuestión regional en el proceso de gestación del estado nacional argentino. Algunos problemas de interpretación." In *La unidad nacional en América Latina. Del regionalismo a la nacionalidad,* ed. Marco Palacio, 51–85. México: El Colegio de México, 1983.

Cicerchia, Hector Ricardo. *Historia de la vida privada en la Argentina.* Buenos Aires: Troquel, 1998.

———. "Las Vueltas del Torno: Claves de un Malthusiasmo popular." In *Mujeres y cultura en la Argentina del siglo XIX,* ed. Lea Fletcher, 196–206. Buenos Aires: Editora Feminaria, 1994.

———. "*La vida maridable*: Ordinary Families in Buenos Aires (Argentina, 1778–1850)." Ph.D. diss., Columbia University, 1995.

———. "Minors, Gender, and Family: The Discourses in the Court System of Traditional Buenos Aires." *The History of the Family: An International Quarterly* 2, no. 3 (1997): 331–46.

———. "Vida Familiar y practicas conyugales. Clases populares en una ciudad colonial, Buenos Aires, 1800–1810." *Boletín del Instituto de Historia Argentina y Americana Dr. E. Ravignani* 3:2 (1900) 91–109.

Cott, Nancy F. *The Bonds of Womanhood: "Women's Sphere" in New England, 1780–1835.* New Haven CT: Yale University Press, 1997.

Cunningham, Hugh. "Histories of Childhood." *The American Historical Review* 103, no. 4 (October 1998): 1195–1208.

del Carril, Bonifacio, and Aníbal G. Aguirre Saravia. *Iconografía de Buenos Aires: La ciudad de Garay hasta 1852.* Buenos Aires, Municipalidad de la Ciudad de Buenos Aires, 1982.

Dellepiane, Antonio. *Dos patricias ilustres.* Buenos Aires: Imprenta y Casa Editora "Coni.," 1923.

De Toqueville, Alexis. *Democracy in America.* Trans. George Lawrence, J. P. Mayer, ed. New York: Anchor Press, 1969.

Dore, Elizabeth. "One Step Forward, Two Steps Back: Gender and State in the Long Nineteenth Century." In *Hidden Histories of Gender and State in Latin America,* ed. E. Dore and M. Molyneaux, 3–32. Durham NC: Duke University Press, 2000.

Dore, Elizabeth, and Maxine Molyneaux, eds. *Hidden Histories of Gender and State in Latin America.* Durham NC: Duke University Press, 2000.

Earle, Rebecca. "Rape and the Anxious Republic: Revolutionary Colombia, 1810–1830." In *Hidden Histories of Gender and State in Latin America,* ed. E. Dore and M. Molyneaux, 127–46. Durham NC: Duke University Press, 2000.

Ediciones Federales. *Con Rosas o contra Rosas.* Buenos Aires: Ediciones Federales, 1989.

Fletcher, Lea, ed. *Mujeres y cultura en la Argentina del siglo XIX.* Buenos Aires: Editora Feminaria, 1994.

Frederick, Bonnie. *Wily Modesty: Argentine Women Writers, 1860–1910.* Tempe: Arizona State University Center for Latin American Studies Press, 1998.

Furlong, S. J., Guillermo. *La cultura femenina en la época colonial.* Buenos Aires: Editorial Kapelusz, 1951.

Galmarini, Hugo Raul. "Los españoles de Buenos Aires despues de la Revolución de Mayo: La suerte de una minoría desposeida del poder." *Revista de Indias* 46: 561–92.

Garavaglia, Juan Carlos. "Economic Growth and Regional Differentiation: The River Plate Region at the End of the Eighteenth Century." *Hispanic American Historical Review* 65 (1): 51–89.

Garavaglia, Juan Carlos, and Jorge D. Gelman. "Rural History of the Río de la Plata, 1600–1850: Results of a Historiographical Renaissance." *Latin American Research Review* 30, no. 3 (1995): 75–105.

García Belsunce, Cesar, et al. *Buenos Aires, 1800–1830, tomo III: Educación y*

asistencia social. Buenos Aires: Ediciones del Banco Internacional y Banco Unido de Inversión, 1978.

Garrels Elizabeth. "Sarmiento and the Woman Question: From 1839 to the *Facundo.*" In *Sarmiento: Author of a Nation*, ed. Tulio Halperín-Donghi et al., 272–93. Los Angeles: University of California Press, 1994.

———. "Sobre Indios, Afroamericanos, y los Racismos de Sarmiento." *Revista Iberoamericana* 63, nos. 178–79 (January–June 1997): 99–113.

Gelman, Jorge. "Producción y explotaciones agrarias bonaerenses entre la colonia y la primera mitad del siglo XIX. Rupturas y continuidades." *Anuario del* IEHS *"Profesor Juan C. Grosso"* 12 (1997): 57–62.

Gillis, John R. *For Better, For Worse: British Marriages, 1600 to the Present.* New York: Oxford University Press, 1985.

Gil Lozano, Fernanda, Valeria Silvina Pita, and María Gabrieli Ini, eds. *Historia de las Mujeres en la Argentina: Colonia y siglo XIX.* Madrid: Taurus, 2000.

Goldberg, Marta B. "La población negra y mulata de la ciudad de Buenos Aires, 1810–1840." *Desarrollo Económico* 16, no. 61 (1976): 75–99.

———. "Las Afroargentinas, 1750–1850." In *Historia de las Mujeres en la Argentina: Colonia y siglo XIX*, ed. Gil Lozano et al., 67–85. Madrid: Taurus, 2000.

Goldberg, Marta, and Silvia Mallo. "La población africana en Buenos Aires y su campaña. Formas de vida y de subsistencia (1750–1850)." *Temas de Africa y Asia* (1993).

Gonzalbo Aizpuru, Pilar, ed. *Familias iberoamericanas. Historia, identidad y conflictos.* México City DF: El Colegio de México, 2001.

———, ed. *Familia y educación en iberoamérica.* México City DF: El Colegio de México, 1999.

———, ed. *Género, familia y mentalidades en América Latina.* San Juan PR: Editorial de la Universidad de Puerto Rico, 1997.

———, and Cecilia Rabell, eds. *La familia en el mundo iberoamericano.* México City DF: Instituto de Investigaciones Sociales, 1994.

González Arrilli, Bernardo, ed. *La tiranía y la libertad: juicio histórico sobre Juan Manuel de Rozas.* Buenos Aires: Ediciones Libera, 1970.

González Bernaldo, Pilar. "La 'identidad nacional' en el Río de la Plata postcolonial. Continuidades y rupturas con el Antiguo Régimen." *Anuario del* IEHS *"Profesor Juan C. Grosso"* 12 (1997): 109–22.

Gudmundson, Lowell. "De 'negro' a 'blanco' en la Hispanoamérica del siglo XIX: la asimilación afroamericana en Argentina y Costa Rica." *Mesoamérica* 7, no. 12 (December 1986): 309–29.

Güiraldes, Ricardo. *Don Segundo Sombra*. Buenos Aires: Centro Editor de América Latina. 1979.

Gutiérrez, Ramón. *When Jesus Came, The Corn Mothers Went Away: Marriage, Sexuality, and Power in New Mexico, 1500–1846*. Stanford: Stanford University Press, 1991.

Guy, Donna J. *Argentine Sugar Politics: Tucumán and the Generation of Eighty*. Tempe: Center for Latin American Studies, 1980.

———. "Emilio and Gabriela Coni: Reformers, Public Health, and Working Women." In *The Human Tradition in Modern Latin America*, ed. William H. Beezley and Judith Ewell, 77–92. Wilmington DE: Scholarly Resources Press. 1997.

———. "Mothers Alive and Dead: Multiple Concepts of Mothering in Buenos Aires." In *Sex and Sexuality in Latin America*, ed. Daniel Balderston and Donna Guy, 155–73. New York: New York University Press, 1997.

———. *Sex and Danger in Buenos Aires: Prostitution, Family, and Nation in Argentina*. Lincoln: University of Nebraska Press, 1991.

———. "Women, Peonage, and Industrialization: Argentina, 1810–1914." *Latin American Research Review* 25, no. 3 (1985): 65–90.

Guy, Donna J., and Thomas Sheridan, eds. *Contested Ground: Comparative Frontiers on the Northern and Southern Edges of the Spanish Empire*. Tucson: University of Arizona Press, 1998.

Halperín-Donghi, Tulio. *Politics, Economics, and Society in Argentina in the Revolutionary Period*. Trans. by Richard Southern. New York: Cambridge University Press, 1975.

Hecht, Tobias, ed. *Minor Omissions: Children in Latin American History and Society*. Madison: University of Wisconsin Press, 2002.

Johnson, Lyman L. "Dangerous Words, Provocative Gestures, and Violent Acts: The Disputed Hierarchies of Plebeian Life in Colonial Buenos Aires." In *The Faces of Honor*, ed. Lyman L. Johnson and Sonya Lipsett-Rivera, 127–51. Albuquerque: University of New Mexico Press, 1998.

———. "Distribution of Wealth in Nineteenth-Century Buenos Aires Province: The Issue of Social Justice in a Changing Economy." In *The Political Economy of Spanish America*, ed. Kenneth Andrien and Lyman Johnson, 197–214. Albuquerque: University of New Mexico Press, 1994.

———. "The Frontier as an Arena of Social and Economic Change: Wealth Distribution in Nineteenth-Century Buenos Aires Province." In *Contested Ground: Comparative Frontiers on the Northern and Southern Edges of the Spanish Empire*, ed. Donna J. Guy and Thomas E. Sheridan, 167–81. Tucson: University of Arizona Press, 1998.

————. "Manumission in Colonial Buenos Aires, 1776–1810." *Hispanic American Historical Review* 59, no. 2 (1979): 258–79.

————. "The Price History of Buenos Aires During the Viceregal Period." In *Essays of the Price History of Eighteenth-Century Latin America*, ed. Lyman L. Johnson and Enrique Tandeter, 137–72. Albuquerque: University of New Mexico Press, 1990.

————, ed. *The Problem of Order in Changing Societies: Essays on Crime and Policing in Argentina and Uruguay, 1750–1940*. Albuquerque: University of New Mexico Press, 1990.

Johnson, Lyman L., and Sonya Lipsett-Rivera, eds. *The Faces of Honor: Sex, Shame, and Violence in Colonial Latin America*. Albuquerque: University of New Mexico Press, 1998.

Jones, Kristin. "Calfucurá and Namuncurá: Nation Builders of the Pampas." In *The Human Tradition in Latin America: The Nineteenth Century*, ed. W. Beezley and J. Ewell, 175–86. Wilmington DE: Scholarly Resources Press. 1997.

The Journal of Family History. "Female and Family in Nineteenth-Century Latin America" 16, no. 3 (1991).

Kerber, Linda K. *Women of the Republic: Intellect and Ideology in Revolutionary America*. Chapel Hill: University of North Carolina Press, 1980.

Kluger, Viviana. *Escenas de la vida conyugal: Los conflictos matrimoniales en la sociedad rioplatense*. Buenos Aires: Editorial Quorum, 2003.

Kuznesoff, Elizabeth, and Robert Oppenheimer. "The Family and Society in Nineteenth-Century Latin America: An Historiographical Introduction." *The Journal of Family History* 10, no. 3 (1985): 215–35.

Lanuza, José Luis. *Morenada*. Buenos Aires: Emecé. 1946.

————. *Pintores del Viejo Buenos Aires*. Buenos Aires: Ediciones Culturales Argentinas, 1961.

Lavrin, Asunción. "Introduction: The Scenario, the Actors, and the Issues." In *Sexuality and Marriage*, ed. Asunción Lavrin, 1–46. Lincoln: University of Nebraska Press, 1989.

————. "*Lo femenino*: Women in Colonial Historical Sources." In *Coded Encounters: Writing, Gender, and Ethnicity in Colonial Latin America*, ed. Javier Cevallos-Candau et al. 153–76. Amherst: University of Massachusetts Press, 1994.

————. *Women, Feminism, and Social Change in Argentina, Chile, and Uruguay, 1890–1940*. Lincoln: University of Nebraska Press, 1995.

————, ed. *Sexuality and Marriage in Colonial Latin America*. Lincoln: University of Nebraska Press, 1989.

Levaggi, Abelardo. *Manual de historia del derecho argentina*, 2 vols. Buenos Aires: Ediciones Depalma, 1986–91.

Levene, Ricardo. *Historia del derecho Argentino*, 5 vols. Buenos Aires: Editorial Guillermo Kraft, 1945–58.

Lipsett-Rivera, Sonya. "The Intersection of Rape and Marriage in Late-Colonial and Early-National Mexico." *Colonial Latin American Historical Review* 6, no. 4 (Fall 1997): 559–90.

Lynch, John. *Argentine Dictator: Juan Manuel de Rosas, 1829–1852*. Oxford: Clarendon Press, 1981.

———. *The Spanish American Revolutions, 1808–1826*. New York: W. W. Norton & Company, 1986.

Mallo, Silvia. "Justicia, divorcio, alimentos, y malos tratos en el Río de la Plata, 1766–1857." *Investigaciones y Ensayos* 1991: 373–400.

Masefield, John. *A Poem and Two Plays*. London: Heinemann, 1919.

Masiello, Francine. *Between Civilization and Barbarism: Women, Nation, and Literary Culture in Modern Argentina*. Lincoln: University of Nebraska Press, 1992.

———. *La mujer y el espacio publico: el periodismo femenino en la argentina del siglo XIX*. Buenos Aires: Feminaria Editora, 1994.

Mayo, Carlos. "Un loco amor: romances juveniles perseguidos (para una historia del amor en la Sociedad rioplatense) (1770–1830)." *Investigaciones y Ensayos* 49 (1999): 487–506.

Meyer, Jorge. *Orden y Virtud: El discurso republicano en el régimen Rosista*. Buenos Aires: Universidad Nacional de Quilmes, 1995.

Miller, Francesca. *Latin American Women and the Search for Social Justice*. Hanover NH: University Press of New England, 1991.

Moreno, José Luis. *Historia de la familia en el Río de la Plata*. Buenos Aires: Editorial Sudamericana, 2004.

———. "La infancia en el Río de la Plata: Buenos Aires, ciudad y campaña, 1780–1860." *Cuadernos de Historia Regional* 20 (1998): 83–118.

———. "Sexo, matrimonio y familia: La ilegitimidad en la frontera pampeana del Río de la Plata, 1780–1850." *Boletín del Instituto de Historia Argentina y Americana "Dr. Emilio Ravignani"* 16/17 (1998): 61–84.

Moya, José C. *Cousins and Strangers: Spanish Immigrants in Buenos Aires, 1850–1930*. Los Angeles: University of California Press, 1998.

Nizza da Silva, María Beatriz. "Divorce in Colonial Brazil." In *Sexuality and Marriage in Colonial Latin America*, ed. Asunción Lavrin, 313–40. Lincoln: University of Nebraska Press, 1989.

Panella, Claudio, "Consideraciones acerca de los matrimonios entre católicos

y protestantes en Buenos Aires (1826–1851)." *Temas de Historia Argentina* (1994): 17–38.

Penyak, Lee M. "Safe Harbors and Compulsory Custody: Casas de depósito in Mexico, 1750–1865. *Hispanic American Historical Review* 79, no. 1 (February 1999): 83–99.

Picotti, Dina V., ed. *El negro en la Argentina: presencia y negación.* Buenos Aires: Editores de América Latina, 2001.

Pinch, Adela. "Emotion and History: A Review Article." *Comparative Studies in Society and History* 37, no. 1 (January 1995): 100–109.

Pizan, Christine de. *The Book of the City of Ladies.* New York: Persea Books, 1982.

Pollock, Linda. *Forgotten Children: Parent-child Relations from 1500–1900.* Cambridge: Cambridge University Press, 1983.

Porro, Nellie. "Los juicios de disenso en el Río de la Plata. Nuevos aportes sobre la aplicación de la Pragmática de hijos de familia." *Anuario Histórico Jurídico Ecuatoriano,* 5 (1980): 193–229. Quito, Ecuador: Corporación de estudios y publicaciones.

Premo, Bianca. "Children of the Father King: Youth, Authority, and Legal Minority in Lima." Ph.D. diss., University of North Carolina, Chapel Hill, 2001.

———. "Minor Offenses: Youth, Crime, and Law in Eighteenth-Century Lima." In *Minor Omissions: Children in Latin American History and Society,* ed. Tobias Hecht, 114–38. Madison: University of Wisconsin Press, 2002.

Prestigiacomo, Raquel, and Fabián Uccello. *La pequeña aldea: vida cotidiana en Buenos Aires, 1800–1860.* Buenos Aires: Eudeba, 1999.

Rípodas Ardanaz, Daisy. *Matrimonio en Indias: realidad social y regulación jurídica.* Buenos Aires: Fundación para la Educación, la Ciencia, y la Cultura, 1977.

Rodríguez Molas, Ricardo. *Historia Social del Gaucho.* Buenos Aires: Marú, 1968.

Rosal, Miguel Angel. "Negros y pardos en Buenos Aires, 1811–1860." *Anuario de Estudios Americanos* 51, no. 1 (1994): 165–84.

Ross, Stanley R. and Thomas F. McGann, eds. *Buenos Aires: 400 Years.* Austin: University of Texas Press. 1982.

Rossi, Vicente. *Cosas de negros* 1926. Reprint, Buenos Aires: Taurus, 2001.

Ruggiero, Kristin. "Honor, Maternity, and the Disciplining of Women: Infanticide in Late Nineteenth-Century Buenos Aires." *Hispanic American Historical Review* 72, no. 3 (1992): 353–73.

Sábato, Hilda. *Agrarian Capitalism and the World Market: Buenos Aires in the Pastoral Age, 1840–1890.* Albuquerque: University of New Mexico Press, 1990.

Sáenz, Jimena. "Love Story, 1848: El caso de Camila O'Gorman." *Todo es Historia* no. 51 (July 1971).

Sáenz Quesada, María. *Mariquita Sánchez: Vida política y sentimental*. Buenos Aires: Editorial Sudamericana, 1995.

Salvatore, Ricardo. *Wandering Paysanos: State, Order, and Subaltern Experience in Buenos Aires During the Rosas Era*. Durham NC: Duke University Press, 2003.

Sarmiento, Domingo F. *Life in the Argentine Republic in the Days of the Tyrants: Or, Civilization and Barbarism*. Trans. Mrs. Horace Mann. New York: Hafner Publishing, 1971.

Schettini, Adriana. "Camila O'Gorman: La levadura de un amor prohibido." In *Mujeres argentinas: El lado femenino de nuestra historia*, prologue by María Esther de Miguel. Buenos Aires: Extra Alfaguara, 1998.

Scobie, James R. *Revolution on the Pampas: A Social History of Argentine Wheat*. Austin: University of Texas Press, 1964.

Seed, Patricia. "Colonial and Postcolonial Discourse." *Latin American Research Review* 26, no. 3 (1991): 181–200.

———. *To Love, Honor, and Obey in Colonial Mexico: Conflicts Over Marriage Choice, 1574–1821*. Stanford: Stanford University Press, 1988.

Sempat Assadourian, Carlos. *El sistema de la economía colonial: mercado interno, regiones, y espacio económico*. Lima: Instituto de Estudios Peruanos, 1982.

Senor, María Selva. "La construcción de la 'familia ideal.' La familia segun los jurisconsultos de la Universidad de Buenos Aires, primera mitad del siglo XIX." Paper presented at 51 Congreso Internacional de Americanistas, Santiago, Chile, July 2003.

Shorter, Edward. *The Making of the Modern Family*. New York: Basic Books, 1975.

Shumway, Jeffrey M. "The Purity of My Blood Cannot Put Food on My Table: Changing Attitudes toward Interracial Marriage in Nineteenth-Century Buenos Aires." *The Americas* 58, no. 2 (October 2001): 201–20.

Shumway, Nicolas. *The Invention of Argentina*. Los Angeles: University of California Press, 1991.

Slatta, Richard W. *Gauchos and the Vanishing Frontier*. Lincoln: University of Nebraska Press, 1992.

Smith, Peter H. *Politics and Beef in Argentina: Patterns of Conflict and Change*. New York: College University Press, 1969.

Socolow, Susan M. "Acceptable Partners: Marriage Choice in Colonial Argentina, 1778–1810." In *Sexuality and Marriage in Colonial Latin America*, ed. Asunción Lavrin, 209–46. Lincoln: University of Nebraska Press, 1989.

———. *The Bureaucrats of Buenos Aires, 1769–1810: Amor al Real Servicio*. Durham NC: Duke University Press, 1987.

————. *The Merchants of Buenos Aires, 1778–1810: Family and Commerce*. Cambridge: Cambridge University Press, 1978.

————. "Women of the Buenos Aires Frontier, 1740–1810 (or the Gaucho Turned Upside Down)." In *Contested Ground: Comparative Frontiers on the Northern and Southern Edges of the Spanish Empire*, ed. Donna J. Guy and Thomas E. Sheridan, 67–82. Tucson: University of Arizona Press, 1998.

————. *The Women of Colonial Latin America*. Cambridge: Cambridge University Press, 2000.

Solberg, Carl. *The Prairies and the Pampas: Agrarian Policy in Canada and Argentina, 1880–1930*. Stanford: Stanford University Press, 1987.

Stern, Steve J. *The Secret History of Gender: Women, Men, and Power in Late Colonial Mexico*. Chapel Hill: University of North Carolina Press, 1995.

Stevens, Donald F. "Passion and Patriarchy in Nineteenth-Century Argentina: María Luisa Bemberg's *Camila*." In *Based on a True Story: Latin American History at the Movies*, ed. Donald F. Stevens, 85–102. Wilmington DE: Scholarly Resources Inc., 1997.

Stone, Lawrence. *The Family, Sex, and Marriage in England, 1500–1800*. New York: Harper and Row, 1977.

Stone, Marilyn. *Marriage and Friendship in Medieval Spain: Social Relations According to the Fourth Partida of Alfonso X*. New York: Peter Lang, 1994.

Szuchman, Mark D. "A Challenge to the Patriarchs: Love Among the Youth in Nineteenth-Century Argentina." In *The Middle Period in Latin America: Values and Attitudes in the 17th–19th Centuries*, ed. Mark D. Szuchman, 141–66. Boulder CO: Lynne Rienner Publishers, 1989.

————. *Order, Family, and Community in Buenos Aires: 1810–1860*. Stanford: Stanford University Press, 1988.

Szuchman, Mark D., and Jonathan C. Brown, eds. *Revolution and Restoration: The Rearrangement of Power in Argentina, 1776–1860*. Lincoln: University of Nebraska Press, 1994.

Szurmuk, Mónica. *Women in Argentina: Early Travel Narratives*. Gainesville: University Press of Florida, 2000.

Táu Anzoátegui, Victor. *La codificación en la Argentina (1810–1870): Mentalidad social e ideas jurídicas*. Buenos Aires, 1977.

————. *Las ideas jurídicas argentinas (siglos XIX–XX)*. Buenos Aires: Editorial Perrot, 1977.

Taylor, William B. "Between Global Process and Local Knowledge: An Inquiry into Early Latin American Social History, 1500–1900." In *Reliving the Past: The Worlds of Social History*, ed. Olivier Zunz, 115–90. Chapel Hill: University of North Carolina Press, 1985.

Twinam, Ann. "Honor, Sexuality, and Illegitimacy in Colonial Spanish America." In *Sexuality and Marriage in Colonial Latin America*, ed. Asunción Lavrin, 118–55. Lincoln: University of Nebraska Press, 1989.

——. *Public Lives, Private Secrets: Gender, Honor, Sexuality, and Illegitimacy in Colonial Spanish America*. Stanford: Stanford University Press, 1999.

Uribe-Uran, Victor, ed. *State and Society in Spanish America during the Age of Revolution*. Wilmington DE: Scholarly Resources Inc., 2001.

Urquijo, José M. Mariluz. "Los matrimonios entre personas de diferente religión ante el derecho patrio Argentino." *Conferencias y comunicaciones, folleto XXII*, 13–46. Buenos Aires: Instituto de Historia del Derecho, 1948.

Vanderwood, Paul J. "Studying Mexico's Political Process." In *The Evolution of the Mexican Political System*, ed. Jaime Rodríguez O., 266–67. Wilmington DE: Scholarly Resources, 1993.

Zegarra, Margarita. "La construcción de la madre y de la familia sentimental. Una visión del tema a través del *Mercurio Peruano*." *Histórica* 25, no. 1 (July 2001): 161–207.

Zelizer, Viviana. *Pricing the Priceless Child: The Changing Social Value of Children*. New York: Basic Books, 1985.

Index

Page numbers in italics refer to illustrations. The first number is the page number preceding the illustrations; the second number is the illustration number.

adultery, 36
Afro-Argentines, 99, 172nn5–6; in armed forces, 13, 99, 103–6; and economic life, 8–9; and Juan Manuel de Rosas, 99–100; in literature, 100–101, 105–6; population of, 98, 104; and Pragmatic on Marriage, 97–98, 101; and racial classification, 104–6. *See also* race
Age of Revolution, 7, 149n15, 150n18
Alagón, Gregorio, 142–43
Alberdi, Juan Bautista: and the family, 5; and population, 112; and race, 105
Album de Señoritas, 132–34
Alfonso the Wise of León and Castille, 21, 28
American Revolution, 6
anticlericalism, 3, 52. *See also* secularism
Aráoz, Bernabé, 112
architecture, 16-10, 47, 140, 162n7
Artigas, José Gervasio, 49
Azamor y Ramírez, Father Manuel, 68–69

Belgrano, Manuel, 46
Bonaparte, Napoleon, 13
Bourbons (Spanish): and education, 122; reforms of, 70, 94. *See also* Pragmatic on Marriage
Buenos Aires: economy of, 16; growth of, 12; political tensions in, 54–55; settlement of, 11; street life in, 8; travel accounts of, 9, 10, 11, 56

Cabildo, 11, 14, *16-10*
cabildo abierto, 14
Caldcleugh, Alexander, 56
carretas, 11, *16-8*
Casa de Ejercicios (house of spiritual exercises), 71, 80, 91, 117–19
Casa de Niños Expósitos (house for abandoned children), 61, 65, 102
Castañeda, Father Francisco de Paula: and education, 50; and gender, 95
Castelli, Juan José, 14
Castro, Manuel Antonio de, 94, 108, 110
caudillos, 16
child custody: agreement of, 39; cases of, 3; and the economy, 42; maternal rights of, 36, 62; paternal rights over, 23. *See also* children
children, 3; abuse of, 33, 65, 83; attitudes toward, 56–58; compensation for guardians of, 40; daily life of, 8, *16-3*; education of, 25, 29, 60, 61, 62–63; history of, 165n40; and labor, 38–44, 123; natural (*hijos naturales*), 27; and patriarchy, 20; and protection from streets, 35, 37–38; and state

children (*cont.*)
 intervention, 60–67; suffering of, 42–
 44, 65; welfare of, 65. *See also* Casa
 de Niños Expósitos; child custody;
 childhood; disensos
childhood: conceptions of, 58–59; his-
 tories of, 3, 57–58, 165n46. *See also*
 children
Civil Code (Argentina), 19, 137, 142. *See
 also* Vélez Sarsfield, Dalmacio
Constitution of 1826, 16
Council of Trent, 51, 68, 147–48n3
creoles (*criollos*): and the militia, 13; and
 marriage, 45

Defender General of Minors (Defensor
 General de Menores), 39, 42, 61, 64,
 117
disensos, 1–2, 3. *See also* Pragmatic on
 Marriage
divorce, 28, 29–31, 35, 80
Dorrego, Manuel, 17

Echeverría, Esteban: and Afro-Argen-
 tines, 100; and Indians, 48
education, 50, 61, 141. *See also* children:
 education of; women: education of
El Centinela, 52–53, 135
English: invasion of Buenos Aires, 11, 13,
 120, 121; population in Buenos Aires,
 55–56; and trade with Buenos Aires,
 12; treaties with Argentina, 56
Enlightenment: and anticlericalism, 3;
 and children, 56–57, 67; and educa-
 tion, 50; and freedom in marriage,
 144; and independence, 46, 99, 140;
 and patriarchy, 136–37

family, *16-11, 16-12*; historiography of,
 148n1, 149n12, 149n14, 164n39; and the
 law, 21–22; and the Roman Catholic
 Church, 5; and social status, 4; and

the state, 5, 60–67, 111–14, 138, 141; and
 warfare, 53–55. *See also* childhood;
 children; marriage; parents; Pragmatic
 on Marriage; Siete Partidas
federalism, 15, 16, 18, 54
Ferdinand VII, 13, 47
French Revolution, 6

gauchos, 10, 48, 100; definition of, 10,
 152n16; family life of, 10–11, *16-4, 16-5,
 16-6*, 152n17, 170n56
gender, 22, 32, 160n75; and the Church,
 30; and the creation story, 130, 132;
 and double standards, 32, 118–19; and
 literature, 127; opposition to changing
 roles of, 137; roles, 24, 59. *See also*
 masculinity; patriarchy; women
Gillespie, Alexander, 11
Gorriti, Juana Manuela, 122, 128
Guerra, Rosa, 130–31
Güiraldes, Ricardo, 43
Gutiérrez, Ladislao, 88–93

Haiti, 49
Hidalgo, Bartolomé, 47
honor, 5, 25, 27, 28, 103, 141; and mar-
 riage, 25–26; multiple definitions of,
 25–28; and poverty, 109–10; violent
 defense of, 36, 78–79, 107–8. *See also*
 masculinity

illegitimacy: and honor, 26–27; and
 illicit unions, 33–34, 102; levels of, 103;
 rates of, 38
immigration, 98, 125
independence from Spain, 6, 150n18,
 150n21; early governments after, 15.
 See also May Revolution of 1810
Indians: and disensos, 172n9; in econ-
 omy, 152n14; and labor, 123; in liter-
 ature, 47–48; and national identity,
 49; population of, 9; wars with, 133,
 151n12

infanticide, 33
Irigoyen, Bernardo, 143

jurisprudence: and children, 65; continuity of, 21–22; and the family, 3, 65–66, 81–82; and independence, 142–43, 155n6

La Abeja Argentina, 58–59
La Aljaba, 129–30
La Camelia, 129–32
leva (forced military drafts), 53–54
limpieza de sangre (purity of blood), 26, 97, 107–8, 111
Liniers, Santiago, 14
love: paternal, 69, 75–79; romantic, *16-2, 16-7*, 68, 71–72, 73–75, 95–96, 141, 166n3

Manso de Noronja, Juana, 132–34, 138
marriage, 34, 45, 60; civil versus church, 52, 139–40; debates over age of, 60; and economic concerns, 86, 87, 107–14; and freedom, 68, 83; and honor, 5; ideals and realities of, 28, 36, 80–81; interfaith, 55, 113; and the nation, 83; sexual relations before, 34, 102; and social inequality, 3; and Spaniards, 45; violence in, 30. *See* love; Pragmatic on Marriage
masculinity, 30, 31, 32; legal defense of, 36–37; violent defense of, 32, 36–37
Masefield, John, 91–92
May Revolution of 1810: and architecture, *16-10*; and education, 50; and gender, 95; and historical periodization, 6, 150n18, 150n21; impact on marriage of, 70–71, 94–96; and legal change, 21–22, 142; and nationhood, 140; process of, 14; and printing, 46; and race, 98; reforms of, 111
mazorca, 92

Mexico, 49
Mitre, Bartolomé: on English invasions, 13; and national unification, 19, 139; and race, 105
Monteagudo, Bernardo, 99, 111, 142
Morel, Carlos, 10
Moreno, Mariano, 142

nation building, 7, 19, 60, 180n3, 180n6, 181n16. *See also* May Revolution of 1810
newspapers, 46, 52, 59; and women, 115, 119–20. *See also* women: and journalism

O'Gorman, Camila, 88–93

parents, 43; and persuasion and coercion of children, 82–86; and poverty, 63–65; responsibilities of, 24, 28–29. *See also* love: paternal
patriarchy, 140, 167n4; and child custody, 20, 136–38; definition of, 155n9; and Hispanic tradition, 1; and independence, 7, 150n19; legal history of, 20–23; and marriage, 94–96, 144; and women, 116–20. *See also* gender; Pragmatic on Marriage
patria potestad, 22, 23, 81–82. *See also* patriarchy
peónes de campo, 10. *See also* gauchos
Plaza de Mayo, 11, 152n18
popular classes, 49
Portalis, Jean Étienne Marie, 60
Pragmatic on Marriage, 1, 3, 21, 26, 70, 76, 81–82, 94; additions to, 167n17; legal debates over, 81–82; and *limpieza de sangre*, 26; and race, 26, 97, 99, 101, 102–3, 112, 141, 144, 171n2
printing, 46
prostitution, 33, 35, 87
pulperías, 10, *16-3, 16-9*, 27, 152nn14–15

Quiroga, Facundo, 17

race, 64, 97, 103, 112, 140; and census, 104–5; and honor, 107–8; and re-classification, 104–6. *See also* Afro-Argentines; Indians; *limpieza de sangre*
Rivadavia, Bernardino, 16, 50, 126; and cemetery reform, 51; and female education, 126; and the Sociedad de Beneficencia, 61–62
Roman Catholic Church, 16, *16-2*, 51, 142; baptismal records, 75, 76, 79, 87; and civil authority, 51–52; and education, 62–63; and interfaith marriage, 55, 113; jurisdiction over disensos, 3, 16, 51; and liberty in marriage, 73–74; and marriage, 52, 68, 73–74; and women, 30. *See also* anticlericalism; secularism
romantic love. *See* love
Rosas, Juan Manuel de, 17, 18, 51, 54, 60, 128, 130, 142, *16-9*, 154nn40–41, 163n35; and Afro-Argentines, 99–100; and Camila O'Gorman, 88–93; defeat of, 18; and federalism, 18, 54; historiography of, 169–70nn55–56; rise to power of, 17; and Sarmiento, 18
Rosas, Manuelita, 91, 99
Rossi, Vicente, 100–101, 106
Rossini, Gioachino, 72
Rousseau, Jean Jacques, 46, 127, 130

Saavedra, Cornelio, 13, 14
Sánchez, Mariquita: and disenso versus parents, 52, 68–69, 71–72; and English invasions, 13; and race, 13; and ro-mantic love, 73, 95–96; and women's education, 123
San Martín, José de, 49
Sarmiento, Domingo F.: and *Civilization and Barbarism*, 17, 48; and Juan Manuel de Rosas, 18, 154n42; and

race, 105; and women's education, 126–27
secularism, 50. *See also* anticlericalism
sexual relations, 34. *See also* marriage: sexual relations before
Siete Partidas: and family life, 28, 39, 58; history of, 20–21; and interfaith marriage, 55; and legal continuity, 21–22; and patriarchy, 22
slavery, 99, 140. *See also* Afro-Argentines
Sociedad de Beneficencia, 61–62, 135; and education, 126
Spain, 13, 45, 144; and oppression of women, 125
St. Augustine, 22
street life: dangers of, 35–38; and eco-nomic activity, 8, *16-1*, *16-2*

tertulias (literary salons), 88, 128
Thompson, Martín Jacobo de, 68–69, 71–72
Toqueville, Alexis de, 6, 144

unitarians, 15, 16, 54
Urquiza, Justo José, 18, 139

vagrancy, 53
Vélez Sarsfield, Dalmacio, 139–40, 142
Vidal, Emeric Essex, 10

women: and adoption rights, 137–38; and the Church, 30, 133; and economic conditions, 33; education of, 122–27, 129–30; and exploitation, 115; and fashion, 9, 125, 131; and gender roles, 24, 58–59; and history, 116; and independence wars, 120–22, 179n76; initiation of lawsuits by, 135–37; and journalism, 129–34, 178n59; and literature, 127–29; and motherhood, 58–59, 129, 134; and the nation, 119–20, 124, 128; and physical abuse, 30; and violation of gender norms, 36. *See also* gender

IN THE ENGENDERING LATIN AMERICA SERIES

Sex and Danger in Buenos Aires: Prostitution, Family, and Nation in Argentina
Donna J. Guy

*Between Civilization and Barbarism: Women, Nation, and Literary Culture in
Modern Argentina*
Francine Masiello

Women, Feminism, and Social Change in Argentina, Chile, and Uruguay, 1890–1940
Asunción Lavrin

I'm Going to Have a Little House: The Second Diary of Carolina Maria de Jesus
Carolina Maria de Jesus
Translated by Melvin S. Arrington Jr. and Robert M. Levine

*White Slavery and Mothers Alive and Dead: The Troubled Meeting of Sex, Gender,
Public Health, and Progress in Latin America*
Donna J. Guy

*Class Mates: Male Student Culture and the Making of a Political Class in
Nineteenth-Century Brazil*
Andrew J. Kirkendall

Female Citizens, Patriarchs, and the Law in Venezuela, 1786–1904
Arlene J. Díaz

False Mystics: Deviant Orthodoxy in Colonial Mexico
Nora E. Jaffary

Mexican Karismata: The Baroque Vocation of Francisca de los Ángeles, 1674–1744
Ellen Gunnarsdóttir

*The Case of the Ugly Suitor and Other Histories of Love, Gender, and
Nation in Buenos Aires, 1776–1870*
Jeffrey M. Shumway

*A Culture of Everyday Credit: Housekeeping, Pawnbroking, and
Governance in Mexico City, 1750–1920*
Marie Eileen Francois

From Colony to Nation: Women Activists and Gendering of Politics in Belize, 1912–1982
Anne S. Macpherson

CPSIA information can be obtained at www.ICGtesting.com
Printed in the USA
LVOW11s0630271113

362988LV00002B/2/A